A Garland Series

OUTSTANDING
DISSERTATIONS
IN THE

FINE
ARTS

Roman Group Portraiture

The Funerary Reliefs
of the Late Republic and Early Empire

Diana E. E. Kleiner

Garland Publishing, Inc., New York & London

1977

Library of Congress Cataloging in Publication Data

Kleiner, Diana E E
 Roman group portraiture.

 (Outstanding dissertations in the fine arts)
 Originally presented as the author's thesis,
Columbia, 1975.
 Bibliography: p.
 1. Portraits, Group--Rome. 2. Relief (Sculp-
ture)--Rome. 3. Sepulchral monuments--Rome.
I. Title. II. Series.
NB1296.3.K55 1977 733'.5 76-23634
ISBN 0-8240-2703-5

Printed in the United States of America

ROMAN GROUP PORTRAITURE:

THE FUNERARY RELIEFS OF THE LATE

REPUBLIC AND EARLY EMPIRE

Diana E. E. Kleiner

Submitted in partial fulfillment

of the requirements for

the degree of Doctor of Philosophy

in the Faculty of Philosophy

Columbia University

1975

Table of Contents

Preface

This study grew out of a Spring 1971 paper
presented in a Columbia University seminar on Roman
provincial art led by Professor Richard Brilliant.
The seminar paper treated a much broader topic than
the present study – a comparative analysis of the
group funerary portrait reliefs of North Italy,
Bordeaux, and the Danube region. In the course of
my research on the provincial monuments it became
apparent that the formal and iconographic sources
of these reliefs could not be determined satis-
factorily because the comparble material in the
capital had not yet been collected. There seemed to
be a pressing need for a monographical treatment of
the Roman funerary reliefs before any study of the
provincial funerary portraits could be attempted.
Consequently, in consultation with Professor Bril-
liant the present topic was chosen as the subject of
my doctoral dissertation.

During the preparation of this study I have
received advice and assistance from many scholars
and friends, but I am grateful, above all, to Professor
Brilliant, who has directed my research from the begin-

ning. He has, through discussion and correspondence,
aided me in dealing with a wide variety of problems
that arose in the course of my research, and has
immeasurably improved earlier drafts of this disser-
tation. I also wish to thank the other members of
my dissertation defense committee - Professors Alfred
Frazer (chairman), William V. Harris, Larissa Bonfante
Warren, and Douglas Fraser - who made many valuable
suggestions. In particular, Professor Harris's com-
ments on the historical sections were of great value.
I also want to acknowledge my great debt to my hus-
band, Fred S. Kleiner, who has discussed with me many
problems involving the Roman funerary reliefs, as well
as lent personal support during my research and
writing. He has also typed the dissertation manuscript -
twice.

It is also a pleasure to acknowledge the assist-
ance I received from the directors and staffs of the
libraries and photographic archives of Columbia
University, the American Academy in Rome, the German
Archaeological Institute in Rome, and the American
School of Classical Studies in Athens. Financial
support during the period October 1972 - December 1973
was generously provided by the Woodrow Wilson National

Fellowship Foundation.

The dissertation has been prepared in conformation with the guidelines of the American Journal of Archaeology. Abbreviations not included in the AJA guidelines are listed at the end of this study. Traditional Latin transliterations for Greek words have been employed throughout the text and notes.

This published version of the dissertation is essentially the same as that submitted to Columbia in December 1975, except for extensive changes in the photographic documentation.

Chapter One: Introduction

Portraiture is to many people the hallmark of
Roman art, yet there is a large series of Roman
group portraits which has never been collected or
studied as a coherent class of monuments - the fun-
erary reliefs of Roman freedmen and their immediate
descendants. Many of these reliefs are unpublished
and those that have been published are almost always
treated only briefly in more general contexts, such
as studies of Roman portraiture, museum catalogues,
surveys of Roman art and funerary customs, and in
excavation reports.

The purpose of this study is to bring together
the published and unpublished reliefs in one place,
to examine these reliefs typologically and stylist-
ically, to discuss their setting in antiquity, and
to demonstrate the insight these monuments give us
as to the tastes and artistic preferences of their
middle-class patrons. This study is, therefore, not
a history of Republican and Augustan portraiture,
although the stylistic character of the portraits
will be discussed within this broader context. The
Catalogue (Chapter Nine) comprises ninety-two pieces

from the late Republican and Augustan periods; these
are almost all the known examples because later group
portrait reliefs are extremely rare. After the death
of Augustus these monuments were no longer manufactured
in quantity and are less representative of the typical
taste of the wealthier freedmen. Only five examples
of group portrait reliefs survive from the Julio-Claud-
ian and Flavian periods, and seventeen from the second
century A.D. The reliefs all come from Rome or its
environs, although they are now found in museums all
over the world. The geographical designation "Roman"
refers in this study specifically to the ancient city
of Rome and its immediately outlying areas, e.g., the
Via Appia, the Via Tiburtina, Ostia, etc.

The reliefs themselves are of two basic types:
the more ambitious portrayals are full-length repre-
sentations of the deceased and one or more other
figures; the more common are simpler, bust-length
versions of the full-figure types. The latter type
comprises portraits of up to six persons, the former
never more than three. The reliefs depict, almost
without exception, men and women dressed in civilian
garments, represented as frontal busts or quietly
standing figures, emphasizing the virtues of
Romanitas and family unity. The portraits, whether

full- or bust-length, are approximately life-size, and
were originally accompanied by epitaphs, many of which
survive. The inscriptions are usually quite simple,
stating who the persons are and their relationships
to one another, (e.g., pater, 71; uxor, 12 and 71),
their status as libertus or freeborn, their profes-
sions, if any (e.g., medicus, 45; pistor, 12), the
circumstances which led to the erection of the monu-
ment (e.g., ex testamento, 8 and 41; de suo fecit, 55;
patrono fecit, 3), and sometimes which of the persons
portrayed are dead (Θ, 5 and 85) or are still alive
(vivit, 23, 70, and 82).

In antiquity these reliefs were not free-standing
monuments, but decorated the facades (or in some
cases the interiors) of tombs which lined the roads
leading out of Rome. The provenance of many pieces
mow in museum collections is known, and the find-
spots are very often the Via Appia, Via Flaminia,
Via Tiburtina, etc. Often the reliefs have been
found in conjunction with architectural members;
attachment holes, dowels, and traces of iron clamps
are frequently found on the tops, sides, and backs
of the reliefs. Two bust-length portrait reliefs
(9 and 40) are still in situ in the facades of two

travertine tombs at the corner of the modern Via
Statilia and Via di S. Croce in Gerusalemme (Fig.
40b). The two tombs are part of a complex of four
preserved tombs which originally lined the ancient
Via Coelimontana.[1] The two with portraits are
rectangular in ground plan and are connected to
form what is essentially a double tomb. The cellas
and doorways are distinct from one another, but
they share a common wall and foundation and are
both made entirely of tufa blocks, save for the
portrait reliefs, which are travertine. The reliefs
are among the earliest of the series (75 - 50 B.C.)
and indicate that such portraits were situated in
facades from the outset. In this case, the epitaphs
were inscribed on the tomb walls beneath the reliefs,
rather than on the block in which the portraits were
carved.

Another travertine relief, one of the most
elaborate of those preserved, portraying six members
of the Servilius family (92), was found in situ in
the facade of an early Augustan three-story colum-

1. L. Cantarelli, BullComm (1917) 237-242. F. Fornari,
 NSc (1917) 174-179. A. M. Colini, "I sepolcri e gli
 acquedotti repubblicani di via Statilia," Capitolium
 18 (1943) 268-279. Nash, Pictorial Dictionary² II,
 349-351, with bibliography.

9

barium on the grounds of the Villa Wolkonsky.[2] The
tomb has been torn down, but the relief is still on
the premises of the villa. A fourth travertine
relief, with four bust-length portraits of members
of the Fonteius family (73), is set into the facade
of a partially preserved tomb which has been reerected
in the chiostro of the Museo Nazionale Romano. The
tomb is of tufa and was discovered near the Acquedotto
Felice where the railroad track leading out of Rome
divides into two.[3]

These four reliefs are framed on all four sides
and were easily incorporated into the masonry fabric
of the tombs. Other pieces with bust-length por-
traits, but without frames, were probably placed in
niches, either on tomb facades, or inside the struct-
ures. One of the earliest preserved unframed examples
(83) was excavated in the interior of a columbarium on
the Esquiline hill in Rome.[4] Another piece, one of
the rare reliefs dating to the second century A.D.,
was found in a niche below the staircase inside a

2. R. Lanciani, NSc (1881) 137. R. Lanciani, BullComm
 (1881) 198-201.

3. R. Lanciani, BullComm (1880) 142-143.

4. E. Brizio, Pitture e sepolcri sull'Esquilino (Rome
 1876) 134.

columbarium in the Vigna Codini, near the Via di
Porta S. Sebastiano (Fig. 93).[5] The piece is still
in situ; a separate plaque set into the wall gives
the names of the pair as Aponius and Aponia.

There is also considerable evidence that the
full-length portrait reliefs were similarly set into
tomb facades and they too bear marks indicating that
they were attached to walls. The earliest preserved
Roman full-length portrait relief (11), discovered
in excavations below the modern Via Statilia, was
found together with the tufa core of a tomb, an orn-
amented peperino block, and two travertine cippi.[6]
The tomb stood beside the ancient Via Coelimontana
at a location near where several other Republican
tombs have been uncovered, most notably the tufa
tombs of the Quinctii and others (9 and 40) with
their bust-length portraits still in the facades.

An Augustan marble relief depicting two women
standing side by side (8) was similarly found on the

5. P. Campana, "Di due sepolcri romani del secolo di
 Augusto scoperto tra la via Latina e l'Appia presso
 la tomba degli Scipioni," DissPontAcc 11 (1852)
 339. G. Lugli, I monumenti antichi di Roma e sub-
 urbio (Rome 1930) I, 448-449.

6. A. M. Colini, "Bassorilievo funerario di via Sta-
 tilia," BullComm 54 (1926) 177-182.

Via Tiburtina together with a number of marble archi-
tectural blocks, two of which were inscribed with
epitaphs of the deceased. A tract of ancient road,
probably the Via Tiburtina, was also uncovered, and
it is clear that the relief once decorated a tomb
which originally flanked this ancient road.[7]

The best evidence for the insertion of full-
length portrait reliefs into tomb facades comes from
the excavation of the Augustan tomb of the baker
Marcus Vergilius Eurysaces.[8] The monument is situ-
ated between the ancient Via Labicana and Via Prae-
nestina near the point where the two roads converge,
a few meters outside the later Porta Maggiore. The
baker's tomb is irregular in plan, because of its
location between the two roads, and unique in elevat-
ion, consisting of three stories - an unarticulated
socle, and two upper stories decorated on the rear
and lateral sides by grain-measures, pilasters, a
dedicatory inscription repeated three times, and a

7. C. Caprino, NSc 5-6 (1944-45) 73-77.

8. L. Grifi, Brevi cenni di un monumento scoperto a
Porta Maggiore (Rome 1838). L. Canina, AnnInst 12
(1838) 226-229. P. Ciancio Rossetto, Il sepolcro
del fornaio Marco Vergilio Eurisace a Porta Mag-
giore (I monumenti romani 5) (Rome 1973) with
bibliography and a full account of the 1838 excav-
ations.

historiated frieze recording successive stages in
the manufacture of bread. The rear and lateral
sides of the tomb are very well preserved because
the monument served as the core for the central
tower of the Porta Praenestina rebuilt by Honorius;
the fourth, principal facade was demolished when
the tower was erected and the debris was incorpor-
ated into the fabric of the new structure. When
the tower was torn down under Pope Gregory XVI, a
marble relief depicting Eurysaces and his wife
Atistia (12) and an accompanying marble inscription
of the same width as the portrait relief, were
found in the debris above the tomb. The inscription
reads:

> FVIT.ATISTIA.VXOR.MIHEI
> FEMINA.OPITVMA.VEIXSIT
> QVOIVS.CORPORIS.RELIQVAE
> QVOD.SVPERANT.SVNT.IN
> HOC.PANARIO.

Canina and Ciancio Rossetto have convincingly situ-
ated the portrait relief of Eurysaces and Atistia
in the damaged principal facade of the baker's tomb.
The findspot speaks in favor of this, as does the
fact that Atistia is mentioned in the inscription as

uxor mihei and a man and woman are depicted in the
relief; if the man were other than Eurysaces, who
is mentioned on the other three facades of the
tomb, he would have been cited in the marble
inscription as well. The portrait would have
crowned the inscription and together would have
constituted the primary decoration of the main
facade of the tomb, where there was no historiated
frieze, as on the subsidiary sides (Fig. 12b).

The inscriptions that accompany the Roman
funerary portrait reliefs state explicitly that
almost every person depicted is a former slave, a
libertus or liberta, e.g.,

> L(ucius).AMPVDIVS.L(ucii).ET.Ɔ(aiae).L(ibertus).
> PHILOMVSVS (59)

<div align="center">and</div>

> C(aius).LIVIVS.C(aii).L(ibertus).ALEXANDER
> AEMILIA.L(ucii).L(iberta).CLVCERA (67).

Exceptions are few in number and those freeborn
persons who are portrayed are always either the off-
spring of libertini or the patrons who granted free-
dom to the libertini who commissioned the relief,
as in the following examples:

> L(ucius).OCCIVS.L(ucii).F(ilius),

who is represented beside his father, a _libertus_ (_38_),

<div align="center">and</div>

L(ucius).ANTISTIVS.CN(aei).F(ilius),

who is cited in the full inscription as patron (_20_).
Because those who commissioned these funerary por-
traits all come from the same statum of Roman society,
a brief discussion of Roman freedmen during the late
Republic and early Empire is necessary in order to
clarify the social and economic background that gave
rise to the distinctive class of monuments under dis-
cussion.[9]

The bringing back of quantities of captured enemies
as slaves to Rome is first attested in the second cent-
ury B.C., where they were divided into two groups,
the _familia urbana_, composed of domestic slaves, and
the _familia rustica_ of agricultural slaves. The
majority of domestic servants came from the Greek East[10]
and these slaves, who were often relatively well edu-

9. The two major studies of freedmen in late Repub-
 lican and early Imperial times are Duff, _Freedmen_
 and Treggiari, _Roman_ Freedmen. Cf. G. Vitucci,
 "Libertus," _Diz. Epig._ 4 (1958) 905ff.

10. For the origin of the slaves, see M. Bang, "Die
 Herkunft der römischen Sklaven," RömMitt 25
 (1910) 223ff.; 27 (1912) 189ff. L. Westermann,
 The Slave Systems of Greek and Roman Antiquity
 (Philadelphia 1955).

cated or in possession of a valued skill, had the best
chance for manumission. It is for this reason that so
many of the portraits on the funerary reliefs collected
here are labeled with Greek names: Athena (16), Pro-
thesilaus (24), Apollonius (44), Metrodorus (45),
Hermodorus (63), Philomusus and Stephanus (87), to name
only some. Manumission could be obtained by the slave's
purchasing his own freedom at the rate of his value on
the open market. Freedom was also sometimes given freely
by master to slave in return for the work and loyalty
rendered to him, because of a Stoic belief in the uni-
versal brotherhood of man, or in order to reap financial
benefits for the master, as when largess was distributed
and the master wanted to increase his share of the dole.[11]

 Once freed, the slaves were still obligated to
their patron and owed him obsequium et officium,[12]

11. For manumission, see Duff, Freedmen 12-35. Treg-
 giari, Roman Freedmen 11-31. M. Kaser, "Die An-
 fänge der manumissio und das fiduziarisch gebundene
 Eigentum," ZSav 61 (1941) 153ff. E. Volterra,
 "Manomissione e cittadinanza," Studi in onore di
 U. E. Paoli (Florence 1956) 695ff.

12. For obsequium et officium, see Duff, Freedmen
 40ff. J. Lambert, Les operae liberti (Diss. Paris
 1934). M. Kaser, "Die Geschichte der Patronats-
 gewalt über Freigelassene," ZSav 58 (1938) 88ff.
 C. Cosentini, Studi sui liberti. Contributo allo

but they were allowed to take up professions and
thereby earn enough money to live comfortably and,
in the case of the freedmen who are depicted on the
reliefs collected here, enough to erect large-scale
funerary monuments and to commission sculptors to
adorn them. In the early Republic the patron had
provided a burial place for his domestic slaves
and freedmen, who were often buried in the same
sepulcher as the master and his family, but by the
late Republic the libertini had become richer and
more independent and many built their own tombs
according to their own taste. These are the patrons
who commissioned the funerary reliefs in this study,
but at the same date, masters still erected tombs
for the poorer enfranchised slaves, usually in the
form of columbaria, such as those of the Vigna Codini,
where the ashes of hundreds of slaves and freedmen
were housed together.[13]

Because it was believed that the only profes-
sions suitable for the Roman upper classes were
agriculture and service to the state, whether mili-

studio della condizione giuridica dei liberti
cittadini (Catania 1948) I, 72ff. A. Watson,
The Law of Persons in the Later Roman Empire
(Oxford 1967) 228ff.

13. See supra n. 5.

tary, civilian, or both, many of the highest paying
positions in commerce, etc. were open to enfranch-
ised slaves. Libertini became doctors, lawyers, and
bankers, as well as bakers, artists, architects, and
teachers.[14] Eurysaces was very proud of his profes-
sion as master baker (pistor, 12); in one relief in
the Louvre (45), both men are cited as medicus.
Freedmen of rich patrons had, of course, the best
chance of accumulating wealth since they were often
supported in their new endeavors by their former
masters, who might finance them in return for a
share of the earnings; other times a rich patron
might will his fortune to a former slave when he had
no offspring.

It is important to remember in evaluating the
funerary portraits of freedmen that the libertini
had neither legitimate family geneaologies nor a
series of ancestral portraits in their homes, as did

14. H. J. Loane, Industry and Commerce of the City
 of Rome, 50 B.C. - A.D. 200 (Diss. Baltimore
 1938). M. Maxey, Occupations of the Lower
 Classes in Roman Society (Diss. Chicago 1938).
 F. M. De Robertis, Lavoro e lavoratori nel
 mondo romano (Bari 1967). A. Burford, Craftsmen
 in Greek and Roman Society (London 1972).

the nobilitas.[15] The placement of family portraits
on their tombs must have been especially meaningful
to the freedmen and freedwomen, most of whom were
separated from their families when they were torn from
their native lands. By Roman law their real parents
ceased to exist when they were enslaved, and once
freed, they were not allowed to name in their epitaphs
their actual parents, but only their patron or patroness.
Some slaves were allowed to marry, but these were con-
sidered quasi-marriages and often were not recognized
either by the masters or the state. When these slaves
were freed, however, their new family was legitimized
and it was this legitimacy that they were, in a
sense, commemorating. These family reliefs comprise
fathers, mothers, sons, daughters, brothers, and
sisters, but never grandparents or grandchildren,
because the newly enfranchised slaves could legitim-
ately claim a maximum of two generations bearing
the same name. The freed slaves proudly set forth

15. On the patrician ius imaginum and its restriction
 to the nobilitas, see Zadoks, Ancestral Portraiture
 32ff. Vessberg, Studien 41 (ancient texts), 107f.
 R. Bianchi Bandinelli, "Ritratto," EAA 6 (1965)
 721-723. Bianchi Bandinelli, "Sulla formazione del
 ritratto romano" (1957), reprinted in Archeologia
 e cultura (Milan 1961) 172-188, esp. 180-183.

their tripartite Roman names in their epitaphs. The
freedman took over the praenomen and nomen of his
master; his slave name was retained as his cognomen.[16]
In the reliefs where freeborn children are depicted,
care is taken to include the father's name, a privi-
lege denied to the freedmen themselves, and in some
cases also the freeborn son's tribe and military
status,[17] as in the following examples:

C(aius).VETTIVS.C(aii).F(ilius).SECVNDVS (84)

P(ublius).SERVILIVS.Q(uinti).F(ilius).GLOBVLVS
Q(uintus).SERVILIVS.Q(uinti).L(ibertus).HILARVS.
PATER (71)

16. For the nomenclature of libertini, see Duff,
Freedmen 52ff. Treggiari, Roman Freedmen 250-251.
A. Oxe, "Zur alteren Nomenklatur der römischen
Sklaven," RhM 59 (1904) 108ff. T. Frank, "Race
Mixture in the Roman Empire," AHR 21 (1917)
689ff. B. Doer, Die römische Namengebung (Stutt-
gart 1926). The freedman's commemoration in stone
of the tria nomina as a symbol of the acquisition
of Roman citizenship has been emphasized by L. R.
Taylor, "Freedmen and Freeborn in the Epitaphs of
Imperial Rome," AJP 82 (1961) 129-130. Cf. E.
Levy, "Libertas und Civitas," ZSav 78 (1961)
142ff. H. Chantraine, "Zur Entstehung der Frei-
lassung mit Bürgerrechtserwert in Rom," ANRW I,2
(1972) 59-67.

17. For the status of the sons of freedmen, see Duff,
Freedmen 66. Treggiari, Roman Freedmen 67-68,
229-235. M. L. Gordon, "The Freedman's Son in
Municipal Life," JRS 21 (1931) 65ff. Taylor, AJP
82 (1961) 113ff. Only freeborn men could serve
in the Roman army.

L(ucius).SEPTVMIVS.L(ucii).F(ilius).ARN(iensis).
EQVES (39).

In the chapters that follow the funerary portrait
reliefs of Roman freedmen will be analyzed from several
typological and stylistic viewpoints. Chapter Two deals
with the identity of the figures portrayed, their relat-
ionships to each other, and the familial and professional
ties that led to the commissioning of group funerary por-
traits. The various formats of the portrait reliefs are
described and tabulated in Chapter Three; the subsidiary
representations which decorate the frames of the reliefs
(attributes, tools, etc.) are also discussed in this
chapter. Chapter Four treats the materials used for the
relief slabs; the question of the source and cost of the
various stones, and the significance of the materials
for dating purposes, are discussed. Chapter Five deals
with the funerary portraits themselves. In this chapter,
the various portrait types are described and tabulated,
the style of the portraits is discussed and compared
with that of contemporary portraits in the round, and
the value of the portrait types and styles as indications
of the date of the ninety-two reliefs is treated. Chapter
Six is devoted to the description and analysis of the
hairstyles depicted in the reliefs; the coiffures re-
flect changing fashions in the capital and are important

criteria for the establishment of the chronology of
the funerary portraits. In Chapter Seven the garments
depicted in the reliefs are described and the stylistic
development of drapery representation during the late
Republic and early Empire is outlined. The statuary
models for the full-length and truncated funerary
portraits are also treated in this chapter. In the
Conclusion, Chapter Eight, the class of monuments is
characterized as a whole and the significance of the
funerary reliefs for our understanding of the artistic
preferences of freedmen during the late Republican and
Augustan periods is evaluated. An attempt is made to
determine the motives that might have led to these
commissions by freedmen and the sociological implicat-
ions of such a choice.[18] The final chapter, Chapter
Nine, is the catalogue of the ninety-two surviving
funerary reliefs. A bibliography, list of illustrations,
and photographs of every piece catalogued, are appended
at the end of the study.

18. For the sociological implications of Roman art in
 general, see G. Niebling, "Zur soziologischen Struktur
 der römischen Kunst," Atti del XIV Congresso di
 Sociologia (Rome 1950) 4. R. Brilliant, "Storia dell'
 arte e sociologia," La Critica Sociologia 5 (1968)
 79-88.

Chapter Two: Identification of Figures Portrayed

In this chapter the identity of and relation-
ships among those portrayed in the freedmen fun-
erary reliefs are analyzed in order to determine
what ties (marital, blood, or other) led to the
commissioning of a group funerary portrait. The
identity of the figures can be determined by in-
scriptions, sex, gestures, postures, and attributes;
when an epitaph survives, there is rarely any am-
biguity as to who is portrayed.

All ninety-two reliefs depict groups of figures
that may be classified under one of the following
five headings:

(1) a married couple,

(2) a husband and wife with one or more
children,

(3) conliberti, i.e., liberti of the same
patron not united by marriage,

(4) a patron and one or more of his liberti,

(5) a combination of the above.

Type 1, the married couple, by definition, com-
prises only two figures, and is the simplest and one
of the most common types of funerary portrait on the

surviving freedmen reliefs. In two cases, the fact
of marriage is explicitly stated: Marcus Vergilius
Eurysaces refers to his wife, FVIT.ATISTIA.VXOR.MIHEI.
FEMINA.OPITVMA, etc. (12), and in a relief formerly
in the Lansdowne collection, the inscription between
the male and female heads makes reference to the
union of husband and wife, HANC.TALEM.CONIVGEM, etc.
(32). In the remaining cases, where an inscription
is lacking or reference is not made to marriage, the
gestures, postures, and attributes of the figures
often demonstrate that husband and wife are depicted.

In Greek funerary reliefs various members of
the family group shake hands with the departing per-
son, the deceased, and the handclasp is, in these
cases, a gesture of farewell, often made between
two members of the same sex.[1] In the funerary por-
trait reliefs from the city of Rome, only men and
women clasp hands, and this gesture, the dextrarum
iunctio, designates that they are married; it is not
a gesture of leave-taking as in the Greek reliefs.

1. For the dextrarum iunctio on Greek grave stelae,
see K. Friis Johansen, The Attic Grave Reliefs of
the Classical Period (Copenhagen 1951) 29ff. Some
scholars do not think that the handshake signifies
leave-taking; instead the reunion of two people
who had been separated by death has been suggested,
with numerous variations. For these theories, see
Johansen 53ff.

The Roman dextrarum iunctio between man and woman
refers to the most important moment of the marriage
ceremony - the joining of right hands - and the ges-
ture is probably symbolic of the affection, devotion,
and fidelity which unite the pair.[2] In several
reliefs where a man and woman are depicted alone,
the artist has shown that the couple is married by
representing the two figures in a dextrarum iunctio.
This is the case with a fragmentary full-length por-
trait in the Museo Nazionale Romano (13), the Aiedius
family relief in Berlin (18), a relief with an illeg-
ible inscription in the Villa Medici (28), a severely
damaged portrait in the Casale di S. Palombo on the
Via Satricana (31), and with the famous portrait
group popularly known as "Cato and Porcia" in the
Vatican (34). In the last example, the dextrarum
iunctio is reinforced by the resting of the woman's
left hand on the man's right shoulder. Visual,
rather than physical, contact is made between Cnaeus
Pompeius and his wife Numonia in a relief in the

2. For the gesture of dextrarum iunctio in Roman art,
 see B. Kötting, "Dextrarum iunctio," Reallexikon
 für Antike und Christentum 3 (Stuttgart 1957) 881-
 888. L. Reekmans, "La dextrarum iunctio dans l'icon-
 ographie romaine et paléochrétienne," Bull. Inst.
 Hist. Belge Rome 31 (1958) 23-95. Reekmans, "Dex-
 trarum iunctio," EAA 3 (Rome 1960) 82-85.

Museo Nazionale Romano depicting two facing profile portraits (24). In other reliefs, the normal frontality of the male and female portraits is broken to a lesser degree by a slight turning of the heads toward one another:

Cat. nos. 12, 18, 22, 28, 30, 34.
In two of these reliefs (28 and 34) the inward turning of the heads is accompanied by a dextrarum iunctio; in a third instance, the inscription states that husband and wife are depicted (Eurysaces and Atistia, 12).

Certain attributes and postures also signify marriage. In the full-length portrait relief from the Via Statilia (11), the togatus holds a scroll, a tabula nuptiales or libellus; the woman is shown in the pudicitia posture, lightly grasping the veil which covers her head. The combination of togatus with scroll and pudicitia is often encountered in scenes depicting or symbolizing marriage.[3] A togatus and a woman of the pudicitia type also appear in a bust-length relief in the Museo Nazionale Romano (23) where the man's left hand and scroll are not represented.

3. Reekmans, EAA 3 (1960) 82.

We can assume that in most cases where only a
man and a woman are represented and where inscrip-
tions mentioning marriage, or marital gestures, at-
tributes, etc. are lacking, the two figures are hus-
band and wife. The epitaphs give us information
regarding the background of the couple. In some
reliefs, the husband and wife are both slaves freed
by the same patron, as in the following two examples:

P(ublius).AIEDIVS.P(ublii).L(ibertus).AMPHIO
and his wife,

AIEDIA.P(ublii).L(iberta).FAVSTA.MELIOR (18)
and,

L(ucius).TAMPIO.L(ucii).L(ibertus)
and his wife,

TAMPIA.L(ucii).L(iberta) (26).

In these two instances the men and women may have
contracted quasi-marriages or contubernia while still
slaves.[4] Such contracts were not recognized by the
state, but may have been accepted by the master; upon
manumission, the marriage was formalized. It some-
times occurred that the husband or wife was freed
first, and that he or she then purchased the freedom

4. For contubernia, see Treggiari, Roman Freedmen 209.
 T. Frank, "Race Mixture in the Roman Empire," AHR
 21 (1916) 697. P. E. Corbett, The Roman Law of
 Marriage (Oxford 1930).

of the spouse.[5] Since the freedman took his master's
name, it is impossible to tell whether Tampia, e.g.,
was freed by Lucius Tampius, the master, or by Lucius
Tampius, the freed slave; the former is more likely
the case. These couples are therefore also con-
liberti and could be included under type 3 as well.

Very often, the inscriptions indicate that the
man and woman represented together come from differ-
ent familiae, and were thus married after manumis-
sion. The wife of Marcus Vergilius Eurysaces (12),
e.g., is Atistia, not Vergilia.M(arci).L(iberta).
The following other examples document similar mar-
riages after release from slavery:

AELIVS.Q(uinti).L(ibertus)
and his wife,

LICINIA.CN(aei).L(iberta).ATHENA (16),
and,

CN(aeus).POMPEIO.CN(aei).L(ibertus).PROTHESILAVO
and his wife,

NVMONIA.L(ucii).L(iberta).MEGISTHE (24),
and,

A(ulus).PINARIVS.A(uli).L(ibertus).ANTEROS
and his wife,

5. Treggiari, Roman Freedmen 209-210.

OPPIA.Ɔ(aiae).L(iberta).MYRSINE (25).

The marital bond of Pompeius and Numonia is con-
firmed by their portrayal as facing profile portraits.

Finally, some inscriptions show that the married
couple is made up of a freeborn patron and one of
his enfranchised slaves,[6] as in the following two
examples:

L(ucius).ANTISTIVS.CN(aei).F(ilius)
and his wife,

ANTISTIA.L(ucii).L(iberta).PLVTIA (20),
and,

GRATIDIA.M(arci).L(iberta).CHRITE
and her husband,

M(arcus).GRATIDIVS.LIBANVS (34).

In the latter case, the man and woman ("Cato and
Porcia") are united by a dextrarum iunctio and the
placement of the woman's hand on her husband's
shoulder. Both reliefs could also be classified
under type 4, a patron and one or more of his
liberti or libertae.

Portraits of husband and wife are often elabor-
ated to include their offspring (type 2), the children

6. For intermarriage between classes, especially
 between a patronus and a liberta, see Duff,
 Freedmen 60ff.

usually being inserted between the parents in the
composition. A relief in the Vatican, formerly in
the Lateran collection (71), is an exception to this
rule, but the father-mother-son relationship of the
three figures portrayed is explicitly stated in the
inscription:

Q(uintus).SERVILIVS.Q(uinti).L(ibertus).

HILARVS.PATER,

the father,

SEMPRONIA.C(aii).L(iberta).EVNE.VXOR,

his wife, and,

P(ublius).SERVILIVS.Q(uinti).F(ilius).

GLOBVLVS,

their son.

In this case, the father and mother were freed by
different patrons, the mother by Caius Sempronius,
the father by Quintus Servilius, whose name he took;
the freeborn son of Quintus is named Publius, cog-
nomen Globulus. A second relief in which the relat-
ionship of the family members is certain is in the
Museo Nazionale Romano (85); Lucius Vettius, his
wife, and two daughters are represented:

Θ.L(ucius).VETTIVS.Ɔ(aiae).L(ibertus).ALEXAND(er),
the deceased father,

VETTIA.Ɔ(aiae).L(iberta).HOSPITA,

his living wife,

Ɵ.VETTIA.L(ucii).F(ilia).POLLA,

their dead daughter, and,

VETTIA.L(ucii).L(iberta).ELEVTHERIS,

their living daughter.

Lucius Vettius and Vettia Hospita were both **freed by** the same patroness and perhaps contracted a <u>contubernium</u> while still slaves, giving birth to Vettia Eleutheris, who was freed by Lucius, the father; Vettia Polla was freeborn.[7] The man and woman turn toward one another and are united in a <u>dextrarum iunctio</u>; the relationships among the figures would thus be clear even without the inscription, although we would not know who was alive and who deceased.

In other reliefs, where inscriptions are lacking, the father-mother-child relationship is implied by gestures, postures, etc. A young boy is flanked by a man and woman who turn toward each other and clasp hands in a relief in the Musei Vaticani (<u>68</u>); a father, mother, and son are obviously portrayed. In a second relief in the Vatican (<u>70</u>), a small boy

7. For children born in slavery and then manumitted by a freed parent, see Treggiari, <u>Roman Freedmen</u> 212ff.

is similarly flanked by a man and woman; the two
adults look at each other and the woman reaches out
to touch the man, clearly her husband and the father
of the boy.

Two other bust-length portrait reliefs in the
Vatican depict a young child flanked by a man and
woman who must be the parents, although all three
heads are frontal in each case. In both instances
the figures are named. The relief from the Galleria
Lapidaria (67) carries portraits of the Livius
family:

C(aius).LIVIVS.C(aii).L(ibertus).ALEXANDER,
the father,

AEMILIA.L(ucii).L(iberta).CLVCERA,
the mother, and,

APOLLONI(us),
the son.
Caius Livius and Aemilia are former slaves of differ-
ent patrons; Apollonius may be their freeborn son,
but it is not stated. In the Museo Chiaramonti
relief (69), the following figures are depicted:

L(ucius).VIBIVS.L(ucii).F(ilius).TRO(mentina),
the father,

VECILIA.Ɔ(aiae).L(iberta).HILAE,

the mother, whose married name is given as

 VIBIA.L(ucii).L(iberta).PRIMA,

and,

 L(ucius).VIBIVS.FELICIO.FELIX,

their son.

The Museo Chiaramonti relief is especially inter-
esting because the father is a freeborn member of
the Tromentina tribe who married a freedwoman of
Vecilia who then changed her name to Vibia; the
son took the father's *praenomen* as well as *nomen*,
as his father had taken the grandfather's names.

 Full-length portrait reliefs of man, woman, and
child also survive, although without inscriptions.
In a relief in the giardino of the Museo Nazionale
Romano (65), the father-mother-son relationship is
made clear by the turning of the man's head toward
the woman (whose figure is not preserved), the *dex-*
trarum iunctio between man and woman, and the child's
turning toward its mother. A second relief, in the
Villa Doria Pamphili (66), depicts a father holding
a scroll, a mother, and a daughter who grasps a por-
tion of her mother's palla. Both father and daughter
turn toward the mother; the upper part of the woman's
figure is not preserved. Finally, a fragmentary

relief in the Villa San Michele on Capri (64) can be
cited in which the mother and son turn slightly
toward the missing figure of the father.

Freedmen reliefs also survive in which the son
is already an adult, but is nevertheless portrayed
with his parents. This is the case with a relief in
the Piazza Garibaldi in Mentana (55) where the free-
born son, a military tribune, is flanked by his
freed parents, who turn toward one another. The
inscription gives their names as:

L(ucius).APPVLEIVS.L(ucii).L(ibertus).

ASCLEPIADES,

the father,

APPVLEIA.L(ucii).L(iberta).SOPHANVBA,

the mother, and,

L(ucius).APPVLEIVS.L(ucii).F(ilius).

TR(ibunus).MIL(itum),

the son.

The father and mother are probably conliberti. Con-
liberti and their grown son are also represented on
a travertine relief in the giardino of the Museo
Nazionale Romano (38):

L(ucius).OCCIVS.L(ucii).L(ibertus),

the father,

OCCIA.L(ucii).L(iberta).AGATHEA,

the mother, and,

L(ucius).OCCIVS.L(ucii).F(ilius).PAL(atina),

a freeborn son entered in the Palatina tribe.

A relief in the Palazzo Colonna (58), depicting
an older man and woman and a young man, may be a
similar instance of father-mother-adult son, because
the woman turns toward the man, probably her husband.
Other reliefs, with frontal portraits of man, woman,
and youth, may also be father-mother-child groups
(e.g., 37, 42, 54, 56), but the absence of inscript-
ions, dextrarum iunctio, etc. make their interpre-
tation uncertain.

In addition to family portraits, the freedmen
funerary reliefs of Rome sometimes portray groups of
two or more members of the same sex who are former
slaves freed by the same patron and who may or may
not be related by blood (type 3). Two surviving
reliefs, each depicting two men, are important
examples of this type because in each case the accom-
panying inscription establishes that the two figures
are conliberti. In the relief in the British Museum
(3), two freedmen of Publius Licinius are portrayed:

P(ublius).LICINIVS.P(ublii).L(ibertus).PHILONIC(us),

and,

P(ublius).LICINIVS.P(ublii).L(ibertus).DEMETRIVS.
In the second relief, presently imbedded in a colum-
barium facade on the grounds of the Villa Doria Pam-
phili (5), two freedmen of Lucius Visellius are
represented; both are cited as deceased (Θ):

Θ.L(ucius).VISELLIVS.L(ucii).L(ibertus),
and,

Θ.L(ucius).VISELLIVS.L(ucii).L(ibertus).
In both examples, the conliberti do not have similar
features and there is a significant discrepancy in
age between them; they are probably not brothers.
The men may have been members of the same trade
guild or collegium as well as having served the same
master; one of the primary functions of the collegium
was to secure proper burial for its members.[8]

We may assume that, in most cases, members of
the same sex portrayed together are conliberti. The
bust-length reliefs portraying two men in Leningrad
(2) and in the Palazzo Mattei in Rome (4) and the
full-length portrait relief of two men in the Museo
Nazionale Romano (1) should be considered as por-

8. Duff, Freedmen 115ff. J. P. Waltzing, Etude histor-
 ique sur les corporations professionelles chez les
 romains (Louvain 1895-1896) IV, 236ff. F. M. De
 Robertis, Il diritto associativo romano dai collegi
 della repubblica alle corporazioni del basso impero
 (Bari 1938).

traits of conliberti. In the case of the full-length
relief and the Palazzo Mattei relief, the features
of the two men portrayed are so similar that it is
also possible that they are brothers who were freed
by the same patron. A relief in the Museo Capitol-
ino (35) consists of bust-length portraits of three
men who may also be conliberti. The two flanking
men are still alive (VIV) and it is possible that
the older, centrally placed man is not their con-
libertus, but the patron who freed them, perhaps in
his will.

The Capitoline relief might therefore be an
example of the fourth type of freedmen group funer-
ary portrait, that representing a patron and one or
more of his enfranchised slaves. Two examples of
this type have already been cited in the discussion
of portraits of married couples (type 1), for patrons
sometimes married their freed slaves: Lucius Antist-
ius and his wife Antistia Lucii liberta Plutia (20),
and Marcus Gratidius Libanus and his wife Gratidia
Marcii liberta Chrite (34). Two more examples of
special interest may now be cited. The first is a
marble relief in Boston (41) portraying three mem-
bers of the Gessius family, a young woman clad in a

palla, an elderly man wearing a cuirass and holding
a sword, and a young man dressed in a toga. The
three are named respectively:

GESSIA.P(ublii).L(iberta).FAVSTA,

P(ublius).GESSIVS.P(ublii).F(ilius).ROM(ilia),
and,

P(ublius).GESSIVS.P(ublii).L(ibertus).PRIMVS.
The central, elderly figure, Publius Gessius of the
Romilia tribe is the patron; the two flanking fig-
ures are his freed slaves, but it is uncertain
whether they are sister and brother, husband and wife,
or unrelated. It has also been suggested that Gessia
Fausta may be Publius Gessius the elder's wife and
that Publius Primus is their son,[9] but this is im-
possible since Publius Primus would then have been
freeborn (Publii filius) not a freedman (Publii
libertus).

A second three-figure relief, in Palermo (44),
presents a more unusual grouping of patron and freed
slaves. Two men and one woman are represented, whose
names are given as:

CN(aeus).GEMINIVS.CN(aei).L(ibertus).APOLLONIVS,

9. For these suggestions, see Vessberg, Studien 191.

CN(aeus).GEMINIVS.CN(aei).L(ibertus).

AESCHINVS.PATRONVS,

and,

GEMINIA.CN(aei).L(iberta).PRIMA.

All three are thus freed slaves, but the central
figure, Cnaeus Geminius Aeschinus, is cited as
patron. He was apparently freed first, by his
master Cnaeus Geminius, and then purchased the
freedom of two conliberti or acquired his own slaves
whom he later freed.

Many other freedmen reliefs, without inscript-
ions, may also portray the patron as well as his
former slaves, but in no case can the patron be
identified with certainty. One relief in the Museo
Nazionale Romano (60), in which it seems likely
that a patroness and two freed slaves are repre-
sented, deserves mention. A man and wife, who turn
toward one another and are united by a dextrarum
iunctio, are portrayed next to a frontal, veiled,
rather aloof woman. The veiled woman may be the
patroness of the married conliberti; it is also
possible, although unlikely, that she is a sister or
unrelated former fellow slave.

Types 1 - 4 occur not only independently, but in

various combinations on the freedmen funerary reliefs
of Rome, and in the most elaborate reliefs the rela-
tively simple groupings of types 1 - 4 can become so
complex that, in the absence of inscriptions, the
identification of those portrayed is impossible.
The simplest instance in which two types appear to-
gether in one relief, and where the relationship
among the figures is given by the epitaph, is the
marble portrait group of three Clodii in the Musée
du Louvre (45). The relief portrays two men and one
woman; the central man and the woman are a married
couple (type 1) because they turn their heads toward
one another, while the second man is depicted in a
frontal position. The inscription furnishes the
names of the three figures and the professions of
the men:

A(ulus).CLODIVS.TERTIVS.MEDICVS,

A(ulus).CLODIVS.METRODORVS.MEDICVS,

and,

CLODIA.A(uli).L(iberta).HILARA.

Metrodorus and Hilara are married conliberti; Tertius
is likewise a conlibertus and is probably portrayed
beside the others because of his professional ties
with Metrodorus (medicus). The relief is thus composed

of type 1 and type 3 group portraits – the married
couple and conliberti.

A more complex example of the combination of
types may be seen in a travertine relief presently
imbedded in a cloister wall in the church of S.
Giovanni in Laterano in Rome (82). Portrait types
2 (man, woman, and child) and 3 (conliberti) are
combined. The inscription tells us that Caius
Gavius Dardanus, his freeborn son, and his wife, a
conliberta, are still alive and that the brother of
Dardanus, Caius Gavius Salvius, a conlibertus and
fellow carpenter, is dead. Dardanus has probably
commissioned the relief in memory of his brother,
and included portraits of himself and his own fam-
ily. It is possible that the woman and child are
the wife and son of Salvius, but the situation of
the boy between Dardanus and the woman renders this
unlikely. The inscription reads as follows:

C(aius).GAVIVS.C(aii).L(ibertus).DARDANVS.VIVIT,
the father,

C(aius).GAVIVS.SPV.F(ilius).RVFVS.VIVIT,
the son,

GAVIA.C(aii).C(aii).L(iberta).ASIA.VIVIT,
the mother, and,

C(aius).GAVIVS.C(aii).L(ibertus).SALVIVS,

the brother,

 DVO.FRATRES.FABREI.TIGN(arii).

A similar combination of types 2 and 3 appears
in a relief found on the Via Salaria and presently
in a house on the Via Po in Rome (84); the relation-
ship among the figures is, however, less clear. The
inscription identifies the four persons, a woman, a
man, a boy, and a younger woman respectively, as:

 ANTONIA.P(ublii).L(iberta).RVFA,

 C(aius).VETTIVS.Ɔ(aiae).L(ibertus).NICEPHOR,

 C(aius).VETTIVS.C(aii).F(ilius),SECVNDVS,

and,

 VETTIA.C(aii).L(iberta).CALYBE.

The following things are certain: Caius Vettius
Secundus is the son of Caius Vettius Nicephor; the
latter was freed by the wife of Caius Vettius; Vettia
Calybe was freed either by Caius Vettius himself or
more likely by Caius Vettius Nicephor, the freedman;
and Antonia Rufa was freed by a different patron,
Publius Antonius. Because Antonia and Vettius have
different nomina (and therefore are not conliberti)
and there is a discrepancy in age between Nicephor
and Calybe, Caius Vettius Nicephor is probably

married to Antonia Rufa and portrayed with their
son (type 2). Vettia Calybe is possibly a blood
relation of Nicephor, a former slave of the same
master whose freedom he purchased (type 3), but it
cannot be ruled out that Calybe is unrelated and
that she commissioned the monument, including (in
addition to her own portrait) images of her patron
and his wife and son (type 4).

The interpretation of a five-figure relief in
the Vatican, formerly in the Lateran collection (89),
is less problematical, even though there is a greater
number of portraits. Two married couples and a
conliberta are depicted; their names are as follows:

FVRIA.Ɔ(aiae).L(iberta),

a frontally positioned freedwoman,

P(ublius).FVRIVS.P(ublii).L(ibertus),

a freedman who inclines his head toward his wife Furia,

FVRIA.Ɔ(aiae).L(iberta),

wife of Publius Furius,

FVRIA.Ɔ(aiae).L(iberta),

who turns toward her husband, Caius Sulpicius, and,

C(aius).SVLPICIVS.C(aii).L(ibertus),

a freedman.

The three women, all conlibertae, are perhaps sisters,

since they bear a family resemblance. The two married sisters are depicted with their husbands, freedmen of different familiae, that of Publius Furius and that of Caius Sulpicius.

With the multiplication of images, the relationships can become confused, even where there is an inscription giving the names of those portrayed. This is the case with a marble relief in the Ny Carlsberg Glyptothek in Copenhagen (87) depicting freedmen and freedwomen of the Servilius and Scaevius familiae. We know that the third and fourth figures, Marcus Scaevius Hospes and Scaevia Italia are married because they are represented in a dextrarum iunctio. The first two figures, Caius Servilius and Scaevia Chreste may also be husband and wife because of their proximity and because they are not conliberti. The fifth figure, Marcus Scaevius Stephanus, an elderly man, is a conlibertus but his relationship to the younger people with whom he is portrayed is uncertain; he may be a father, but he cannot claim legal standing as such, or he may be related professionally, as the doctors in the Louvre relief (45) or the carpenters in the S. Giovanni in Laterano relief (82).

One of the most complex of the surviving group

funerary portraits of libertini, a travertine relief in the Villa Wolkonsky (92), probably depicts two married couples, one with a child (types 1 and 2), and a conlibertus (type 3). The following persons are named in the accompanying inscription:

M(arcus).SERVILIVS.PHILARCVRVS.L(ibertus), a freedman,

M(arcus).SERVILIVS.PHILOSTRATVS.L(ibertus), a freedman who is united with Servilia Anatole Frugi in a dextrarum iunctio,

SERVILIA.ANATOLE.L(iberta).FRVGI, wife of Philostratus,

SERVILIA.THAIS.L(iberta), a freedwoman,

M(arcus).SERVILIVS.MENOPHILVS.L(ibertus), probably her husband, because at his left shoulder a young boy is depicted, namely

LVCINI(us), their son.

Where inscriptions are lacking, the relation-ships among the figures are difficult to determine, and certainty is impossible. A four-figure relief in the Villa Wolkonsky (75), e.g., depicts a man and woman, probably a husband and wife because of the

turn of the man's head, flanked by two other men, perhaps their grown sons, a brother and a son, con- liberti, or other combinations. A relief in Copen- hagen (76) is a similar case where a married couple and two other men are portrayed. In a four-figure relief found on the Via Appia (80), a husband and wife in a dextrarum iunctio are flanked by a younger man and a younger woman, probably although not cer- tainly, their grown children. A relief from the Esquiline (83) depicts a man and woman clasping hands, a young boy, and at the left end of the relief, a second woman (conliberta, sister, patroness?). A husband and wife appear in a relief in the wall of a house on the Via di Portico di Ottavia (90) with a small boy and a younger man and woman; the two youths may be the boy's brother and sister, a brother and his wife, conliberti, etc. The possibilities become almost infinite in such relief as that in the Museo Nazionale Romano (86) with a central group por- trait of two women and a man (wife, husband, daughter?) and two flanking men; and with six-figure relief in the Museo del Palazzo dei Conservatori (91) with bust- length portraits of a man, a woman, two men, a woman, and a man respectively. Despite the ambiguities that

remain in these complex reliefs, we can be certain
that they portray combinations of the four basic
group portrait types – married couple, man and wife
with children, _conliberti_, or patron and his _liberti_.

The foregoing discussion has thus clarified the
ties that led to the commissioning of a group por-
trait by _libertini_ – chiefly familial ties, but also
the bonds formed by having served a common master
and the adoption of a common profession or trade,
and the tie of gratitude which led a freedman or
freedwoman to include the portrait of his or her
patron or patroness on the funerary monument. In-
scriptions have also proved that not every person
represented is deceased, but that the bonds formed
in life between family members, _conliberti_, or between
liberti and their patrons, were not broken by death.

Chapter Three: Format of the Group Portrait Reliefs

Thus far it has been demonstrated that the
ninety-two reliefs collected here form a homogeneous
body of material in function (decoration of tombs)
and patronage (libertini and their immediate descend-
ants). There is, however, some variety with regard
to the format or overall design of these group por-
trait reliefs. The ninety-two reliefs may be classi-
fied under one or more of the following categories:

Format A: Full-length portrait reliefs -
Reliefs in which the individuals are portrayed as
standing figures.

Format B: Bust-length portrait reliefs -
Reliefs in which only the head, shoulders, bust, and
sometimes one or two arms or hands, of the individ-
uals are portrayed.

Format C: Tondo portrait reliefs - Reliefs in
which the heads of those portrayed are presented
within circular frames, although the slab itself is
rectangular.

Format D: Portrait reliefs with frames - Relief
slabs which are framed on all four sides, usually by
an unarticulated border a few centimeters in width.

Format E: Portrait reliefs without frames -
Relief slabs which are unframed, except for a base
below the portraits, and where the portraits often
extend beyond the slab at top and sides.

Format F: Inscribed portrait reliefs - Reliefs
in which the epitaph is inscribed directly on the
slab, usually below the portraits, on the frame.

Format G: Portrait reliefs with separate in-
scriptions - Reliefs which do not bear inscriptions;
the epitaphs were carved on separate plaques or
directly on the tomb walls.

Format H: Portrait reliefs with architectonic
embellishment - Reliefs in which the portraits are
framed by columns, pilasters, pediments, etc.

Format I: Portrait reliefs with subsidiary
representations - Reliefs in which, in addition to
the portraits, objects or subsidiary figures are
represented, usually tools or other attributes which
indicate the profession of those portrayed.

Format J: Convex portrait reliefs - Relief
slabs which are convex in shape and therefore destined
to be placed in a curved tomb facade.

Format K: Multi-sided portrait reliefs -
Relief slabs which are decorated on two adjacent sides

and therefore destined to be placed at one corner
of a tomb facade, or reliefs decorated on three
adjacent sides and therefore destined to extend
across the entire width of one element of the tomb
facade.

The relative popularity of the various formats
may be gauged from the following table:

TABLE I. FORMAT OF GROUP PORTRAIT RELIEFS

	Number of Examples	Percentage
Format A (Full-length por-		
trait reliefs)	9	9.78%
Format B (Bust-length por-		
trait reliefs)	83	90.22%
Format C (Tondo portrait		
reliefs)	3	3.26%
Format D (Portrait reliefs		
with frames)	79	85.85%
Format E (Portrait reliefs		
without frames)	13	14.13%
Format F (Inscribed por-		
trait reliefs)	44	47.83%
Format G (Portrait reliefs		
with separate inscriptions)	48	52.17%

Format H (Portrait reliefs
 with architectonic embel-
 lishment) 14 15.24%

Format I (Portrait reliefs
 with subsidiary represent-
 ations) 5 5.43%

Format J (Convex portrait
 reliefs) 1 1.09%

Format K (Multi-sided por-
 trait reliefs) 2 2.17%

Formats A – K are not mutually exclusive and, therefore, in Table I the total number of examples is greater than 92 and the total percentage is greater than 100%. The ways in which the various formats are combined in the Roman funerary reliefs are listed in Table II. In this case, the total number of combinations does equal 92 and the total percentage is 100%.

TABLE II. COMBINATIONS OF FORMATS

	Number of Examples	Percentage
Formats A, E, and G combined	9	9.78%
Formats B, D, and F combined	26	28.26%
Formats B, D, and G combined	33	35.88%
Formats B, E, and F combined	3	3.26%

Formats B, E, and G combined 1 1.09%

Formats B, D, F, and H combined 7 7.60%

Formats B, D, F, and I combined 3 3.26%

Formats B, D, F, and K combined 1 1.09%

Formats B, D, G, and H combined 4 4.35%

Formats B, C, D, F, and H combined 2 2.17%

Formats B, C, D, G, and J combined 1 1.09%

Formats B, D, F, H, and I combined 1 1.09%

Formats B, D, F, I, and K combined 1 1.09%

The most significant combinations, e.g., the
fact that all full-length reliefs (Format A) also do
not have frames (Format E) and have separate inscript-
ions (Format G), are discussed under the individual
format headings.

Format A: Full-length portrait reliefs

Cat. nos. 1, 8, 11, 12, 13, 37, 64, 65, 66.

Format B: Bust-length portrait reliefs

Cat. nos. 2, 3, 4, 5, 6, 7, 9, 10, 14, 15, 16, 17,
18, 19, 20, 21, 22, 23, 24, 25, 26, 27,
28, 29, 30, 31, 32, 33, 34, 35, 36, 38,
39, 40, 41, 42, 43, 44, 45, 46, 47, 48,
49, 50, 51, 52, 53, 54, 55, 56, 57, 58,
59, 60, 61, 62, 63, 67, 68, 69, 70, 71,

72, 73, 74, 75, 76, 77, 78, 79, 80, 81,
82, 83, 84, 85, 86, 87, 88, 89, 90, 91,
92.

The most important consideration in the design
of a group portrait relief was the choice between
full-length and bust-length representations of those
portrayed. All ninety-two Roman funerary reliefs
thus fall under either Format A or B. (Two of the
bust-length portrait reliefs (81, 83) include full-
length representations of children, but these are
exceptional cases; none of the full-length portrait
reliefs incorporates bust-length portraits.) It is
interesting that only nine of the surviving reliefs
are of the full-length type and we may assume that
such portraits were produced in much smaller quanti-
ties than the simpler, less expensive bust-length
version. The preserved full-figure portraits are
generally not only larger than the bust-length
reliefs, but also more ambitious in terms of com-
position, typology, etc. No two are identical and
this, too, would have added to the cost of these
monuments. We can probably attribute the greater
number of bust-length reliefs to economic rather than
artistic factors.

Format C: Tondo portrait reliefs

Cat. nos. 20, 48, 78.

A separate category is formed by those funerary
reliefs in which the portrait heads appear within
tondi, although still within overall rectangular,
horizontally oriented frames. In this format
special prominence is given to the head, which is
presented within its own frame. The tondi are of
various types and the tondo portrait reliefs are
among the most elaborate of those preserved. In
a relief in the British Museum (20), the portraits
of Lucius Antistius and his wife are displayed in
tondi in the form of shells bordered by a laurel
wreath; flowers, a simple molding, and a framed epi-
taph complete the decoration of the relief. Two
male portraits also appear in shell tondi surrounded
by wreaths in a relief in the Palazzo dei Conservatori
depicting the Bennius family (48); the portrait of
Bennia Musa is, however, set against a floral back-
drop within a tondo. The portraits are set apart
from the epitaph by a molding and are bordered by
pilasters. A second relief in the same collection
(78) presents two male and two female portraits
within plain tondi bordered by laurel wreaths and

surrounded by an elaborate floral pattern.

Format D: Portrait reliefs with frames

Cat. nos. 2, 3, 4, 5, 6, 7, 9, 10, 14, 15, 16,
17, 18, 19, 20, 21, 22, 24, 25, 26,
27, 28, 29, 30, 31, 33, 35, 36, 38,
39, 40, 41, 42, 43, 44, 45, 46, 47,
48, 49, 50, 51, 52, 53, 54, 55, 56,
57, 58, 59, 60, 61, 62, 63, 67, 68,
69, 70, 71, 72, 73, 74, 75, 76, 77,
78, 79, 80, 81, 82, 84, 85, 86, 87,
88, 89, 90, 91, 92.

Format E: Portrait reliefs without frames

Cat. nos. 1, 8, 11, 12, 13, 23, 32, 34, 37, 64,
65, 66, 83.

The overwhelming majority of surviving funerary
reliefs of freedmen is framed on all four sides, but
frames are absent on all nine full-figure portrait
reliefs (Format A). The vertically oriented reliefs
lack frames at the top and sides because they extended
over several masonry courses and did not themselves
serve as building blocks, as was normally the case
with the bust-length reliefs (Format B). The absence
of frames also served to enhance the illusion that

these full-length portraits were actual free-standing statues. The full-figure reliefs were probably set into shallow niches on the tomb facades, as was the portrait relief depicting the baker Eurysaces and his wife Atistia (12). Four of the preserved bust-length examples (9, 40, 73, 92), all framed above and below and at left and right, were found in situ in the facades of tombs, where the height of the reliefs was equal to that of one masonry course. This can be seen most clearly in the case of the attached tombs at the corner of the modern **Via** Statilia and **Via** di S. Croce in Gerusalemme (Fig. 40b). Almost all the framed bust-length reliefs bear traces of attachment marks for dowels or clamps at top, bottom, or sides.

There are, however, four surviving bust-length reliefs which are unframed at the top and sides (23, 32, 34, 83) and these, like the full-length portraits, were probably set into niches, either on the facades or the inner walls of tombs. One of the four (83) was found inside a columbarium on the Esquiline hill and the relief was very likely inserted into one of the columbarium niches. Two of the other reliefs (23, 32) bear inscriptions between the portrait busts in small letters which would have been

illegible from the ground had they been placed high
on the facades of tombs; both epitaphs would have
been legible at eye-level, as in a lower columbarium
niche. It is significant that the only two epitaphs
placed on the background of the relief, between the
heads of those portrayed, are on unframed bust-length
reliefs. Another indication that these unframed
reliefs did not serve as masonry blocks, as did the
framed examples, is that parts of the figures often
extend beyond the borders of the slabs. This is the
case with the portraits of Publius Vaterius and his
wife in the Museo Nazionale Romano (23) and to a
lesser degree with those portrayed on the Esquiline
relief (83).

Format F: Inscribed portrait reliefs
 Cat. nos. 3, 5, 10, 14, 16, 17, 18, 20, 21, 23,
 24, 25, 28, 32, 33, 34, 35, 36, 38,
 39, 41, 43, 44, 45, 46, 47, 48, 51,
 55, 57, 59, 63, 67, 69, 70, 71, 72,
 81, 82, 84, 85, 87, 89, 92.

Format G: Portrait reliefs with separate inscriptions
 Cat. nos. 1, 2, 4, 6, 7, 8, 9, 11, 12, 13, 15,
 19, 22, 26, 27, 29, 30, 31, 37, 40,

42, 49, 50, 52, 53, 54, 56, 58, 60,
61, 62, 64, 65, 66, 68, 73, 74, 75,
76, 77, 78, 79, 80, 83, 86, 88, 90,
91.

All ninety-two funerary reliefs must originally
have been accompanied by epitaphs which identified the
figures portrayed and, at least in some cases, fur-
nished data about their lives (tribe, profession, etc.).
The surviving reliefs are almost equally divided
between those bearing inscriptions on the portrait
slab itself (Format F) and those without inscriptions
(Format G).

Several different format variations were employed
for the epitaphs on the inscribed reliefs of Format F.
Most frequently, the epitaph was carved on the frame
of the relief, usually directly below the portraits.
In two cases, the names are placed above the figures
(25, 36); in three reliefs (16, 51, 82) the inscrip-
tions are carved above and below those portrayed. In
two of the latter reliefs (16, 51) the names are given
in two lines, e.g.,

A.ANTESTIVS.A.L. ANTESTIA A.ANTESTIVS

man woman man

ANTIOCHVS RVFA A.L.NICIA (51).

In the third relief (<u>82</u>) the names are given below while additional information about those portrayed is given above the portraits:

VIVIT VIVIT

<u>man</u> <u>boy</u>

C.GAVIVS.C.L.DARDANVS C.GAVIVS.SPV.F.RVFVS

VIVIT DVO.FRATRES.FABREI.TIGN.

<u>woman</u> <u>man</u>

GAVIA.C.C.L.ASIA C.GAVIVS.C.L.SALVIVS.

Sometimes the epitaph is in its own frame below the portraits (<u>20</u>, <u>28</u>, <u>87</u>) or is carved on the background of the relief between the heads (<u>23</u>, <u>32</u>). In three reliefs (<u>41</u>, <u>51</u>, <u>59</u>) the inscription appears to the left and/or right of the portraits, as well as below, and in one case (<u>70</u>) the entire inscription, or at least that part which is preserved, is carved to the left of the portraits.

In those cases where no epitaph is carved on the portrait slab (Format G), we may assume that the names of those portrayed appeared elsewhere on the tomb, probably on a separate plaque set into the wall below the portraits, or carved directly into the masonry blocks themselves. Five examples of

separate inscriptions survive. In two instances
(9, 40) the inscriptions are carved in the facade
wall below the portraits; in three other cases (8,
12, 73) the epitaphs appear both on the walls of
the tomb itself and on framed plaques set into the
wall.

Format H: Portrait reliefs with architectonic
embellishment

 Cat. nos. 3, 9, 10, 19, 20, 24, 36, 39, 40, 46,
 48, 68, 72, 87.

 Thirteen times the rectangular frame of the bust-
length reliefs was embellished with architectural
elements, ranging from simple moldings to elaborate
aediculae with pediments and columns. Moldings are
found on the inner borders of the rectangular frames
of seven of the preserved portrait reliefs (10, 19,
20, 24, 36, 46, 87); the most elaborate molding
encloses the profile portraits of Cnaeus Pompeius and
his wife Numonia in the Museo Nazionale Romano (24).
Alternating spiral columns and fluted pilasters frame
the portraits of four freedmen in a relief in the
Palazzo Colonna in Rome (72); unarticulated arches
frame the heads of the three women and two men por-

trayed on the facades of the two tombs still stand-
ing beside the modern Via Statilia (9, 40).

The most complicated architectonic decoration
appears in a relief in the Museo Nazionale Romano
depicting an elder man, a woman, and a young man
(39). Each portrait appears within an aedicula con-
sisting of Tuscan columns on bases, an unadorned
pediment, and acroteria in the form of palmettes.
A simpler, aedicula-type frame with pilasters
encloses the portrait of Caius Cincius Chrestus in
the Villa Wolkonsky (Fig. 94);[1] the portrait is
Augustan and thus considerably later than the Terme
relief (second quarter of the first century B.C.).
A relief in the British Museum (3) is itself in the
form of an aedicula with a pedimental top rather than
a simple rectangular frame. This relief, like the
unframed portrait reliefs (Format E), is ill suited
for use as a masonry block and was probably set into
a niche. The same is true for an arcuated relief in
the Vatican (68) depicting a man, wife, and child.
These two reliefs are exceptional cases and are the
only two surviving instances of group portrait reliefs
which are not of rectangular format, whether vertical
(Format A) or horizontal (Format B).

1. Matz-Duhn III, no. 3909. DFK Neg. 72.33.27.

Format I: Portrait reliefs with subsidiary repre-
sentations

Cat. nos. 3, 38, 51, 59, 92.

Some frames are decorated with objects or sub-
sidiary figures instead of, or in conjunction with,
architectural elements; these images almost always
relate to the profession or trade of at least one of
those portrayed in the relief. A good example is
the relief in the British Museum (59) depicting Lucius
Ampudius Philomusus and probably his wife and daughter,
although they are not named. To the left and right
of the portraits, two grain measures with four legs
are carved in low relief, the one to the right being
considerably larger than the one to the left. The
small grain measure bears a second inscription,

L.AMPVDIVS.L.ET.Ↄ.L.PHILOMVSVS.MODI,

a repetition of the inscription below the portraits,
with the addition of the word modi(us) or grain
measure (or perhaps the cognomen Modi(arius));[2]
Lucius Ampudius was obviously a miller.

A similar instance of trade implements appearing
beside a portrait is the relief of the Antestius family

2. A. H. Smith, "L. Ampudius Philomusus," JRS 8 (1918)
 179-182.

in the Vatican (51). To the left of the portrait of
Aulus Antestius Antiochus are metalworking tools and
some products of the metalworker's craft, notably a
large cantharus. These seem to indicate the trade
of Antestius Antiochus, although the name of a fourth
person, whose portrait is not present, is carved
immediately above the cantharus, A(ulus).ANTESTIVS.
A(uli).A(uli).L(ibertus).SALVIVS, perhaps a freedman
of the two men who are portrayed in the relief.

Tools are also represented in the relief in the
British Museum (3) depicting two freedmen of Publius
Licinius. In the pediment are shown the hammer, dies
and pincers used in the production of coins, while to
the right are representations in relief of the tools
of a metalworker, sculptor, or carpenter.[3] To the
left of the portraits is depicted a fasces, possibly
the attribute of a lictor,[4] but more likely a symbol
of manumission.[5] The last moment in one of the cere-
monies in which slaves were granted their freedom was

3. C. C. Vermeule, NCirc 61 (1953) 450; 62 (1954) 102:
 diecutter. B. Ashmole, BMQ 21 (1957) 72: sculptor
 and metalworker. W. H. Manning, BMQ 29 (1964-65)
 26: carpenter.

4. C. C. Vermeule, NCirc 61 (1953) 450; 62 (1954) 102.
 B. Ashmole, BMQ 21 (1957) 72.

5. W. H. Manning, BMQ 29 (1964-65) 26.

the touching by a lictor of the slave with the rod
or _vindicta_ which is shown behind the _fasces_ in the
British Museum relief.[6] A _fasces_ is also depicted
to the right of the portraits in the Servilii
relief in the Villa Wolkonsky (<u>92</u>).[7]

The relief of the Occius family in the Museo
Nazionale Romano (<u>38</u>) constitutes a special case.
To the left and right are represented two bull's
heads and **diminutive** full-length figures of a man
and woman carrying sacrificial instruments; they are
perhaps the son and wife of Lucius Occius, who is
portrayed at the center of the relief.

Mention should also be made of three reliefs
(<u>29</u>, <u>54</u>, <u>86</u>), all from the Via Appia, which are bor-
dered at left and/or right by broad, unarticulated
surfaces. These may have been decorated with
painted attributes or symbols, such as those discussed
above, or with painted epitaphs. Two reliefs survive
(<u>41</u>, <u>70</u>) in which carved inscriptions appear in the
broad areas to left and/or right of the portraits.
It is, however, also possible that these broad bands

6. Duff, _Freedmen_ 23.

7. The _fasces_ is not visible in the illustrated photo-
 graph, but can be seen in Altmann, _Grabaltäre_ 196,
 fig. 156.

form parts of pilasters which bordered the portraits
to left and right. A broad pilaster and a composite
capital separate the portrait of Publius Servilius
Globulus from those of his parents, Quintus Servilius
and Sempronia, in a relief in the Vatican (71). The
pilaster is, in this case, not merely a subsidiary
decorative device, but a primary element in the
articulation of the entire facade of the tomb.

Format J: Convex portrait reliefs
 Cat. no. 78.
Format K: Multi-sided portrait reliefs
 Cat. nos. 38, 47.

Formats J and K comprise funerary reliefs of
unusual format. The three surviving examples are
especially important because they document the em-
ployment of bust-length portrait reliefs in ways
somewhat different from the canonical placement of
the relief in the center of a flat facade, or from
the still rarer placement of the relief in a niche.
The only preserved relief of Format J is a convex
relief in the Palazzo dei Conservatori (78), already
cited because of its tondo portraits (Format C);
the relief must have been set into the curved facade

of a cylindrical tomb.

Multi-sided reliefs of Format K are somewhat more common. A relief in the Museo Capitolino (47) depicts a husband and wife within a rectangular frame, and at a right angle to them, another man whose name is given as Caius Rupilius; the relief must have been placed at the right corner of a tomb facade. Two comparable examples depicting only one figure each may be cited: a marble relief in the Museo Nazionale Romano (Fig. 95) portraying Aulus Iurranius Faustus and, on the right corner of the relief, a triglyph;[8] and a travertine relief in the Villa San Michele on Capri, in which Lucius Careius is depicted on one face and an inscription on another face.[9] Both reliefs would have been located at the right corner of a facade.

A unique relief with decoration on three adjacent sides is that of the Occius family in the Museo Nazionale Romano (38). The front side bears the portraits of a man, wife, and son, bucrania, and two diminutive full-length figures. On the lateral

8. Unpublished. DFK Neg. 72.24.15A.

9. The full inscription reads: L.CAREIVS.C.F.STE, on the front; and L.CAR/C.F., on the side. A. Andrén, "Classical Antiquities of the Villa San Michele," OpusRom 5 (1965) 134-135, no. 24, pl. 13.

faces of the relief a rosette is carved; the relief
is, therefore, probably of the same width as the
tomb itself or of one element of the tomb.

Despite the many variations in format described
above, what is most striking about the Roman funerary
reliefs is their basic uniformity. The reliefs are
of two major types - vertically oriented full-length
portraits (Format A) and horizontally oriented bust-
length portraits (Format B) - but within each type
the degree of variation is minimal. This is especially
true of the full-figure portraits which are never
embellished with the architectural frames, pictorial
devices, etc. which occasionally appear on the bust-
length reliefs. The large majority of reliefs con-
sists of either full-length or bust-length frontal
portraits with little, if any, interaction among those
portrayed, and without any further elaboration. The
two basic types were established more or less simul-
taneously in the period 75 - 50 B.C. and some of the
earliest examples are among the most elaborate (9, 38,
39, 40). Once established, the two primary formats
were maintained with little change until the popularity
of this type of funerary commemoration waned rapidly
in the first century A.D.

Chapter Four: Materials

The ninety-two funerary reliefs depicting
Roman freedmen and their families are carved in a
limited variety of stones; all but one are made of
travertine or Italian marble. A discussion of
these stones is, nevertheless, important because
different types of stone tended to be used for the
funerary reliefs in different periods. The material
chosen for a specific relief is, thus, an objective
and valuable indication of the date of the relief.

Travertine (Lapis travertinus)[1]

Twenty of the ninety-two reliefs (21.74%) are
carved in travertine:

Cat. nos. 5, 9, 14, 15, 16, 17, 38, 39, 40,
42, 61, 70, 73, 74, 75, 81, 82, 83,
85, 92.

Travertine is a variety of porous limestone

1. R. Delbrueck, Hellenistische Bauten in Latium
(Strassburg 1907-1912) II, 43-44, 56ff. T. Frank,
Roman Buildings of the Republic. An Attempt to
Date Them from their Materials, PAAR 3 (1924) 32-
33. Vessberg, Studien 173, 179-180. Blake, Roman
Construction 44-48. Lugli, Tecnica I, 316-317,
319-326, 329.

found in abundance between Rome and Tivoli. The
proximity of the quarries to Rome made travertine
a relatively inexpensive sculptural material. The
stone's handsome appearance and hardness made it a
popular material for sculpture; its durability led
to its widespread use as a building stone.

Travertine began to be used in architectural
projects late in the second century B.C. The earl-
iest, firmly datable, employment of travertine in a
Roman building is in the Pons Milvius (109 B.C.),
where the stone was used in the arched courses of
the front and back of the bridge.[2] During the first
century B.C. travertine was the preferred material
for public structures and was often chosen for
arches, porticoes, bridges, theaters, and amphi-
theaters.

Travertine is frequently found in conjunction
with peperino or Anio tufa; in these cases, the most
important parts of the building, both in structural
and decorative terms, were made of travertine. This
principle is well illustrated by three tombs of the
period 75 - 50 B.C. which have survived intact or in

2. Delbrueck, Hellenistische Bauten I, 3-11. Frank,
 Roman Buildings 33, 141-142. Blake, Roman Construct-
 ion 134. Lugli, Tecnica I, 321, 325.

part and still have portrait reliefs in the facades:
the two tombs at the corner of the modern Via Sta-
tilia and Via di S. Croce in Gerusalemme (9, 40) and
the tomb of the Fonteii, now reerected in the chiostro
of the Museo Nazionale Romano (73). In all three
instances the masonry blocks are peperino;[3] the por-
trait reliefs, which constitute the center of inter-
est, are carved in travertine.

By the time of Augustus, when Italian marble
became available in quantity, travertine had assumed
a role of secondary importance, at least in the con-
struction of important buildings, and had lost favor
as a material for architectural sculpture. This is
confirmed by the sharp decline in the number of
travertine funerary reliefs after 30 B.C.:

75 - 50 B.C.

10 reliefs; 9, or 90%, are of travertine.

Cat. nos. 9, 14, 15, 16, 38, 39, 40, 73, 83.

3. Peperino, or lapis Albanus, is a porous pepper-
colored stone found in the hills near Rome. It
was not generally employed as a building material
until the close of the second century B.C.; its
period of greatest utilization was the first three
quarters of the first century B.C. P. di Tucci,
"Saggio di studi geologici sui peperini del Lazio,"
MemAccLincei (1879) 357ff. E. I. Miles, "Remarks
on the peperino," BritAmerSoc (1894-96) 310ff.
Frank, Roman Buildings 22-24. Blake, Roman Con-
struction 34-38. Lugli, Tecnica I, 184, 197-198,
303-306.

<u>40 B.C.</u>

 3 reliefs; 3, or 100%, are of travertine.

 Cat. nos. <u>17</u>, <u>74</u>, <u>75</u>.

<u>30 - 13 B.C.</u>

 47 reliefs; 6, or 12.77%, are of travertine.

 Cat. nos. <u>5</u>, <u>42</u>, <u>61</u>, <u>81</u>, <u>82</u>, <u>92</u>.

<u>13 B.C. - A.D. 5</u>

 32 reliefs; 2, or 6.25%, are of travertine.

 Cat. nos. <u>70</u>, <u>85</u>.

"Palombino"[4]

Only one relief, that found on the Via Statilia depicting a man and woman at full-length and datable to the period 75 - 50 B.C. (<u>11</u>), is carved in a marble-like limestone, which may be palombino (<u>marmor Coralliticum</u>). Palombino has the color of white ivory and is quarried in Phrygia. It shows an affinity to the semi-crystalline stone called "pietra di Subiaco."[5] Similar limestones have, however, been noted in Italy, although no source has been found in

4. Blake, <u>Roman Construction</u> 53-54. A. Moretti, "Marmo," <u>EAA</u> 4 (1961) 862. R. Gnoli, <u>Marmora romana</u> (Rome 1971) 223-224. C. Promis, <u>Le antichità di Alba Fucense negli Equi</u> (Rome 1836) 99, discusses a stone found in Italy similar to the Phrygian palombino.

5. Moretti, <u>EAA</u> 4 (1961) 862.

the vicinity of Rome, and the Via Statilia relief may actually be carved in a high quality Italian limestone. In either case, the stone would have been selected because of its color at a time when Italian marble was not yet available in Rome.

The Via Statilia relief was found together with peperino architectural fragments, confirming that the finest material was probably always used for the facade relief, while less costly materials were employed for the masonry structure of the tomb.

Luna marble (Marmor Luniense)[6]

Seventy-one of the ninety-two reliefs (77.16%) are carved in Luna marble:

Cat. nos. 1, 2, 3, 4, 6, 7, 8, 10, 12, 13, 18, 19, 20, 21, 22, 23, 24, 25, 26, 27,

6. H. Blümner, Technologie und Terminologie der Gewerbe und Künste bei Griechen und Römern III (Leipzig 1884) 39-41. C. Dubois, Etude sur l'administration et l'exploitation des carrières marbres, porphyre, granit, etc. dans le monde romain (Paris 1908) 3-17. L. Banti, "Antiche lavorazioni nelle cave lunensi," StEtr 5 (1931) 475-497. Goethert, Republik 39-40. T. Frank, An Economic Survey of Ancient Rome (Baltimore 1933) I, 370. Vessberg, Studien 63-65, 114. Blake, Roman Construction 53. Lugli, Tecnica I 328-329. A. Moretti and J. B. Ward-Perkins, "Marmo," EAA 4 (1961) 861-862, 869. P. H. von Blanckenhagen, "Laokoon, Sperlonga und Vergil," AA 84 (1969) 264.

28, 29, 30, 31, 32, 33, 34, 35, 36,
37, 41, 43, 44, 45, 46, 47, 48, 49,
50, 51, 52, 53, 54, 55, 56, 57, 58,
59, 60, 62, 63, 64, 65, 66, 67, 68,
69, 71, 72, 76, 77, 78, 79, 80, 84,
86, 87, 88, 89, 90, 91.

Marmor Luniense is a fine-grained white marble
with a blue-grey tinge quarried near modern Carrara.
Until 177 B.C., when the Romans established 2000
colonists at Luna,[7] the area was in Etruscan hands.
There is, however, no evidence that the Etruscans
made any use of the stone for their buildings or
sculpture. Although imported marbles were used in
Rome from the early second century on for fine sculp-
ture and important buildings, the rich source of
marble at Luna remained untapped until the close of
the Republican period, except for a single instance
at Luna itself in 155 B.C., when M. Claudius Metellus
dedicated a monument the base of which was fashioned
out of local marble. Otherwise, the first recorded
use of Luna marble as a building material is in 48
B.C., when Mamurra's residence on the Caelian hill in
Rome was ornamented with columns of solid Luna and

7. Livy 41.3.

Carystos marble.[8] It seems certain, therefore, that
the quarries at Luna were first opened under Caesar,
and that the use of Italian marble as a building
material in Rome does not antedate ca. 50 B.C. The
location of Luna, near the sea, greatly facilitated
the distribution of its marble. The stone was
brought by ships to Ostia and thence transported on
the Tiber inland to Rome, where special wharves were
constructed to receive it.[9]

It was, however, only after Caesar's death, in
the 30s, that Luna marble became available in Rome
in large quantities. The famous boast of Augustus
that he found Rome a city of brick and transformed
it into a city of marble was made possible by the
recent full-scale exploitation of the Luna quarries.
The first major building in which Italian marble was
used extensively was the Temple of Apollo Palatinus,
begun in 36 and dedicated in 28 B.C.[10] Luna marble,
especially the finer varieties suitable for statuary

8. Pliny, N.H. 36.48. Cf. N.H. 36.135.

9. Strabo 5.222.

10. G. Lugli, "Il tempio di Apollo Aziaco e il gruppo
 augusteo sul Palatino," AttiAccSLuca N.S. 1 (1951/52)
 26-55. H. Bauer, "Das Kapitell des Apollo Palatinus-
 Tempels," RömMitt 76 (1969) 183-204.

and relief sculpture, must not have been readily
available for modest monuments such as the funerary
portraits of freedmen until after ca. 30 B.C. This
date receives confirmation from the funerary por-
traits collected here, none of which appears to have
been made prior to 30 B.C. and be of marble:

75 - 50 B.C.

 10 reliefs; none is of marble.

40 B.C.

 3 reliefs; none is of marble.

30 - 13 B.C.

 47 reliefs; 41, or 87.45%, are of marble.

 Cat. nos. 1, 2, 3, 4, 6, 18, 19, 20, 21, 23,
26, 27, 28, 29, 30, 31, 35, 36, 37,
41, 43, 44, 45, 46, 47, 48, 49, 50,
51, 52, 53, 54, 60, 62, 72, 76, 77,
78, 79, 86, 91.

13 B.C. - A.D. 5

 32 reliefs; 30, or 93.75%, are of marble.

 Cat. nos. 7, 8, 10, 12, 13, 22, 24, 25, 32, 33,
34, 55, 56, 57, 58, 59, 63, 64, 65,
66, 67, 68, 69, 71, 80, 84, 87, 88,
89, 90.

In conclusion, with the possible exception of

palombino, the ninety-two reliefs were made of Ital-
ian stones available in Rome in large quantities.
Travertine was the preferred material in the pre-
Augustan period, but after ca. 30 B.C., when Luna
marble could be purchased in Rome, travertine
quickly was replaced by the newly available white
marble. In the Augustan period, travertine was
relegated to a secondary role; in the tomb of the
baker Marcus Vergilius Eurysaces (12), e.g., Italian
marble was employed for the portrait relief and the
epitaph, travertine for the remainder of the structure.
This use of the more costly material for the portrait
relief conforms to the practice of the earlier part
of the century when travertine or "palombino" was
used sparingly in the construction of tombs, specific-
ally for the figural reliefs, and peperino was employed
for the masonry blocks.

Chapter Five: Portraiture

The ninety-two funerary reliefs in the Catalogue
incorporate over 250 individual portraits datable to
the last three quarters of the first century B.C.
Every portrait may be classified under one of the
following four types:

Type A: Full figure - The entire figure is
depicted in the relief, as on Greek funerary stelae.
The figure is always represented standing and is
usually shown frontally, but sometimes turns toward
one or more accompanying figures.

Type B: Bust-length figure with hands - Only
part of the figure is depicted; the representation
is cut off by the lower border of the relief. The
head, shoulders, bust and one or two hands are por-
trayed; the figure appears to be looking through a
window. The portrait is usually frontal, but some-
times the figure turns toward one or more accompany-
ing figures.

Type C: Bust-length figure without hands - As
in Type B, the head, shoulders and bust of the
figure are portrayed and the representation is cut
off by the lower border of the relief. In Type C

portraits, however, the hands of the figure are not shown. Except in one relief, where profile portraits are depicted, the busts are always rigidly frontal.

Type D: Portrait bust - Only the head and shoulders of the figure are represented and unlike Types B and C, the representation is not cut off by the lower border of the relief; the image is rounded at the bottom and is a complete entity. The portrait appears as a piece of sculpture set into a frame, rather than as a living being looking through a window.

The relative popularity of the various types may be gauged from the following table:

TABLE III. PORTRAIT TYPES

	Number of Examples	Percentage
Type A (Full figure)	11	11.96%
Type B (Bust-length figure with hands)	71	77.17%
Type C (Bust-length figure without hands)	9	9.78%
Type D (Portrait bust)	11	11.96%

(N.B. - Although the four types are mutually exclusive, some reliefs comprise portraits of

more than one type; therefore the total number
of examples is greater than 92 and the total
percentage is greater than 100%.)

Type A: Full figure

Cat. nos. 1, 8, 11, 12, 13, 37, 64, 65, 66,
81, 83.

Type A portraits are the most ambitious of the
four types. The portrait is a representation of the
entire body of the person depicted; therefore Type A
portraits convey the greatest sense of physical
presence. Many of the surviving examples are made
up solely of frontal portraits, as if a series of
statues were set up side by side. The relief repre-
sentations often correspond to known statuary types:
the togatus with arm sling (1, 11, 12, 37, 66), pudi-
citia (11, 37), palliata (64), etc. These statuary
types are discussed below in the section on costumes,
Chapter Seven.

In some cases, however, there is a marked inter-
action among the persons portrayed which enhances the
illusion of physical presence. In a fragmentary
relief in the Museo Nazionale Romano (13) a man and
woman are turned toward one another and are joined in

a dextrarum iunctio. In a second relief in the same collection (65), another couple is similarly depicted in a dextrarum iunctio; a young boy, standing between his parents, is represented turning toward his mother and grasping a section of her palla. A young girl is shown in the same way in a relief in the Villa Doria Pamphili (66); in this case there is, however, no physical contact between the parents.

As one would expect, Type A portraits are the rule for tall, vertically oriented reliefs (Format A), but there are two instances where a Type A portrait appears beside bust-length portraits in a horizontally oriented relief (Format B). In a relief in the Museo Nazionale Romano (83) a small boy dressed in a toga is depicted full-length between a bust-length portrait of a woman and bust-length portraits of a couple joined in a dextrarum iunctio; the latter are undoubtedly the boy's parents. A second relief, in the Vatican (81), includes a full-length representation of a nude infant between a bust-length image of a man and bust-length portraits of the child's parents joined in a dextrarum iunctio. In both cases, the full-length portrait is of a child. The juxtaposition of full- and bust-length portraits

was acceptable in these cases because a consistent
scale was more or less maintained. The togate
child in the Terme relief is depicted in a some-
what reduced scale, but the size of the infant in
the Vatican relief is consistent with that of the
adults in the relief.

Type B: Bust-length figure with hands
 Cat. nos. 2, 4, 5, 6, 7, 9, 10, 14, 15, 16, 17,
 18, 21, 23, 26, 27, 28, 29, 30, 31,
 34, 35, 36, 38, 39, 40, 41, 42, 43,
 44, 45, 46, 47, 49, 50, 52, 53, 54,
 55, 56, 57, 58, 59, 60, 61, 62, 63,
 68, 69, 70, 71, 72, 73, 74, 75, 76,
 77, 79, 80, 81, 82, 83, 84, 85, 86,
 87, 88, 89, 90, 91, 92.

The bust-length figure with hands is, by far,
the most common portrait type in the Roman funerary
reliefs. Type B portraits appear in over 75% of the
surviving reliefs and in almost every relief of
Format B (horizontally oriented reliefs with bust-
length portraits). In this type, the full-length
portrait (Type A) is reduced to its most essential
part - the head and upper body, including the hands.

The figure is cut off by the lower border of the
relief and the impression is conveyed of an inter-
rupted representation, rather than of an artificial
reduction of the body to a portrait bust (Type D).

The term "bust-length figure" is here used in
a general rather than an exact sense; Type B por-
traits actually vary somewhat in length. Most of
the portraits are indeed bust-length, i.e., head,
shoulders, and upper body to the level of the chest
and biceps. The elbows are frequently not depicted
and only the hand and lower arm are included within
the frame. Some of the portraits are longer, extend-
ing to waist level (e.g., 23, 34, 45, 56, 68, 69,
87, 88). The longest preserved "bust-length" por-
traits appear in an early, travertine relief in the
Museo Nazionale Romano (16), depicting Quintus Aelius
and his wife Licinia Athena; the representations
extend from head to hips.

Many of the Type B portraits are truncated
versions of the statuary types represented on the
full-length portrait reliefs. Most reproduce the
chief features of the quietly standing togati and
palliatae with arm slings in reliefs 1, 11, 12, 37,
and 64. Four reliefs (23, 62, 69, 91) include a

truncated version of the more complicated _pudicitia_ type of full-length reliefs 11 and 37.

The inclusion of hands in Type B portraits lends animation to the figures and gives the portraits a greater sense of physical presence than Type C portraits (bust-length figures without hands). In addition, the hands sometimes perform a specific function, e.g., the underlining of the marital bond of a couple by a _dextrarum iunctio_ or by the placement of one arm on the spouse's shoulder (34, 90).

The hands sometimes hold objects which indicate the profession of the person portrayed. Five military officers are depicted with swords and sheaths (39, 41, 49, 55, 88). A _sistrum_ is held by a veiled woman in a travertine relief in the Museo Nazionale Romano (74). The _sistrum_ is the metallic rattle which was used in celebrating the rites of Isis and this woman was evidently a priestess of the cult.[1] Small children and youths are occasionally shown holding their pets (50, 79, 90), a motif which is also encountered in the full-length reliefs (66).

Rarely, both hands are depicted, and in each case it is for a specific purpose. In eleven cases

1. B. M. Felletti Maj, "Iside," _EAA_ 4 (1961) 235-240.

(18, 28, 31, 34, 60, 68, 81, 85, 87, 90, 92) both
hands are represented because of a dextrarum iunctio.
In two reliefs (50, 90) both hands of the figures
holding pets are shown, and in two other cases (23,
69), both hands are depicted because the position
of the hands is a chief feature of the pudicitia
statuary type, which is reproduced in a truncated
version in the two reliefs.

Type C: Bust-length figure without hands

Cat. nos. 6, 24, 33, 36, 40, 51, 60, 70, 92.

The bust-length portrait without hands is rare
on the Roman funerary reliefs and is a less animated
portrait type than the version with hands; the por-
traits are almost always rigidly frontal. The im-
pression of a living being looking through a window
is, nevertheless, conveyed, despite the absence of
hands. Usually Type C portraits appear beside Type
B portraits and the exclusion of the hands may be
attributed to a lack of space. This is clearly the
case with the portraits of children inserted between
two adult portraits or between an adult portrait and
the frame in three reliefs (70, 85, 92). Economical
use of the available space probably also accounts

for the absence of hands on some portraits in four
other reliefs (6, 36, 40, 60). In only three cases
(24, 33, 51) is a relief composed exclusively of
Type C portraits. In one of these reliefs, that
depicting Cnaeus Pompeius and his wife Numonia (24),
the absence of hands is easily explained by the fact
that the two busts are represented in profile.

Type D: Portrait bust
Cat. nos. 3, 19, 20, 22, 25, 32, 48, 67, 69,
78, 85.

Type D portraits form a distinct class because,
unlike Types A - C, there is no illusion of a living
being, but rather a representation of a sculptured
image set into a frame. The image is not interrupted
by the frame, but is artificially truncated at the
bottom, usually by a semicircle running from just
above one shoulder to just above the other. Type D
portraits are thus complete entities and sometimes
these busts are set into frames within the frames,
i.e., in tondi (20, 48, 78), thereby further empha-
sizing their nature as objects, as opposed to persons.[2]

2. On the portrait bust and its origin, see P. Bien-
 kowski, "Note sur l'histoire du buste dans l'antiqu-
 ité," RA (1895) 293-297. V. Scrinari, "Busto," EAA
 2 (1959) 227-231. G. M. A. Richter, "The Origin

Type D portraits are restricted to the Augustan
period, as shall be demonstrated below. The busts
are both draped and undraped and sometimes both
types appear in the same relief (67, 69). The
length of the busts is generally shorter than that
of the Type B and C portraits. The longest por-
trait busts appear in a relief in the Vatican
depicting Caius Livius and his family; the images
extend to just below the level of the chest.
Usually only a small area below the collarbone is
represented; in no case is the shoulder itself
included in the portrait.

The fact that Type D portraits are representa-
tions of objects rather than representations of per-
sons raises the possibility that this form of por-
trait was meant to conjure up the image of ancestral
portraits in the armarium of the atrium of a patric-
ian house and that Type D portraits are exclusively
of dead persons. Funerary reliefs depicting por-
trait busts in such household shrines are known; one
is in the Nationalmuseet in Copenhagen, another in

of the Bust Form for Portraits," Charisterion Eis
A. K. Orlandos 1 (1965) 59-62. Portrait busts
must be distinguished from "partial statues" which
are cut off horizontally at the bottom. Richter
59, with bibliography.

the cloister of S. Paolo fuori le mura in Rome.[3]
In certain cases, the epitaphs leave little or no
doubt that the portrait bust on a funerary relief
is an image of a deceased person. In a relief in
the British Museum depicting Lucius Antistius and
his wife Antistia Plutia (20), both portraits are
busts set into tondi. The relief was dedicated
by two freedmen of Lucius to their patron and to
his wife - Rufus l(ibertus), Anthus l(ibertus),
imagines de suo fecerunt patrono et patronae pro
meritis eorum; one may assume that both Lucius and
his wife are dead. In a relief in the Museo Nazion-
ale Romano (85), Lucius Vettius, his wife, and two
children are portrayed. Only one person, one of
the children, is represented as a portrait bust,
and the inscription tells us that she, Vettia Polla,
is dead (θ). However, Lucius Vettius is also cited
as dead and he is represented in a bust-length por-
trait in a dextrarum iunctio with his living wife.
In a relief formerly in the Lansdowne collection (32)
a lengthy inscription informs us that the husband
has dedicated the monument to his departed wife;

3. Zadoks, Ancestral Portraiture pl. 4. Guide to the
 National Museum, Oriental and Classical Antiquity
 (Copenhagen 1950) 101. DfK Neg. 72.20.4 (S. Paolo
 fuori le mura).

both are depicted as portrait busts, although only one is dead. It is, therefore, unwise to attribute a specific significance to the portrait bust type where epigraphical evidence is lacking or ambiguous.

Some of the Type D portrait busts are presented within tondi. The question may also be raised whether the tondi have a significance beyond their function as decorative framing elements. Portraits within tondi are closely related to the clipeatae imagines or portraits mounted on shields. Such portraits are well documented in the Republican and early Augustan periods and were used in a variety of contexts, military-triumphal, honorific, and funerary.[4] Tondi appear in only three reliefs (20, 48, 78) and in each case every portrait bust is set in a tondo. Only in the British Museum relief (20) is there an inscription which suggests that both people are dead. The portrait in a tondo may, therefore, signify that the person portrayed is deceased, but the evidence is too scanty to draw a firm conclusion.

4. The two major studies of the clipeata imago are J. Bolten, Die Imago clipeata. Ein Beitrag zur Porträt- und Typengeschichte (Paderborn 1937) and R. Winkes, Clipeata Imago. Studien zu einer römischen Bildnis- form (Bonn 1969). On the tondo in general see G. Florescu, "Médaillon dans l'art graeco-romain," MonPiot 53 (1963) 220ff.

First Century B.C. Portraiture: Style and Chronology[5]

Surviving literary sources are unanimous in pro-
claiming that the first century B.C. witnessed the
blossoming of portraiture in Italy.[6] During this
century stone, as opposed to bronze, silver, gold,
and other costly materials, was increasingly used for
portraits. The production of portraits in stone made
possible the economical replication of sculptured
likenesses of important personages and also permitted
the commissioning of durable portraits by Romans of

5. The two major studies of Republican portraiture are
 Vessberg, Studien and Schweitzer, Bildniskunst.
 Vessberg's study is of primary importance here
 because the funerary reliefs form an integral part
 of his discussion of Republican portraiture. Ber-
 noulli, RömIkon I, West, Porträt-Plastik I, and
 Kaschnitz von Weinberg, Mittelmeerische Kunst III,
 include important chapters on Republican portrait-
 ure. For Republican numismatic portraiture, see
 Zehnacker, Moneta II, 969-1081. M. Bieber, "The
 Development of Portraiture in Roman Republican
 Coins," ANRW I,4 (1973) 871-898. Important articles
 of smaller scope are V. Poulsen, "Probleme der
 römischen Ikonographie, 1. Eine Gruppe frührömischer
 Porträts," Archaeologisk-Kunst-Historisk Meddelelser
 II,1 (Copenhagen 1937) 5-32. L. Laurenzi, "Problemi
 della ritrattistica repubblicana romana," Aevum 14
 (1940) 367-384. V. Poulsen, "Probleme der Datierung
 frührömischer Porträts," ActaArch 13 (1942) 178-198.
 E. Schmidt, "Römerbildnisse vom Ausgang der Repub-
 lik," BerlWinckPr 103 (Berlin 1944). Gazda, "Etruscan
 Influence". An excellent, up-to-date and concise
 survey of the period is given by Hiesinger, "Por-
 traiture," with bibliography 820ff.

6. The sources have been collected and discussed by
 Vessberg, Studien 46ff.

lesser means, notably freedmen.

It is also during the first century B.C. that
Rome became an important artistic center. Many
works of art were transported to Rome and many art-
ists were brought to the capital as slaves; others
immigrated to Rome in search of commissions.[7] Under-
standably, the art of the late Republican period is
characterized by the coexistence of diverse stylistic
trends and by eclecticism. The so-called "Italo-
Hellenistic" or "Mid-Italic" style which dominated
Roman sculpture of the third and second centuries B.C.
and produced such works as the bronze "Brutus" of the
Palazzo dei Conservatori[8] and the stone portrait of
Q. Ennius from the Tomb of the Scipios[9] was gradually
modified as Roman artists became increasingly exposed
to the sculpture of the Hellenistic East. A complic-

7. For the artistic climate in Rome at the end of the
 second and the beginning of the first century B.C.
 see F. Coarelli, "L'ara di Domizio Enobarbo e la
 cultura artistica in Roma nel II secolo a.C.,"
 Dialoghi di Archeologia 2 (1968) 325ff.

8. Vessberg, Studien 123-124, 169-170, pl. 15. R.
 Bianchi Bandinelli, Rome, the Center of Power (New
 York 1970) 28. T. Dohrn, Helbig4 II, 268-270, no.
 1449, with further bibliography.

9. T. Dohrn, "Der Vatikanische 'Ennius' und der Poeta
 Laureatus," RömMitt 69 (1962) 76-95, pls. 31, 34b,
 36a, 37b. Dohrn, RömMitt 70 (1963) 178-181. G.
 Hafner, Das Bildnis des Q. Ennius (Baden-Baden 1968)
 esp. 42ff.

ated process of assimilation took place which was
made even more complicated by the fact that the
works of Greek art which flooded the capital were
themselves of different styles ranging from con-
sciously classicizing pieces to exuberant baroque
creations. Likewise, the artists who came to work
in Rome represented the varied artistic backgrounds
of Central and South Italy, Greece and the Greek
islands, and Asia Minor.

It is thus impossible to outline a clear step-
by-step evolution of Republican portrait style from
decade to decade; instead we must be prepared to
accept that at any given time works of quite different
character were being produced. Nevertheless, it is
possible to describe two fundamentally different
stylistic trends in the late Republican period. The
first is an outgrowth of the "Mid-Italic" style[10] and
is essentially veristic; the portraits are usually
somber, static, frontal, without an overt display
of emotion, and considerable attention is paid to
the superficial details of the subject's appearance –

10. The Mid-Italic style has been discussed most
 extensively by Kaschnitz von Weinberg, Mittelmeer-
 ische Kunst III, 405ff.; Römische Kunst II (Berlin
 1961) 105-134. Bianchi Bandinelli, Center of
 Power 27ff. Cf. Vessberg, Studien 169-172.
 Schweitzer, Bildniskunst 53ff.

skin texture, lines, blemishes, etc. resulting in
a maplike representation of the face. In the second
trend, which owes its character to Hellenistic Greek
art,[11] greater emphasis is placed on dramatic move-
ment and inner expression; the subject appears
charged with energy, the eyes are often upturned and
the neck twisted, and the surfaces are modelled in
large, plastic forms.

Both styles, which Vessberg has called the
sachliche Stil and the hellenistische Stil respect-
ively,[12] may be found in the numismatic portraits of
the pre-Augustan period. These portraits constitute
our only series of clearly dated monuments during the
late Republic, but it must be borne in mind that the
portraits of moneyers' ancestors which appear on
the coins may be based upon sculptured likenesses
which are earlier in date. Numismatic portraits of
the sachliche Stil include those of C. Coelius
Caldus, ca. 62 B.C.,[13] A. Postumius Albinus, Type I,

11. The Hellenistic Greek component of Roman Repub-
 lican portraiture has been treated most fully by
 G. Hafner, Späthellenistische Bildnisplastik
 (Berlin 1954). Schweitzer, Bildniskunst 59ff.

12. Vessberg, Studien 166-167, 180-199, 209-220.

13. Vessberg, Studien 128-129. Crawford, Coinage 457-
 458, no. 437. Zehnacker, Moneta II, 996-998.

49-48 B.C.,[14] C. Antius Restio, ca. 46 B.C.,[15] and
Julius Caesar, Group A, 44 B.C.[16] Hellenistische
Stil numismatic portraits include those of L. Cornelius
Sulla and Q. Pompeius Rufus, ca. 54 B.C.,[17] and Pompey
the Great, Type I, ca. 46-45 B.C.[18]

It is interesting to note that in the ten
funerary reliefs datable to the period 75 - 50 B.C.
the hellenistische Stil does not appear and the
sachliche Stil is the rule:

Cat. nos. 9, 11, 14, 15, 16, 38, 39, 40, 73,
83.

As on the coins of the first half of the first
century B.C. with portraits in the sachliche Stil,
the chief interest of the artists who carved these
ten funerary reliefs was the objective recording of

14. Vessberg, Studien 132-134. Crawford, Coinage 466,
no. 450. Zehnacker, Moneta II, 1002-1003.

15. Vessberg, Studien 134. Crawford, Coinage 470, no.
455. Zehnacker, Moneta II, 1004-1005.

16. Vessberg, Studien 138-142. Crawford, Coinage
487ff., no. 480. Zehnacker, Moneta II, 1017-1019.

17. Vessberg, Studien 129-132. Crawford, Coinage 456,
no. 434. Zehnacker, Moneta II, 998-1002.

18. Vessberg, Studien 134-137. Crawford, Coinage 480,
no. 470. Zehnacker, Moneta II, 1007-1011.

the features of mature and elderly men, the heads
of households. The primary characteristics of the
mature male portraits of this period may be isolated
by comparing the numismatic portraits with the
detailed photographs of three men on the funerary
reliefs: the togate man on the relief from the Via
Statilia (11), Quintus Aelius on a relief in the
Museo Nazionale Romano (16), and the father on the
relief from the Tenuta Cappelletti in Rome, now in
the same museum (39). All these heads share the
following features: broad, massive faces, closely
cropped hair which follows the shape of the skulls,
broad noses with lined ridges, large ears, furrowed
foreheads, lined cheeks, level eyebrows with clearly
delineated hairs, deeply set eyes with thick upper
and lower eyelids and bags under the eyes, tightly
shut mouths with thin lips and diagonal lines lead-
ing downward from the corners, and lined or sunken
necks.

The female and youthful portraits of this period
are more conventional and less personalized than the
portraits of older men; in the case of the young men,
the more generalized representation of the face is
easily ascribable to age, but in the case of the women

one must assume that the idealization of the features was intentional. Nevertheless, many of the same stylistic and technical features of the male portraits appear in the portraits of the wives and sons. The women in the Via Statilia (11) and Tenuta Cappelletti (39) reliefs and Licinia Athena (16), e.g., share several features with their husbands: broad faces, sharp brows which cast shadows over the eyes below, heavy upper and lower eyelids, broad noses, and downward-turned lips, although the lips are fuller and fleshier, and the skin is, of course, smooth, unlined, and free of blemishes. Similarly, Lucius Septumius, the son in the Tenuta Cappelletti relief (39), has smoother features and fuller lips than his father, but both share the same closely cropped hair, heavy-lidded eyes, oversized ears, and prominent chins. In no case do we find the spirited portraiture of the hellenistische Stil; in fact, nearly every portrait of this period is rigidly frontal and, with the exception of the Esquiline relief (83) with its full-length portrait of a child and dextrarum iunctio, there is no contact whatsoever among the individuals portrayed.

Only three reliefs may be dated to the transit-

ional period between the mid century and Augustus:

Cat. nos. 17, 74, 75.

These portraits of ca. 40 B.C. still adhere to the sachliche Stil and retain many of the features of the portraiture of the second quarter of the first century, including the distinction between mature male portraiture and portraiture of women and younger men. The portrait of the elderly man in the four-figure Villa Wolkonsky relief (75) shares with its earlier counterparts the caplike, closely cropped hair, furrowed brow, individually delineated eyebrow hairs, bags under the eyes, large ears, tightly compressed lips, and lined cheeks, but there are some new features which will continue to be found in some Augustan reliefs, notably the more prominent bone structure with deeply sunken cheeks and the more oval, less broad face. The portrait may be compared with a bust in the Museo Chiaramonti of the Vatican, an Augustan copy of a late Republican portrait,[19] which exhibits the same sunken cheeks, tight lips, etc. Also significant is that in some of

19. Amelung, Skulpturen I, 397, no. 135. Vessberg, Studien 227-228, pl. 68.1-2. Schweitzer, Bildnis- kunst 73. H. von Heintze, Helbig[4] I, 272, no. 359.

the heads, e.g., those of the other two men and
the woman in the Wolkonsky relief (75), the lips
curve upward to form a restrained smile with small
dimples at the corners of the mouth. All the por-
traits are rigidly frontal and there is no inter-
action among the figures, as in the preceding period.

The early Augustan period, 30 - 13 B.C., is the
time of greatest popularity of group funerary por-
traits of freedmen; 47 examples, or over 51% of the
surviving reliefs, may be dated to this time:

Cat. nos. 1, 2, 3, 4, 5, 6, 18, 19, 20, 21,
23, 26, 27, 28, 29, 30, 31, 35, 36,
37, 41, 42, 43, 44, 45, 46, 47, 48,
49, 50, 51, 52, 53, 54, 60, 61, 62,
72, 76, 77, 78, 79, 81, 82, 86, 91,
92.

One of the most striking features of the por-
traits of this period is the continuation of the
sachliche Stil despite the appearance of a new,
classicizing style in Augustan court portraiture;
the interest in depicting the features of old and
middle-aged men is maintained. There is also a new
interest in objectively recording the features of
older women. A number of veristic female portraits

appear on the reliefs of this period, although the
more idealizing style of the earlier periods does
not die out. At the same time, one can see the
effect of the Augustan style upon the portraiture
of freedmen, especially in portraits of young men
and women, but also in portraits of some mature men.

The 47 surviving funerary reliefs of 30 - 13
B.C. incorporate 135 individual portrait heads; 80
of these, or over 59%, are representations of old
or mature men. In general, these portraits retain
the salient characteristics of the sachliche Stil
of the earlier part of the century: the cap-like,
closely cropped hair, furrowed brows, bags under
the eyes, large ears, lined cheeks, delineation of
the individual hairs of the eybrows, and thin down-
turned mouths with diagonal gashes at the corners.
The survival of these features in portraits of 30 -
13 B.C. is especially clear if one compares the por-
traits of the togatus on the Via Statilia relief (11)
and the man on the bust-length relief in the Palazzo
dei Conservatori (15) with the two older men at the
right in the three-figure relief in the Museo Capi-
tolino (35), the togatus on the left of a full-
length portrait relief in the Museo Nazionale Romano

(1), or any of the portraits of mature or elderly
men in the following reliefs:

Cat. nos. 2, 4, 5, 6, 7, 19, 26, 27, 28, 30,
36, 43, 44, 45, 46, 48, 50, 51, 52,
60, 61, 62, 72, 76, 77, 78, 79, 81,
82, 86, 91, 92.

One trend in Republican portraiture that first
appeared in the funerary reliefs of ca. 40 B.C. comes
to the fore in the early Augustan period: the por-
trayal of an old bald man with prominent cheekbones
and sunken cheeks, a thin, though clearly defined
upper lip, and a broader, slightly parted lower lip.
This type, seen in incipient form in the portrait of
the old man in the Villa Wolkonsky relief (75), is
more fully developed in the period 30 - 13 B.C. A
characteristic portrait of this type of the early
Augustan period is that of an old man in a two-figure
relief in the British Museum (3). The old man to
the right, a freedman of Publius Licinius, is bald,
except for thin sideburns above each large ear. His
forehead is high and his face is thin, with sunken
cheeks. The eyebrows have individually delineated
hairs and the orbital ridge falls in two or three
folds of skin over the eyes. The nose is long and

somewhat thinner than in the earlier portraits;
diagonal lines lead from the nostrils to the edges
of the mouth. The mouth itself has a thin, but well-
defined upper lip, and a wide lower lip. The chin
is broad and there is a distinct area of shadow
below the mouth. This type of portrait has tradit-
ionally been called the Totenmaskentyp[20] because
many of the chief features of portraits of this type
have been said to be characteristic of the appear-
ance of the face after death. Such portraits have
often been said to have been based upon actual wax
death masks. The primary exponent of this theory
is Zadoks-Josephus Jitta; her discussion of the
problem is worthy of quotation at length, because the
issue involved is especially important: "A few hours
after death the face of the deceased has already
considerably altered; the rigor mortis fixes these
changes...The bony structure becomes more apparent.
The form of the forepart of the skull grows very pro-
nounced. Temples and cheeks fall in, cheek- and jaw-
bones strongly protrude...The closed eyes sink deep
into their orbits because the moisture in the tissues
supporting the eyeballs and the tone in the eye mus-

20. Zadoks, Ancestral Portraiture 47ff. Vessberg, Studien
 194-195.

cles disappear. The bridge of the nose grows very
prominent; its tip falls in. The naso-labial fur-
rows become deeper, the folds grow limp. The mouth
hangs loosely down with drooping corners and is
often drawn awry; the lips are sunken, especially
the upper one, so that the distance between nose and
lips is unnaturally lengthened. The chin, no longer
under control, becomes long and drawn out while its
point falls slightly in. The entire face is often
drawn awry owing to the position of the head. Every
detail, every little line and wrinkle is smoothed
away; death masks hardly ever show anything of the
so-called "verism" generally attributed to them."[21]

The head of Publius Licinius Demetrius, the old
man in the British Museum relief (3), undoubtedly
shares some features with the death masks described
by Zadoks, but there are also notable departures. The
eyes are open and were probably painted, the skin has
retained its lines and wrinkles, and, most important,
muscular control of the face is still evident. Other
Totenmaskentyp portraits of this period similarly
share features with Zadoks' death masks, but like the
British Museum head, the sense of a living being is

21. Zadoks, Ancestral Portraiture 47-48.

still present, the skin retains its lines, and the
eyes are open: Publius Aiedius Amphio, in a relief
in Berlin (18); Lucius Antistius, in a relief in
London (20); Publius Vaterius, in a relief in the
Museo Nazionale Romano (23); Publius Gessius, in a
relief in Boston (41); and an unnamed man at the
left of a relief on the Via Appia (54). Especially
significant is the fact that Publius Vaterius is
cited as living: P.VATERI.C.L.PTOLEMAE.VIVIT.

One must conclude, therefore, that the associ-
ation of these portraits with death masks is tenuous,
and that Zadoks' attribution of this trend in por-
traiture to the period 150 - 30 B.C.[22] is erroneous.
As Vessberg and Boethius have concluded, the Toten-
maskentyp is a late development in Republican por-
traiture and has little to do with actual casts of
the deceased's features after death. The type should
be viewed instead as a further step in the evolution
of the sachliche Stil, a more profound attempt at
objectively recording the effects of advanced age on
a man's features.[23]

22. Zadoks, Ancestral Portraiture 46.
23. Vessberg, Studien 97ff., 194ff. A. Boethius, "On
 the Ancestral Masks of the Romans," ActaA 13 (1942)
 226-235.

A third trend in adult male portraiture in the
early Augustan period represents a striking departure
from the veristic portraits of 75 - 40 B.C. This
trend documents the hesitant acceptance of the
Augustan classicizing style in the portraiture of
early Augustan freedmen of middle and advanced age.

A good example of this transitional portrait
type is the portrait of the man on the left in the
relief from the Via Biberatica (78). The man
appears to be about sixty years old and his age is
shown in particular by his sunken neck. His hair
is combed in the late Republican manner, forming a
straight line across the forehead; the hair is, how-
ever, somewhat longer and has more substance than
the cap-like hair of the more traditional portraits.
The ears are still large, the brow still furrowed,
and as in earlier portraits, two deep lines lead
from the nostrils to the edges of the lips. The
face is, however, thinner, less fleshy, and, in
general, less lined. The eyes are not ringed with
heavy lids but with more delicate ones; the corners
of the upper lids continue beyond the edge and curve
up slightly. The hair of the eyebrows is not deline-
ated and the brows are merely sharp lines, slightly

arched. The mouth is full and well-formed. A second
example of this transitional portrait type is the
portrait of the togatus on the right in the full-
length relief in the Museo Nazionale Romano (1). The
bone structure is emphasized, the face is thin, and
the line of the upper eyelids continues in an even
greater curve. The lips are curved upward as if in
a smile and there are dimples at the corners of the
mouth. Other portraits of this type include those
of the men in two reliefs in Lucerne (21) and Rome
(47), and those of the men at the left in three reliefs
in the Museo Capitolino (35), the Palazzo dei Conserva-
tori (36), and the Municipio in Narni (43).

In the early Augustan funerary reliefs the best
examples of the new classicizing style appear in por-
traits of young men, for Octavian-Augustus was him-
self a young man during the early years of his prin-
cipate. The official portrait style of this period
can best be judged from numismatic portraits,[24]

24. For the numismatic portraits, see esp. K. Kraft,
Zur Münzprägung des Augustus (Wiesbaden 1969). For
the portraits in the round, as well as the coin
portraits, see O. J. Brendel, Ikonographie des Kaisers
Augustus (Heidelberg 1931). H. Kähler, Die Augustus-
statue von Primaporta (Cologne 1959). Zanker, Actium-
Typus. A good collection of photographs of early
Augustan numismatic and sculptured portraits is to
be found in Zanker, Actium-Typus.

because the coins are firmly dated, as in the late Republican period. On the coins Augustus is depicted as a young, heroicized ruler with a completely un-lined face. The flesh of his face and neck is firm and the forms are clear and precise; there are no facial blemishes and no concentrations of fatty tissue. The profile is sharp, with an aquiline nose, pointed chin, and clearly defined, slightly upturned lips with dimples at the corners of the mouth. The ears are still large as are the eyes; the gaze is slightly upward. The brows are slightly arched and sharply defined, without any delineation of the individual hairs. The hair of the head is abundant and it is plastically rendered; the cap-like coiffure of the late Republic is abandoned.

The best example of this new style in the fun-erary reliefs of the period 30 - 13 B.C. is the por-trait of Publius Licinius Philonicus (3). Philonicus is about 30 years old. His face is broad at the cranium and narrow at the chin; the features are smooth except for small furrows in the forehead and at the bridge of the nose. The brows are sharp and clearly defined; the eyelids are thinly outlined and the upper lids curve upward somewhat at the edges.

The nose is long and narrow, although the ears are still large. The lips are full and round and there are dimples at the corners of the mouth. The hair recalls that of some late Republican portraits since it recedes slightly at the temples and adheres closely to the skull, but for the first time the long strands of hair are individually represented and are combed in different directions. Another portrait with similar classicizing features is that of the young man at the right of a three-figure relief on the Via Appia (54). Other youthful male portraits of this period are of a more conservative and realistic nature:

Cat. nos. 35, 36, 41, 43, 46.
Republican traditions in male portraiture remained strong in the period 30 - 13 B.C.

There are 45 portraits of old or middle-aged women in the funerary reliefs of 30 - 13 B.C. Unlike the portraits of women of comparable age in the reliefs of 75 - 40 B.C., which were essentially idealized and unindividualized, these female portraits are generally more objective records of the features of those portrayed and constitute parallels for the sachliche Stil of the male portraits.

The tondo portrait of Antistia Plutia in the
British Museum (20) is a good illustration of the
new trend. Antistia is an old woman and although
her skin is unlined and free of blemishes, many in-
dividual features are carefully recorded. Her small
eyes are set closely together, her face is thin and
her chin is prominent. The lips are thin, the ears
large, and the neck is lined. Her portrait is
almost as harsh and unflattering as that of her hus-
band.

Equally descriptive, unflattering portraits of
two women appear in the relief from the Via Biber-
atica (78). The woman on the left is overweight, as
her pudgy face indicates. There are accumulations
of fatty tissue in the cheeks and below the chin and
two diagonal lines run from the nose to the corners
of the mouth. Similar lines appear on the face of
the other woman on the Via Biberatica relief. This
second woman has a thin face with prominent cheek-
bones and somewhat sunken cheeks; her lips are very
thin, the ears are large, and the eyes small and
narrow. The two portraits convey the features of
opposite physical types. Unidealized portraits of
other women appear in the following reliefs:

Cat. nos. 18, 21, 26, 27, 37, 41, 43, 44, 45, 46, 47, 48, 62, 81, 86, 91.

The more generalized female portrait of the period 75 - 40 B.C. is, however, still retained in many cases. Perhaps the best example is the portrait of Stagla Ammia in the Museo Nazionale Romano (23). The woman has the same broad face, parted hair, and unpersonalized features as the women in the Tenuta Cappelletti relief (39) and the four-figure relief in the Villa Wolkonsky (75). Other generalized adult female portraits of this period include the veiled women in the Via Cassia relief (30), and the three-figure relief of the Museo Nuovo of the Palazzo dei Conservatori (49), the woman in the S. Giovanni in Laterano relief (82), and the older women in the following other reliefs:

Cat. nos. 19, 28, 51, 52, 60, 61, 77, 92.

The new Augustan style dominates the portraits of the two young women of this period (50, 61). Youthful female portraits appear in the funerary reliefs for the first time ca. 30 B.C. and both portraits are idealized and unpersonalized. The faces are oval, the eyes are almond-shaped with arched brows. The lips are small and rounded with dimples

at the corners of the mouth.

The last years of the first century B.C. and the first years of the first century A.D. are marked by a continuation of the trends in portraiture noted in the period 30 - 13 B.C., with two significant developments: the classicizing style is universally adopted for portraits of young men and women, although the sachliche Stil dominates adult portraiture; and the number of portraits of small children increases dramatically. Thirty-one reliefs may be firmly dated to the period 13 B.C. - A.D. 5:

Cat. nos. 7, 10, 12, 13, 22, 24, 25, 32, 33, 34, 55, 56, 57, 58, 59, 63, 64, 65, 66, 67, 68, 69, 70, 71, 80, 84, 85, 87, 88, 89, 90.

Portraits of middle-aged and elderly persons are still the norm in the funerary reliefs of this period; 59 of the 86 surviving portrait heads depict older men or women. The male portraits are mostly of the late Republican type and closely resemble portraits of men of similar age of the period 30 - 13 B.C. One can compare, e.g., the portraits of Marcus Gratidius Libanus (34) and Aulus Pinarius Anteros (25) with that of the central man in a relief

in the Museo Capitolino (35). All three men have
short, closely cropped hair which recedes at the
temples and forms a semicircle over the forehead.
The foreheads are furrowed, the faces lined, the
ears large, and the mouths have thin upper and
fuller lower lips with creases at the corners.

The Totenmaskentyp portrait is also retained
in the reliefs of 13 B.C. - A.D. 5. The best pre-
served example is the portrait of the baker Marcus
Vergilius Eurysaces (12). The head of Eurysaces,
with its broad, rounded skull, bald pate, long nose,
sunken cheeks and downward turning mouth, is very
similar to such Totenmaskentyp portraits as that of
Publius Aiedius in Berlin (18). The eyes of the
baker are sunken deep into the sockets, unlike the
other heads of this type and thus the Eurysaces
head is, in a sense, closer to Zadoks' description
of actual death masks than the other heads. The
baker's tomb is dedicated to his wife, and there is
no indication that Eurysaces himself was dead at the
time his portrait was carved. The head has an
excellent counterpart in a portrait from a fragmentary
funerary relief found in Rome near the tomb of Cae-
cilia Metella.[25]

25. Vessberg, Studien 195, pl. 34.2.

Two other Totenmaskentyp portraits of this per-
iod are worthy of note, that of Lucius Vibius (69)
with its wide, bald head, sunken cheeks, long nose,
and somewhat askew mouth, and that of an old man in
a five-figure relief in Copenhagen (88).

During the period 13 B.C. - A.D. 5, idealizing
portraits of older men were also produced (32, 63,
88, 89). The skin is relatively smooth, the wrinkles
deemphasized, and the features take on some of the
traits of the emperor himself. A good example is
the portrait of Caius Rabirius Hermodorus in a relief
in the Museo Nazionale Romano (63). Rabirius is an
old man who still has the cap-like short hair fash-
ionable during the late Republic. His forehead is
lined, but his eyes are sharply delineated with the
upper lids curving upward at the corners; the brows
are thin with sharp ridges. The cheeks are fleshy
and unlined and the lips are full, with dimples at
the corners of the mouth.

Older female portraits of this period are of
two basic types, as in the early Augustan period:
unpersonalized and idealized, or objective and spe-
cific. The former type was the rule in the period
75 - 50 B.C. and a few such portraits were still

manufactured in the period 13 B.C. - A.D. 5. A
good example is the portrait of Gratidia in the
Vatican (34). Her hair is parted in the center in
the Hellenistic Greek fashion, the face is oval in
shape and unlined, the brows are arched, the nose
long and aquiline, and the corners of the mouth
dimpled. Five other reliefs include similar por-
traits (32, 64, 70, 85, 89).

Most of the women represented in the reliefs
of 13 B.C. - A.D. 5 are, however, portrayed in the
sachliche Stil, i.e., their faces are rendered ob-
jectively and their personal features are emphasized.
Such a portrait is that of Aemilia in a relief in
the Vatican (67). Aemilia has a broad face, a short
forehead with closely set eyes, and thin lips. The
portrait of Vibia Prima, also in the Vatican (69),
is similarly unidealized. The face is broad and
lined, the nose broad and the eyes small. An espec-
ially penetrating portrait is that of an unnamed
woman in a relief in the Museo Nazionale Romano (80).
The face is relatively thin, the eyes closely set
and rimmed with thick upper and lower lids. The
brows are knit in a serious expression which is in-
tensified by the pattern of free-flowing locks of

hair which frame the forehead and face.

Other reliefs with women portrayed in the sachliche Stil of 13 B.C. - A.D. 5 are

Cat. nos. 8, 10, 24, 33, 56, 57, 58, 59, 63, 68, 71, 84, 87, 88.

The seven portraits of young men of this period are all in the classicizing Augustan style:

Cat. nos. 55, 56, 58, 80, 87, 88, 90.
The outstanding example of a portrait rendered in a manner similar to the Augustan court style is a portrait of a young man in a relief in Copenhagen (88). The young man is in the center, between a middle-aged couple and an elderly couple. He is nude with a chlamys draped over his left shoulder and he holds a sword **sheath** in his left hand, befitting his probable status as a free-born member of the Roman army. His face is round and unlined, the cranium broad and the forehead high. His hair is rather long and is plastically rendered. His nose is long and aquiline; his eyes almond-shaped with delicate lids. His brows are sharply delineated and finely arched; his mouth well-rounded with dimples at the corners. Portraits of the young Augustus share many of the same features with the Copenhagen

portrait.[26] The young man in a relief in Mentana
(55) is a second instance of an Augustan style por-
trait combined with a heroically nude body.

The five young women (22, 59, 80, 84, 90) in
the reliefs of 13 B.C. - A.D. 5 are also rendered
in a style close to that of the Augustan court. In
a relief in the Museo Nazionale Romano (80), e.g.,
the young woman's hairstyle conforms to the latest
fashion in the capital. Her face is round with round
eyes and arched brows. Her mouth has full lips and
dimples at the corners. The portrait is best com-
pared to a contemporary marble head, perhaps repre-
senting Livia, in the Akademisches Kunstmuseum in
Bonn.[27]

The reliefs of 13 B.C. - A.D. 5 include, for
the first time, a significant number of children.
This new vogue for representing children was probably
due to the adoption of Caius and Lucius Caesar by
Augustus, his designation of them as heirs, and the
consequent multiplication of imperial family group

26. Two portraits, one from Lucus Feroniae, the other
 in the Villa Albani, are especially close. Zanker,
 Actium-Typus 21-22, pls. 15a and 19a, with biblio-
 graphy.

27. W. H. Gross, Julia Augusta (Göttingen 1962) 95-96,
 pl. 20, with bibliography.

portraits throughout the Empire.[28] Children are
represented, usually between their parents, in the
following reliefs of this period:

Cat. nos. 64, 65, 66, 67, 68, 69, 70, 71, 84,
85, 90.

Both the portraits of little boys and little girls
conform to the Augustan classicizing style: round
heads with regular, sharply delineated features, and
plastically rendered hair. One need only compare the
portrait of Lucius Vibius the Younger in a relief in
the Museo Chiaramonti of the Vatican (69) with a head
of Lucius Caesar in the Museo Nazionale of Naples[29]
to demonstrate how closely the portraits of children
in the funerary reliefs conform to those of the
Augustan court. Similar portraits of little boys
appear in the following reliefs:

Cat. nos. 64, 65, 67, 68, 70, 71, 84, 90.
Little girls appear in two reliefs (66, 85) and have
the same regular features, round faces, dimpled
cheeks, etc. as in the portraits of boys.

In summation, the funerary portraits of freedmen

28. See infra, Chapter Seven.

29. Zanker, Actium-Typus 47-48, pl. 36b, with biblio-
 graphy.

during the late Republic and early Empire reveal a
heterogeneity of styles. In the period 75 - 50 B.C.
the heroicizing hellenistische Stil of some aristo-
cratic numismatic portraits does not appear in any
of the surviving funerary portraits; the heads con-
form rather to the sachliche Stil of other numis-
matic portraits in that an attempt was made to pre-
sent the personal features of the deceased in an
objective, and usually unflattering, manner. At
the same time the female portraits were generalized
and unpersonalized, but by the period 30 - 13 B.C.
they had become more realistic, with a greater inter-
est shown in the recording of individual physiognomic
peculiarities. During the early Augustan period the
sachliche Stil was retained for many of the portraits
of older men, but a new classicizing style was
adopted for portraits of young men and women and
also for some representations of middle-aged and
elderly people. This style, based on the Augustan
court style, came to fruition in the period 13 B.C. -
A.D. 5, when many of the youthful funerary portraits
are fully comparable to imperial likenesses and when
the portraits of Caius and Lucius Caesar served as
models for portraits of freeborn children. Many of

the portraits of older men and women, however,
carried on the Republican and early Augustan sach-
liche Stil, even if some of the technical features, -
e.g., the carving of brows, eyelids, and mouths, -
are characteristic of contemporary imperial portraits.

The chief characteristic of the funerary por-
traiture of this century is thus the simultaneous
coexistence of different styles - not only at the
same date, but within the same relief. Two examples
may be cited in this connection. The portraits of
the Vibius family in the Vatican (69) include a
Totenmaskentyp for the father, a realistic female
portrait for the mother which reveals certain tech-
nical features of the Augustan style, e.g., the
carving of the eyelids and mouth, and a fully clas-
sicizing head of a young boy which is most comparable
to the official portraits of Augustus' young heirs.
The five-figure relief in Copenhagen (88) presents
an even more complex juxtaposition of portrait styles.
The elderly couple at the right is represented in the
sachliche Stil and the portrait of the man is one of
the best surviving examples of the Totenmaskentyp.
The portraits at the left, while still recording
personal features, have been generalized to a certain

extent in conformity with the new classicizing style.
The heroic portrait at the center has direct paral-
lels in the portraits of the emperor himself.

This heterogeneity of style in the funerary por-
traiture of freedmen is of unique importance for our
understanding of Roman portraiture and Roman art in
general, because, as we have already stated, these
funerary images are very likely the first and only
portraits commissioned by the former slaves. We are,
therefore, not dealing with copies of older por-
traits, which is so often the case with aristocratic
family portraiture, but with new portraits conceived
at the same time for the same monument. The retention
of older portrait styles and types in Augustan reliefs
once again testifies to the stylistic disunity of
much of Roman art.

Chapter Six: Coiffures

The changing fashions in men's and women's hairstyles during the late Republic and early Empire are documented in the extensive series of surviving funerary portrait reliefs. These coiffures, datable by comparison with numismatic portraits and portraits in the round of known date, furnish a valuable standard for the dating of the funerary reliefs and also provide insight into the reception of upper-class fashions by the Roman middle class. In this chapter, male and female coiffures are treated separately and, within each section, chronologically.

Male Coiffures, ca. 75 B.C. - A.D. 5[1]

During the quarter century 75 - 50 B.C. three different male hairstyles are depicted on the funerary reliefs. Two of these are comparable to coiffures which appear on earlier Etruscan or Mid-Italic monuments; the third hairstyle is that cur-

1. There is no comprehensive study of male hairstyles during the late Republican and Augustan periods, as there is for female coiffures.

rently in fashion in Rome.

The first style is a cap of hair which closely follows the shape of the skull and forms a semicircular arch over the forehead. Specific renditions of this hairstyle vary. The individual strands of hair are rarely carved and were probably delineated with paint; occasionally, locks of hair are indicated by the sculptor. This coiffure appears in third and second century B.C. votive terracotta heads from Central Italy. Good examples may be found in the Museo Gregoriano of the Vatican[2] and in the British Museum.[3] In both cases only a few strands of hair are etched into the terracotta; the rest were probably painted.

Three examples of this cap-like coiffure occur in the early funerary reliefs - two in the three-figure relief in situ on the Via Statilia (40), a mature man and a young man, and one in the Fonteii relief in the Museo Nazionale Romano (73), a mature man. This hairstyle does not appear in any later reliefs and is even at this time out of fashion in Rome.

2. Vessberg, Studien 176, pl. 21.3-4.
3. Vessberg, Studien 176, pl. 22.3.

The second male coiffure of the period 75 - 50
B.C. also has parallels in late Etruscan and Mid-
Italic art. The hair is combed forward over the
top of the skull and the forehead. The hair is
longer, as are the sideburns; curving strands
fall over the forehead and ears, in contrast to
the simple arch of the first style. This coiffure
is probably best known from the bronze portrait
of "Brutus" in the Palazzo dei Conservatori,[4] but
is common on late Etruscan cinerary urns and sar-
cophagi. One of the best examples is the head of
an old man on a sarcophagus of unknown provenance
now in the Ny Carlsberg Glyptothek in Copenhagen.[5]
This hairstyle appears four times in the early
funerary reliefs. Two times the coiffure is worn
by an older man (14, 39), once by a young man (39),
and once by a child (83). This type of coiffure
does not occur in any funerary relief later than

4. Vessberg, Studien 123-124, 169-170, pl. 15. R.
Bianchi Bandinelli, "Il 'Bruto' Capitolino,
scultura etrusca a Chiusi," Dedalo (1925) 5ff.
T. Dohrn, Helbig[4] II, 268-270, no. 1449, with
bibliography.

5. R. Herbig, Die jungeretruskischen Steinsarkophage
(Berlin 1952) 321, pl. 98b. Cf. Vessberg, Studien
pl. 90.1-3. On the possible influence of Etruscan
carving techniques in the workshops producing
early Roman funerary reliefs, see Gazda, "Etruscan
Influence" 855ff.

50 B.C.

The most popular, and most up-to-date, hair-
style of the early period is that worn by the men
represented on coins of the sachliche Stil of the
first half of the first century B.C. This coif-
fure, which may conveniently be referred to as
the late Republican hairstyle, can be seen on the
denarii with portraits of C. Coelius Caldus,[6] A.
Postumius Albinus,[7] and C. Antius Restio.[8] The
coins, although struck during the middle decades of
the first century B.C., are perhaps based on contempor-
ary portraits of the moneyers' ancestors executed
earlier in the century. The hair is short, as are
the sideburns, but unlike the first Republican
style, the hair recedes at the temples, forming a
gentle arc over the forehead. The hair extends to
just below the ear at the back of the neck. The
most famous portrait in the round with this hair-

6. Vessberg, Studien pl. 3.7-8. Crawford, Coinage
 457-458, no. 437. Zehnacker, Moneta II, 996-998.

7. Vessberg, Studien pl. 4.8-10. Crawford, Coinage
 466, no. 450. Zehnacker, Moneta II, 1002-1003.

8. Vessberg, Studien pl. 4.1. Crawford, Coinage
 470, no. 455. Zehnacker, Moneta II, 1004-1005.

style is the early first century B.C. bronze statue of the "Arringatore" in the Museo Archeologico of Florence.[9] A similar coiffure appears in a terra-cotta head of the mid first century B.C. in the Villa Giulia in Rome[10] and in marble portraits in the Vatican and in Berlin.[11]

In the funerary reliefs of the period 75 - 50 B.C. seven examples of the late Republican hair-style are preserved:

Cat. nos. 11, 15, 16, 38 (two men), 73, 83. In all but one case the hairstyle is worn by an old or mature man. Lucius Occius, a young freeborn man, also wears his hair combed in this fashion (38).

Unlike the first two coiffures, the late Republican hairstyle recurs in funerary reliefs through the Augustan period:

Ca. 40 B.C.

Cat. nos. 17, 74, 75. The portraits are both of older and young men; no other coiffure is depicted during this transitional period.

9. Dohrn, *Arringatore* 16, pls. 1, 10, 11.

10. Dohrn, *Arringatore* 18, pl. 3.1.

11. Schweitzer, *Bildniskunst* figs. 78 and 79 respect-ively.

30 - 13 B.C.

 Cat. nos. 1, 5 (two men), 6 (two men), 20, 26,
27, 28, 35 (two men), 36, 43, 44 (two
men), 45 (two men), 46, 47 (two men),
50 (two men), 51, 52 (two men), 60,
61, 62, 76 (two men), 78, 81, 82, 86,
91, 92.

In this period, the late Republican hairstyle remains
quite popular, but is almost exclusively confined to
portraits of older men. Only four young men (1, 36,
43, 46) have their hair combed in the late Republican
fashion.

13 B.C. - A.D. 5

 Cat. nos. 24, 25, 34, 57 (two men), 58, 63, 65,
67, 70, 71, 84, 85, 87, 88.

The late Republican hairstyle declines in popularity
by this date and is worn only by old or mature men.

 There are, in some cases, stylistic differences
in the rendering of the late Republican hairstyle in
the Augustan period. In Cat. nos. 24, 25, 34, and 60,
e.g., the hair is especially short and appears almost
shaven; the individual hairs are indicated by short
chisel strokes or stippling. In the majority of cases,
the hair is rendered more plastically than in the

period 75 - 40 B.C., and instead of an unbroken
semicircle over the forehead, separate locks and
curls are depicted.

A new development in freedmen's hair fashion
in the early Augustan period is the adoption of the
current court coiffure. In this hairstyle the
hair is combed forward over the forehead and does
not recede at the temples. The hair is longer than
in the late Republican hairstyle and covers more of
the forehead and ears.[12]

There are two variant renderings of this Augustan
coiffure in the funerary reliefs of the period 30 -
13 B.C. In the first variant the artist depicts
the hair as a relatively flat cap over the skull; the
individual locks form an even edge over the forehead
and ears. This variant is seen solely in portraits
of mature men and never in elderly or youthful por-
traits:

Cat. nos. 2 (two men), 4, 19, 21, 30, 48, 78, 92.
Probably the best example of the variant may be seen
in the portrait of the man at the left of the Via

12. For the portraits of Augustus, see the following
 monographs, with further bibliography: O. Brendel,
 Ikonographie des Kaisers Augustus (Heidelberg 1931).
 H. Kähler, Die Augustusstatue von Primaporta
 (Cologne 1959). Zanker, Actium-Typus. Photographs
 of individual heads are most conveniently consulted
 in the recent volume by Zanker.

Biberatica relief (78). This head, and the others
of this type, may be compared to numismatic portraits
of the time of the Second Triumvirate (ca. 45 - 30
B.C.), e.g., those of Q. Labienus Parthicus[13] and
M. Junius Brutus,[14] and to contemporary portraits in
the round, e.g., two travertine and marble heads now
in Copenhagen.[15] This variant in the rendering of
the Augustan hairstyle is confined to funerary por-
traits of the period 30 - 13 B.C.

In the second Augustan variant the hair is
rendered more plastically and the arrangement of
individual locks is more disorderly. Instead of
a series of parallel locks falling over the fore-
head, the hair is combed in layers which often over-
lap and do not form an even line over the forehead.
This variant is closest to the official style of
rendering the coiffure of the young emperor himself
and may be seen in portraits of Octavian of the
"Actium" type.[16] This variant appears in the funerary

13. Vessberg, Studien pl. 9.5-6. Crawford, Coinage
 529, no. 524. Zehnacker, Moneta II, 1065-1066.

14. Vessberg, Studien pl. 9.2-3. Crawford, Coinage
 517-518, nos. 506, 508. Zehnacker, Moneta II,
 998-1002.

15. Vessberg, Studien 231-232, pl. 71.1-4.

16. Zanker, Actium-Typus pl. 7 (Rome, Museo Capitolino).

portraits of both young men and mature men of the
period 30 - 13 B.C.:

Cat. nos. 3, 36, 41, 49, 54 - young men; and
72, 76, 77 (three men), 81, 92 (two
men) - mature men.

Several of these heads have close parallels in
Augustan court portraiture. The unruly hair of the
young man at the center of a relief in the Palazzo
dei Conservatori (36) may be compared to that of a
head of Augustus from Tyndaris.[17] The rendition
of the hairstyle of the second man from the left in
a second relief in the Palazzo dei Conservatori (77)
may be compared with that of a portrait of Augustus
from the forum of Lucus Feroniae.[18]

This second variant continues to appear in
funerary reliefs of the following period, 13 B.C. -
A.D. 5:

Cat. nos. 22, 55, 58, 65, 67, 68 (man and boy),
69, 70, 80 (two men), 84, 87, 88, 89
(two men), 90 (two men).

None of these portraits is of an old man, although

17. Zanker, Actium-Typus pl. 21a.
18. Zanker, Actium-Typus pl. 15a.

four are of mature men (68, 80, 89). The variant is
regularly seen in portraits of young men and espec-
ially of boys. The heroic portrait of a young man at
the center of a relief in the Ny Carlsberg Glyptothek
(88) is perhaps the best example of the adoption of
the Imperial coiffure and court style by the middle
classes. The portrait may be compared to one of
Augustus himself in the Museo Capitolino.[19]

The hairstyles of the children also closely
follow court fashions, both in form and style; one
can compare, e.g., the coiffure of the boy in the
Via di Portico di Ottavia relief (90) with that of
Lucius Caesar, as seen in a portrait in the Museo
Nazionale of Naples.[20]

Female Coiffures, ca. 75 B.C. - A.D. 5[21]

19. Zanker, Actium-Typus pl. 7.

20. Zanker, Actium-Typus pl. 36b.

21. There are three major studies of female coiffures
 of this period, although none treats the coiffures
 prior to 40 B.C. R. Steininger, Die weiblichen
 Haartrachten im ersten Jahrhundert des römischen
 Kaiserzeit (Munich 1909). L. Furnée-van Zwet,
 "Fashion in Women's Hair-dress in the First Century
 of the Roman Empire," BABesch 31 (1956) 1-22. K.
 Polaschek, "Studien zu einem Frauenkopf im Landes-
 museum Trier und zur weiblichen Haartracht der
 iulisch-claudischen Zeit," TrZ 35 (1972) 141-210.

The female hairstyles of the funerary reliefs
of 75 - 50 B.C. draw on Hellenistic Greek, late
Etruscan and Mid-Italic coiffures for models.
Eleven female portraits survive from this period,
and six related, but varied, coiffures are repre-
sented. The basic feature of all the coiffures is
that the hair is long and, with one exception,
parted in the center and either drawn back and
fastened or piled on top of the head.

In the simplest of the six hairstyles (14, 38)
the hair is parted in the middle, pulled back in a
series of waves and fastened at the back of the
head. The coiffure is Hellenistic Greek in origin;
the "Venus de Milo" is a famous example.[22] This
type also commonly appears on late Etruscan votive
terracotta female heads, e.g., a fourth or third
century B.C. head from Capua,[23] but does not seem
to have been used for royal female portraits.

The second type of female coiffure of this per-
iod is a variant of the first, with the addition of
either one or two corkscrew curls in front of the

22. M. Bieber, The Sculpture of the Hellenistic Age[2]
 (New York 1961) 159, figs. 673-675, with biblio-
 graphy.

23. M. Bonghi Jovino, Capua preromana (Florence 1965)
 I, 45, pl. 12.3-4.

ears. The two surviving portraits of this type (9,
83) are both veiled. The coiffure is also Hellen-
istic Greek in origin. A single corkscrew curl in
front of each ear appears, e.g., in the portrait of
Berenice II (ca. 273 - 221 B.C.) found in Cyrene
and now in the Benghazi Museum.[24]

In a third variant of this hairstyle the hair
is again parted in the middle and drawn back over
the ears in a series of waves and fastened behind
the head, but the coiffure is made more elaborate
by the combing of the hair in layers over the fore-
head, as in the portrait of the woman in the Tenuta
Cappelletti relief (39). The layering of the hair
is also characteristic of a fourth variant type,
which combines the parted, layered coiffure with
corkscrew curls (11, 16, 40). In two of the three
cases short curls also frame the forehead. This
combination of corkscrew curls in front of the
ears and forehead curls is present in the portrait
of Berenice II from Cyrene.

The fifth coiffure of this period, known from
one funerary relief (9), also has a part in the center

24. Richter, Portraits III, 264, figs. 1822-1823, with
 bibliography.

of the head, but the hair is gathered behind the
ears, rolled into a coil, and then piled on top of
the head. A sixth related hairstyle, worn by the
woman in Cat. no. 15 and the woman at the left of
Cat. no. 83, has been called the Scheitelknotenfrisur
and dated to the period 90 - 60 B.C. by L'Orange.[25]
In this coiffure the hair is tied in a knot on top
of the head. This feature appears on denarii with
the head of Victory struck in Gaul in 82 B.C. by C.
Valerius Flaccus.[26] The coiffure of the woman in
the Palazzo dei Conservatori relief (15) differs
somewhat in that the hair is not parted in the
center, but on the left side. This side part has
precedents in late Etruscan votive terracottas, e.g.,
a head now in the Vatican Museo Gregoriano.[27] Both
of the funerary portraits may be compared with a
Pentelic marble head of the first half of the first
century B.C. in the Museo Nazionale Romano, which

25. H. P. L'Orange, "Zum frührömischen Frauenporträt,"
 RömMitt 44 (1929) 167-179. Cf. Goethert, Republik
 49-50. Vessberg, Studien 185, 248.

26. Crawford, Coinage 379, no. 365. Zehnacker, Moneta
 II, pl. 11, no. 747b. Vessberg, Studien pl. 13.2.

27. G. Kaschnitz-Weinberg, "Ritratti fittili etruschi
 e romani dal secolo III al I av. Cr.," RendPontAcc
 3 (1924-25) 336, fig. 5. Vessberg, Studien 244ff.,
 283, pl. 92.1-2.

combines the Scheitelknot with layered hair, cork-
screw curls before the ears, and forehead curls, as
in the fourth Republican coiffure.[28]

Only one of the six Republican types reappears
in later funerary reliefs, that in which the hair is
parted in the center and drawn over or behind the
ears in a series of waves and fastened behind the
head. Both sub-types (hair covering the ears or hair
pulled behind the ears) occur in the later reliefs:
Ca. 40 B.C.

Cat. nos. 74, 75.

30 - 13 B.C.

Cat. nos. 19, 21, 23, 30, 32, 34, 47, 52, 91.

13 B.C. - A.D. 5

Cat. nos. 70, 85.

By the mid-Augustan period this coiffure was clearly
considered to be old-fashioned. None of the other
five Republican types appears in any relief carved
after 50 B.C.

A new fashion, the nodus coiffure, became popular
in the upper class in the late 40s B.C.; it has no
Greek or Etruscan precedents. In this hairstyle the
hair at the top of the head is parted on both sides

28. Felletti Maj, Ritratti 37, no. 15.

and combed into a roll or <u>nodus</u> over the forehead.
The hair at the sides of the head is combed over
and behind the ears and fastened in the back. The
earliest coins on which the <u>nodus</u> coiffure appears
are two coins minted in Rome by L. Mussidius Longus
in 42 B.C.[29] and by C. Numonius Vaala in 41 B.C.[30]
In each case a woman with individualistic features
is represented, perhaps Fulvia, the first wife of
Marcus Antonius (died 40 B.C.), in the guise of
Victory.[31] The first Roman woman to appear in
her own right on a coin was Octavia, second wife of
Marcus Antonius (born 66 B.C., died 11 B.C.).
She is depicted with a <u>nodus</u> coiffure on an aureus
of 39 B.C. in the Berlin Cabinet.[32] One of the
most characteristic features of Octavia's coiffure
is the thick strand of hair which originates in the
<u>nodus</u> and continues behind it over the top of the
head. A variant of this <u>nodus</u> coiffure may be seen

29. Vessberg, <u>Studien</u> pl. 13.6. Crawford, <u>Coinage</u> 508, no. 494.40.

30. Vessberg, <u>Studien</u> pl. 13.8. Crawford, <u>Coinage</u> 522, no. 514.

31. Furnée-van Zwet, "Hair-dress" 4.

32. Vessberg, <u>Studien</u> pl. 13.9. Furnée-van Zwet, "Hair-dress" 4, no. 5. Crawford, <u>Coinage</u> 531, no. 527.

on an aureus of 38 B.C. in the British Museum, struck
at an Eastern mint by Marcus Antonius and bearing
Octavia's portrait.[33] In this case the nodus is
emphasized and the strand of hair over the head is
thinner. This variant appears on other issues of
36 - 35 B.C.[34]

A portrait of Octavia from Velletri, now in
the Museo Nazionale Romano,[35] datable to the early
30s B.C. by comparison with the numismatic por-
traits, combines features of the Berlin and London
aurei coiffures. The large central strand of hair
is connected to the nodus as in the Berlin variant,
but the bun in back is high and more comparable
to the London head. The Velletri head has the
wavy hair over the ears and the curls falling on
the neck behind the ears that characterize both vari-
ants. By ca. 25 B.C. the strand of hair over the top
of the head seems to have gone out of fashion. A

33. Vessberg, Studien pl. 13.10. Crawford, Coinage
 534, no. 533.3a.

34. BMC, Republic II, 510-511.

35. Felletti Maj, Ritratti 51-52, no. 80. M. L.
 Marella, "Di un ritratto di 'Ottavia'," Atti R.
 Acc. Italia Mem. ser. 7, vol. 3 (1942) 31-82.
 For Octavia see also P. E. Arias, "Nuovi contri-
 buti all'iconografia di Ottavia Minore," RömMitt
 54 (1939) 76-81. H. Bartels, Studien zum Frauen-
 porträt der augusteischen Zeit (Munich 1963) 14ff.

bronze coin with the head of Pax struck at Pella in 25 - 24 B.C.[36] shows a <u>nodus</u> over the forehead, but no strand over the head; instead, the hair is rolled at the sides.

Because of the frames on the funerary reliefs it is impossible to determine which of these minor variants of the <u>nodus</u> coiffure is depicted. The <u>nodus</u> first appears in a travertine relief in the Villa Wolkonsky of ca. 40 B.C. (<u>17</u>) and becomes quite popular in reliefs datable to the 20s B.C., because of the portrait and drapery style and, in many cases, the Luna marble:

Cat. nos. <u>20</u>, <u>44</u>, <u>60</u>, <u>61</u> (two women), <u>78</u> (two women), <u>81</u>, <u>82</u>, <u>91</u>, <u>92</u> (two women). There was, therefore, a short lag between the first appearance of the <u>nodus</u> coiffure on coins and its widespread popularity on the funerary reliefs. The hairstyle appears only twice in reliefs of the period 13 B.C. - A.D. 5:

Cat. nos. <u>59</u>, <u>88</u>.

A head of a woman, formerly in the von Bergen collection, datable to the early 30s B.C. because of its resemblance to the profile portrait of

36. Furnée-van Zwet, "Hair-dress" 2, no. 11.

Octavia on the Berlin aureus, shows another vari-
ation in the nodus which is visible in the funerary
reliefs because it is not affected by the frame.[37]
The nodus is divided into three parts: a large
roll flanked by two smaller ones. The hair on the
sides is slightly waved and is combed over the top
part of the ears and is fastened in a bun high at
the back of the head.[38] Three older women in marble
reliefs of ca. 30 B.C. are represented with this
tripartite nodus variation:

 Cat. nos. 26, 41, 43.

Octavia was not the only member of the Augustan
court to set the trend in female coiffures. A vari-
ation of the nodus coiffure worn by Livia and Julia,
the wife and daughter of Augustus is also emulated on
funerary reliefs. This variant may be seen on a Per-
gamene coin struck after 20 B.C. bearing portraits of
Livia as Hera and Julia as Aphrodite.[39] There is

37. S. Fuchs, "Neue Frauenbildnisse des frühen Kaiser-
 zeit," Die Antike 19 (1938) 255ff., pls. 28-29,
 figs. 3, 6, 7. Furnée-van Zwet, "Hair-dress" 12,
 figs. 4-5.

38. Another head with the tripartite nodus coiffure
 is in the Musée Lavigerie in Carthage, and has
 been identified by P. Arias, RömMitt 54 (1939) 77-
 78 as Octavia, but is more likely a private por-
 trait. V. Poulsen, "Studies in Julio-Claudian
 Iconography," ActaArch 17 (1946) 19-20.

39. BMC, Mysia 139, pl. 28.6. Furnée-van Zwet, "Hair-
 dress" 2, nos. 12-13.

still a <u>nodus</u> over the forehead but the central band
of hair over the top of the head has been eliminated;
more attention is paid instead to the hair around the
face which is more elaborately waved than in Octavia's
<u>nodus</u> type. Two women in funerary reliefs datable
late in the period 30 - 13 B.C. wear the Livia-Julia
<u>nodus</u> coiffure:

 Cat. nos. <u>27</u>, <u>45</u>.
This variant also appears in two reliefs of the suc-
ceeding period, 13 B.C. - A.D. 5:

 Cat. nos. <u>89</u>, <u>90</u>.

 Another coiffure which is introduced in the fun-
erary reliefs of 30 - 13 B.C. is the so-called <u>Melon-
enfrisur</u>. In this hairstyle the hair is parted in
the center and at both sides of the head; between the
parts, the hair is combed in long rolls from the
forehead to the back of the head. The <u>Melonenfrisur</u>
was popular in the Hellenistic period, especially in
Egypt, where likenesses of Berenice I and II survive
with this hairstyle.[40] The <u>Melonenfrisur</u> was still
current in the second half of the first century B.C.;
Cleopatra VII wears her hair combed in this fashion

40. Richter, <u>Portraits</u> III, 261, 263-264, figs. 1776,
 1779-1780, 1820-1823.

on a coin struck in Askalon in 38 B.C.[41] The coif-
fure appears later in the century on the Ara Pacis,
where the Melonenfrisur is worn by two small girls.[42]
On the funerary reliefs the Melonenfrisur appears
in two portraits datable shortly before 13 B'.C. (18,
49) and in two others which postdate 13 B.C. (66, 88);
in one case (66) the coiffure is worn by a little
girl, as on the Ara Pacis.

In the period 13 B.C. - A.D. 5 three new hair-
styles are introduced in the funerary reliefs. The
first is a variation of the early Augustan nodus
coiffure which seems to have been extremely popular
with middle-aged women. The nodus over the forehead
is retained but a band of hair which originates in
the nodus is wound about the head over the ears and
tied into the knot at the back of the neck. This
strand of hair may take the form of a simple twist
or an elaborate braid. Polaschek has dated this
coiffure to the period 13 - 1 B.C.[43] and some of the
heads in the funerary reliefs have very close parallels

41. Richter, Portraits III, 269, figs. 1857-1859,
 1862-1864.

42. Polaschek, "Haartracht" 147, fig. 5, no. 4-5.

43. Polaschek, "Haartracht" 150-154, fig. 6, nos. 4-9.

in portraits in the round of this period. One may
compare, e.g., the coiffure of Vibia Prima in a
relief in the Vatican (69) with that of a woman in
a portrait from Rome, now in Copenhagen.[44] Twisted
strands of hair leading from the nodus circle the
head and in each case the nodus is subdivided by
another section of hair. The coiffure of Aemilia
Clucera in another relief in the Vatican (67) with
its cylindrical nodus and twisted strands of hair
at the sides of the head is comparable to that of
the portrait of another woman in the Ny Carlsberg
Glyptothek also found in Rome.[45]

This braided coiffure is very popular in the
period 13 B.C. - A.D. 5 and fourteen examples are
preserved in the funerary reliefs:

Cat. nos. 8, 10, 24, 33, 55, 56, 57, 58, 63,
67, 69, 71, 80, 84, 90.

The coiffure of Atistia in the relief from the
facade of the baker's tomb near the Porta Maggiore
(12) is not duplicated in any of the other funerary
reliefs, but does have parallels in portraits in the
round of the post-Ara Pacis period. Atistia's hair

44. Poulsen, Portraits romains I, 126, no. 99.
45. Poulsen, Portraits romains I, 136, no. 118.

is piled on top of the head in a large bun, as in
a portrait in the Museo Nazionale Romano[46] and two
heads in the Vatican.[47]

 In this period the _nodus_ coiffure is also
replaced in some cases by a central part, although
the specific coiffures differ from the centrally
parted Republican hairstyle of the second quarter
of the century. A central part characterizes the
coiffure of Antonia Minor and other women on the
Ara Pacis[48] and two centrally-parted coiffures on
the funerary reliefs have direct parallels in por-
trait heads of the end of the first century B.C.
The coiffure of the young woman in the Ampudius
family relief in London (59) with its central part
and series of waves combed back from the forehead
may be compared to a head in the Museo Chiaramonti
of the Vatican.[49] The portrait of Vettia Calybe (84)
has a similarly waved and parted coiffure with the

46. Felletti Maj, _Ritratti_ 51, no. 79.

47. Amelung, _Skulpturen_ I, 84, no. 64; I, 981, no. 552.

48. Polaschek, "Haartracht" 146-149, fig. 5, nos. 1-3,
 6. Simon, _Ara Pacis_ pl. 15.

49. Polaschek, "Haartracht" 154-155, fig. 6, no. 13.
 Amelung, _Skulpturen_ I, 594-595, no. 432.

addition of a braid on the top of the head, as in a late first century B.C. portrait head in a private collection in Bonn.[50] Both young women in the reliefs wear their hair in the latest fashion; the older women of this period seem to have preferred the currently fashionable braided variation of the older nodus coiffure.

We have seen that, both in male and female coiffures, the funerary portraits of freedmen reflect the changing modes of the aristocratic class and that, consequently, the hairstyles are a valuable tool for dating the reliefs. There is, however, a tendency in the freedmen portraits to retain older coiffures longer than in upper-class monuments, a tendency which was also noted in the foregoing discussion of portrait style. As in the case of the freedmen portraits, the older modes and styles are often associated with portraits of older persons, and the young men and women and children tend to be the most up-to-date members of the families. These conservative tendencies in the funerary reliefs with regard to portrait styles and coiffures serve once again as a reminder that each relief can

50. Polaschek, "Haartracht" 154-155, fig. 6, no. 14.

be dated only by its most progressive feature and
that the old and the new regularly appear side by
side in a single monument.

Chapter Seven: Costumes and Statuary Types

The garments worn by the freedmen and freed-
women in the Roman funerary reliefs are described
in this chapter and their typological and stylistic
development is traced. The form and style of the
garments provide a valuable indication of the date
of the monuments, especially in the case of the
full-length reliefs. Almost every individual por-
trayed is represented in the posture of a known
statuary type. The statuary models for the funerary
portraits will be cited and discussed in order fur-
ther to characterize the tastes of the patrons of
these monuments. In addition, models will be sug-
gested for some of the more complicated groupings
of figures on the multi-figure, full-length reliefs.

Costumes

The Toga[1]

The toga is the standard male costume on the

1. The basic studies are Wilson, Toga and F. W.
 Goethert, "Toga," RE II,6 (1937) 1651-1660,
 supplemented by other more specific works cited
 below.

funerary reliefs and it is worn by all men over
the age of sixteen, unless they are depicted as
soldiers. The toga is usually worn over a tunic
and is a semi-elliptical mantle; its characteristic
curved contour may be discerned in the lower edge
of the garment which forms a curved diagonal line
above the feet. The toga is always worn with calcei
or closed boots laced with corrigiae (straps). Cal-
cei are clearly visible in Cat. nos. 11, 13, 65, and
66. The toga may be distinguished from the Greek
himation (pallium), which is a rectangular cloak
with a straight edge worn with crepidae or soleae
(sandals), not boots.[2] Another distinguishing fea-
ture of the toga is the lacinia or corner of the gar-
ment which falls between, or to the side of, the
feet.

Unfortunately, because the distinctive features
of the Republican and early Augustan toga are con-
fined to the lower part of the body, it is impossible
to determine if the draped men in the bust-length
reliefs wear the toga or the pallium. Nevertheless,
since the pallium never appears in the full-figure

2. For these terms, see L. Bonfante Warren, "Roman
Costumes. A Glossary and Some Etruscan Derivations,"
ANRW I,4 (1973) 605ff.

reliefs, and since the toga was the emblem of the Roman citizenship recently granted to the freedmen,[3] it is reasonable to assume that it is the toga, rather than the pallium, that is depicted in the bust-length reliefs. Margarete Bieber has designated these funerary portraits as "palliati" because the men are often portrayed in the posture of Greek himation-clad statues,[4] but this designation is inaccurate.

The typological and stylistic development of the toga during the first century B.C. can best be gauged from an examination of the full-length funerary reliefs; the criteria for dating produced by this study may then be applied to the bust-length representations.

The toga exigua was the characteristic civilian dress for Roman men during the first half of the first century B.C.[5] It has the same shape as the toga of later date, but it is a shorter and narrower garment. The toga is wrapped around the body and

3. See supra, Chapter Two.

4. Bieber, "Palliati" 374-417. For togati in this posture, see Polaschek, Mantelstatuen and E. H. and L. Richardson, Jr., "Ad Cohibendum Bracchium Toga," YClSt 19 (1966) 253-268.

5. For the toga exigua, see Goethert, Republik 15ff. West, Porträt-Plastik I, 41-44. Dohrn, Arringatore 16ff.

over the right shoulder, forming a sling for the
right arm, and then over the left shoulder. The
material falls over the body in a few broad folds;
the folds of the sling are taut and narrow. The
right and left ankles and half of the calf are not
covered by the toga.[6] The lower edge of the garment
is only slightly curved and the lacinia falls in
front of the left leg.[7] The "Arringatore," dated
90 - 70 B.C. by Dohrn, wears such an abbreviated
toga,[8] as do the men on the census relief of the
so-called "Altar of Domitius Ahenobarbus." The
date of the latter monument is controversial, but is
probably no later than 70 B.C.[9]

The best example of the toga exigua on the
Roman funerary reliefs is that worn by the man on
the relief from the Via Statilia (11); the style
of drapery is also typical of the period 75 - 50 B.C.

6. Cf. West, Porträt-Plastik I, figs. 27-29.

7. Polaschek, Mantelstatuen 7-8.

8. Dohrn, Arringatore 16ff., pls. 2-7.

9. H. Kähler, Seethiasos und Census. Die Reliefs aus
 dem Palazzo Santa Croce in Rom (Berlin 1966) 24ff.,
 pls. 4-5, 8, 10. F. Coarelli, "L'ara di Domizio
 Enobarbo e la cultura artistica in Roma nel II
 secolo a. C.," Dialoghi di Archeologia 2 (1968)
 302 - 368. L. Budde, "Das römische Historienrelief
 I," ANRW I,4 (1973) 802-804.

The folds of the toga vary in length, breadth, and direction. Those of the arm sling are long and narrow, while the folds over the upper right arm are shorter and wider. The drapery covering the lower part of the body disguises its shape except where the left thigh and knee project through the material. A prominent central flat vertical fold stretches from the abdomen to the lower edge of the toga between the legs. Broad diagonal folds traverse the right leg. The lacinia falls in front of the left foot.

Two funerary statues of the first half of the first century B.C. correspond closely to the Via Statilia togatus in format and drapery style. The first is a travertine portrait of a man with a bird in the Villa Celimontana in Rome, which Vessberg has dated ca. 100 B.C.[10] The second and closer parallel is a headless travertine statue on the Via Appia.[11] Both men wear a toga exigua similar to that worn by the man in the Via Statilia relief. In all three a triangular drapery

10. Vessberg, Studien 175-180, 264, pl. 23.1-2.
11. Unpublished. DFK 72.I.11.

fold falls to the left of the left knee and the
upper left thigh is defined by a curved diagonal
crease. A narrow, flat pleat falls from beneath the
sling to the lower edge of the toga. Curved folds
radiate from this long pleat across the right side
of the body.

In the other funerary reliefs of 75 - 50 B.C.,
only the sling, shoulders, and upper arms are repre-
sented. Yet the rendering of the drapery folds,
with their varying length, breadth, and direction,
is stylistically close to the treatment of the folds
in the Via Statilia, Villa Celimontana, and Via
Appia togati:

Cat. nos. 14, 15, 16, 38, 39, 73, 83.

The toga exigua went out of fashion during the
third quarter of the first century B.C., and in the
early Augustan period (30 - 13 B.C.) the toga is
somewhat longer and wider, the curved edge over the
left leg is more pronounced, and the lacinia falls
to the left of the left leg.[12] A transition between
the two toga types may be seen in the full-length
funerary relief in the Galleria Borghese (37). The
bottom edge of the toga of the man on the left is

12. Polaschek, Mantelstatuen 7-8.

restored, but the curved section of the garment over the left leg which leaves part of the calf visible indicates that the toga is still close to the toga exigua form, but has taken on some of the character-istics of the early Augustan toga. The toga of the man at the right is a toga exigua.

The style of the transitional type toga on the Borghese relief is quite different from that of the Via Statilia type (11). The lines of the early Aug-ustan garment are fairly regular, consisting of long, broad, diagonal folds, although the sling has narrow creases. Thin diagonal pleats fall in the area above the waist. The body is swung outward from the left hip, and this motion is accentuated by a large curving drapery fold. This curved fold is not merely an artistic convention, but is a feature of the early Augustan toga. Wilson has shown that this fold results from the fastening of the garment at the left hip, either by tucking it under the tunic or girdle or by fastening it to the girdle.[13] The detail is emphasized in some statues and merely hinted at in others. In the latter case, the fold becomes a mere convention which is reproduced time and again with-

13. Wilson, Toga 42.

out any regard for its function. This convention
appears no earlier than the last quarter of the
first century B.C. The fold may still be seen in
the late first century B.C. funerary relief in the
Villa Doria Pamphili (66), in a relief of a togatus
in the Museo Nazionale Romano,[14] and in two reliefs
with togati on the Via Appia.[15]

The bust-length funerary reliefs of the period
30 - 13 B.C. exhibit stylistic features similar to
those of the togatus at the left in the Galleria
Borghese relief (37), namely the long, broad, regu-
lar, diagonal folds across the chest and the narrow
folds of the arm sling:

Cat. nos. 2, 4, 5, 6, 18, 23, 26, 27, 28, 30,
35, 41, 42, 43, 44, 45, 46, 47, 49,
50, 52, 54, 60, 62, 72, 77, 79, 81,
82, 86, 91, 92.

A characteristic toga of the period 13 B.C. -
A.D. 5 is worn by the father in the Villa Doria
Pamphili relief (66). The garment is long and wide,
and the bottom edge falls in a broad arc from the
left thigh to the right ankle. The lacinia hangs

14. Unpublished. Inv. 121531. DFK 72.22.22.
15. Unpublished. DFK 72.I.19-21.

between the legs and has a tassel at the bottom corner which touches the ground.[16] The sling is wider than those of the earlier reliefs, e.g., the Via Statilia (11) and Galleria Borghese (37) examples, and like that of Eurysaces on a relief of this period (12), the sling is not confined to the shoulder, but merges with the drapery covering the upper right arm. The lines of the toga are fairly regular, consisting of long diagonal folds less broad than those of the Borghese togati, but not as narrow as those of the baker's toga. The sling is made up of a series of narrow folds. The left hip is swung slightly outward, and this movement is underlined by the curved drapery fold over the left thigh characteristic of Augustan togate statues. As on the funerary reliefs of 13 B.C. - A.D. 5, almost all the togati on the Ara Pacis have a lacinia falling between their feet.[17] The style of the drapery of the Villa Pamphili togatus is also very similar to that of the Ara Pacis togati; compare the Pamphili togatus with a

16. Polaschek, Mantelstatuen 7-8.
17. Simon, Ara Pacis pls. 16b, 17b.

man on the Ara Pacis.[18] Both wear garments with long
folds of medium width; the right thighs, knees, and
calves project boldly through the garments, and sharp
folds accentuate the shape of the right knee when seen
in profile. In both cases the folds of the sling
merge with those over the upper left arm forming a
kind of short sleeve over the left shoulder. This
"sleeve" is a feature which recurs in other contem-
porary togati, e.g., those in two full-length single-
figure reliefs in the Museo Nazionale Romano.[19]

The bust-length togati in the funerary reliefs
of this period share many stylistic features with
the Doria Pamphili togatus and Eurysaces:

Cat. nos. 55, 56, 57, 58, 59, 63, 65, 68, 69,
71, 80, 84, 87, 88.

Two of these figures also have the "sleeve" over
the left shoulder, as in the full-length examples
(69, 71).

A further step in the development of the toga

18. E. Petersen, Ara Pacis Augustae (Vienna 1902) pl. 4,
no. 15. Simon, Ara Pacis pl. 16b (fourth from the
right).

19. B. M. Felletti Maj, NSc (1955) 204-206, fig. 1;
DFK 72.II.8. DFK 72.22.22; unpublished.

in the Augustan period was the addition of the
sinus, formed by loosening the sling over the neck
and right shoulder and allowing it to fall in an
arc below the right hip.[20] The sinus is mentioned
by Quintilian, who says that the early form of toga
had no sinus, but that later the sinus was small.[21]
The earliest firmly datable representations of the
small sinus appear on the Ara Pacis, where the toga
with sinus is depicted beside the early toga with
arm sling type, and the more developed toga with
sinus and umbo. The only representation of a toga
with sinus in the full-length funerary reliefs is
the fragmentary late first-century B.C. relief of
a man and wife in the Museo Nazionale Romano (13).
The sinus is short and comparable to that worn by
some senators in the procession on the north side
of the precinct wall of the Ara Pacis. Because
the abbreviated representations of the toga in the
bust-length reliefs do not extend to the hip, the
sinus cannot be included within the frames.

20. Wilson, Toga 44.

21. Quint., Inst. XI,3,137: nam veteribus nulli
 sinus, perquam breves post illos fuerunt.

The umbo also makes its appearance in the mid-
Augustan period, and again, the first securely
datable representation of this feature is on the
Ara Pacis. The umbo is the loop of drapery at
waist level which is formed by pulling a part of
the main body of the toga outward and over the
sinus.[22] There is only one representation of a
toga with both sinus and umbo among the Roman fun-
erary reliefs - the bust-length portrait of Marcus
Gratidius Libanus in the Vatican (34). Gratidius's
toga may be compared to similar garments on the Ara
Pacis.

The form and style of the togas on the funerary
reliefs are thus important criteria for dating these
monuments. The reliefs mirror drapery developments
in upper-class sculpture and the emulation of upper-
class trends provides a terminus post quem for the
reliefs. There is, however, a degree of conserva-
tivism in some of the representations, as we have
already noted for portraits and coiffures, specif-
ically the retention of older and simpler toga types
in reliefs dating after 13 B.C.

22. Wilson, Toga 49.

Military Costumes

Only in a few funerary reliefs do men wear a
garment other than the toga. Three types of mili-
tary costume are depicted — a leather cuirass with
mantle over the left shoulder (Publius Gessius, 41),
a tunic with mantle over the left shoulder (Lucius
Septumius, 39), and a bare chest with mantle over
the left shoulder (49, 55, 88).

The Palla[23]

The palla is a rectangular mantle worn over a
long tunic. It is large enough so that the upper
edge can be pulled over the head as a veil and so
that the lower edge can reach to the knees. Unlike
the toga, the palla did not undergo an evolution in
form during the first century B.C., and is less
valuable as a dating tool. Broad stylistic differ-
ences may, however, be distinguished between pallas
of late Republican date (75 - 40 B.C.) and those of
Augustan date. As with the toga, the stylistic
characteristics of the palla are best isolated
through an examination of the surviving full-length
reliefs. The major stylistic differences are con-

23. Wilson, Clothing 148-149. Schmidt, Frauenstatuen
 1-19.

fined to the area of the figure below the waist and
cannot be traced in the bust-length reliefs.

The palla and tunic worn by the woman in the
Via Statilia relief (11) may be taken as typical of
the late Republican period. The tunic falls over
the feet and onto the ground in fairly regular ver-
tical folds. The top edge of the palla is pulled
over the head and the lower edge of the outer garment
forms an almost horizontal line at a level just
below the knees. The folds of drapery of the lower
part of the palla are short and broad and the creases
move in a variety of directions. Little attention
is paid to indicating the shape of the body and
positions of the limbs beneath the garment; the
folds seem to have an independent existence.

The palla worn by Atistia (12) and the woman
in the Capri relief (64) differ from the Republican
palla type chiefly in the increased length of the
outer garment and the treatment of the folds, which
are longer and narrower and more regularly distrib-
uted. A major change in the palla is documented by
the Villa Doria Pamphili relief (66), 13 B.C. - A.D.
5. This relief has been grouped with statues of
similar date by Schmidt and represents the most pro-

gressive style of the period.[24] The relief may be
compared with two statues of female members of the
gens Rutilia now in the Vatican Museo Chiaramonti.[25]
The characteristic features of all three palliatae
are the multiple layering of the outer garment so
that a kind of apron falls across the lap, the series
of u-shaped folds which make up the apron, the pattern
of u-shaped folds in the tunic over each foot, and
the series of parallel vertical folds between the
feet. Also characteristic of these and other Augustan
pallas is the use of the drill to render the vertical
folds of the tunic, especially the habit of cutting
incomplete grooves which do not run all the way to
the ground. Such incompletely drilled channels may
also be seen in the tunic of the central woman in the
early Augustan Galleria Borghese relief (37).

Children's Garments: Tunic and Toga

The short-sleeved tunic[26] is the most common
garment worn by the children, both boys and girls,

24. Schmidt, Frauenstatuen 1-19.

25. Schmidt, Frauenstatuen 1-5. Amelung, Skulpturen
I, nos. 355 and 357, pl. 57.

26. Wilson, Clothing 55ff., 130.

in the funerary reliefs:

Cat. nos. <u>64</u>, <u>65</u>, <u>66</u>, <u>67</u>, <u>68</u>, <u>70</u>, <u>85</u>, <u>90</u>, <u>92</u>.
When the child is represented at full-length, the
style of the garment is very close to that of the
parents. The best preserved example is the small
girl who wears a long, girded tunic in the Villa
Doria Pamphili relief (66). The u-shaped folds
which fall over her right leg and the parallel
vertical folds between the legs closely approximate
comparable features of the palla and tunic worn by
the child's mother.

Four boys wear togas in the Roman funerary
reliefs:

Cat. nos. <u>71</u>, <u>82</u>, <u>83</u>, <u>84</u>.
These boys are usually older than their tunic-clad
counterparts, and must be at least sixteen years
old, the age at which a young man could don a
toga.[27] As a sign of their free birth, two of these
youths (<u>71</u>, <u>84</u>) wear a <u>bulla</u> on a cord around their
necks, as do two of the tunic-clad boys (<u>64</u>, <u>70</u>).[28]

27. Wilson, <u>Toga</u> 52.
28. Wilson, <u>Clothing</u> 131-132.

Statuary Types

Togatus with arm sling – Palliata with arm sling

The most common male statuary type reproduced
on the funerary reliefs is the togatus with arm
sling. Full-length representations of this type
appear on **five of the reliefs:**

Cat. nos. 1, 11, 12, 37, 66.

In this statuary type, the toga is wrapped around
the body and the man's right arm rests in a sling
formed by the upper part of the garment, which is
draped over the right shoulder, passes under the
right forearm, and then over the left shoulder.
The sling is usually grasped in the right hand.
The left arm rests at the side of the body and a
scroll is held in the left hand at the level of the
upper thigh. Abbreviated versions of the togatus
with arm sling occur in the following bust-length
reliefs:

Cat. nos. 2, 4, 5, 6, 7, 14, 15, 16, 17, 21,
23, 26, 27, 29, 30, 35, 36, 38, 39,
40, 41, 42, 43, 44, 45, 46, 47, 49,
50, 52, 53, 54, 55, 56, 57, 58, 59
61, 62, 63, 69, 70, 71, 72, 73, 74,

75, 77, 79, 80, 81, 82, 84, 86, 87,
88, 89, 91, 92.

Countless numbers of statues of this type are
preserved in Rome and in collections throughout the
world. The type is based ultimately on a Greek
statuary type of the mid fourth century B.C., the
so-called "Sophocles" or "Aeschines" type, a good
example of which is the copy of a portrait of
Aeschines in a himation in the Museo Nazionale
in Naples.[29] The right arm rests in a sling, as
is the Roman examples, but the left arm is bent
and placed behind the back at the level of the
left hip. A Hellenistic variant of this type which
is closer to the Roman togatus with arm sling type
is also known. The most famous example, datable
to the second half of the second century B.C., is
the statue of a young man from Eretria, now in the
Athens National Museum.[30] In the Eretria type, the
left arm is lowered and a section of the himation
is grasped in the left hand. The portrait of
Dioscurides, from Delos, dated 138 - 137 B.C.,[31]

29. Bieber, "Palliati" 375ff. Polaschek. Mantelstatuen.

30. Bieber, "Palliati" 379, fig. 4.

31. J. Marcadé, Au Musée de Délos, BEFAR 215 (Paris
1969) 131-134, 325-328.

adheres to the Eretria type. This Hellenistic
variant of the Aeschines type was adapted for
Roman togate statues of the arm sling type; in the
Roman examples, however, the left hands hold a
scroll rather than a section of the garment.

The himation with arm sling type was also
adapted for use as a female statuary type, where the
outer garment is a palla. The palliata with arm
sling type is best represented in the funerary
reliefs by the full-length portrait of a woman in
the Villa San Michele in Capri (64). Bust-length
versions, often veiled, appear in the following
reliefs:

Cat. nos. 9, 10, 14, 15, 17, 21, 27, 29, 30,
38, 39, 42, 43, 46, 47, 49, 53, 54,
61, 62, 73, 75, 77, 79, 83, 86, 88,
92.

Togatus and Palliata variants without arm sling

A very popular variant of the toga or palla
with arm sling type, especially for women, appears
in the bust-length reliefs, although not in the
full-length reliefs. In this type, the mantle
(either toga or palla) is allowed to slip off the

right shoulder, revealing the tunic below. The
mantle is wound around the right hip and thrown
over the left shoulder, forming a long, diagonal
band across the chest. The left, rather than right,
arm is bent and held before the chest; the edge of
the garment is grasped in the left hand. The right
arm rests at the side of the body or gathers up
part of the mantle.

Statues of this type are rather rare; prob-
ably the best known example is a statue of Claudius
in the Braccio Nuovo of the Vatican.[32] Claudius
wears, of course, a later form of toga with long
sinus and umbo. Togati in similar postures may
also be found on the Ara Pacis. The type appears
in funerary reliefs of all periods; occasionally
the right arm of a togatus or palliata of this
type is raised in a dextrarum iuctio, e.g., Marcus
Gratidius (34) and Aiedia Fausta (18). In some
cases the women are veiled, as in two reliefs in
the Palazzo Colonna (57, 58).

The following reliefs include representations
of togati of this type:

Cat. nos. 2, 7, 34, 52, 56, 71, 72, 76, 80.

32. Amelung, Skulpturen I, no. 117, pl. 19.

The following include palliatae of this type:

Cat. nos. <u>17</u>, <u>18</u>, <u>26</u>, <u>28</u>, <u>31</u>, <u>44</u>, <u>45</u>, <u>50</u>, <u>57</u>, <u>58</u>, <u>59</u>, <u>60</u>, <u>63</u>, <u>68</u>, <u>71</u>, <u>80</u>, <u>81</u>, <u>85</u>, <u>86</u>, <u>87</u>, <u>89</u>, <u>90</u>, <u>92</u>.

Pudicitia

One of the more popular female statuary types is the so-called <u>pudicitia</u>.[33] The earliest appearance of the type in the Roman funerary reliefs is in the Via Statilia relief (<u>11</u>), 75 - 50 B.C. The woman's left arm is bent and the lower part of the arm rests horizontally on the left hip. The right arm is also bent; the elbow rests on the left hand and the right hand is placed beneath the chin. One part of the palla is wrapped around the head as a veil and a section of the drapery is bunched at the center of the top of the head. The garment is wrapped around the right wrist and is held in the right hand; from there the palla falls in straight vertical folds to the left knee and ends in four tassels. The other end of the outer garment is wrapped over the left arm and around the left hand and then falls vertically over the thighs. A small

33. G. Radke, "Pudicitia," RE 23,1 (1959) 1942-1945. W. Köhler, "Pudicitia," EAA 6 (1965) 539-540.

bunch of folds is visible just above the left hand near the right elbow.

The _pudicitia_ pose is also used in the full-length relief in the Galleria Borghese (37), 30 - 13 B.C., and appears three times in bust-length reliefs, where the distinctive placement of the arms proves the derivation from the _pudicitia_ statuary type:

Cat. nos. 23 (30 - 13 B.C.), 69 (13 B.C. - A.D. 5), 91 (30 - 13 B.C.).

In one instance (69), the positions of the two arms are reversed and the left hand is placed beneath the chin.

The _pudicitia_ type derives from a Greek statue of the early second century B.C. which was widely replicated.[34] In Roman funerary art of the first century B.C., the _pudicitia_ is a popular statuary type, often used in conjunction with a togatus with arm sling, as in the Via Statilia (11) and Galleria Borghese reliefs (37). This juxtaposition of statuary types has precedents in the art of the Hellenistic East; a famous example is the group of the

34. Collignon, Statues _funéraires_ 291ff. Bieber, "Palliati" 385ff.

Delian magistrate Dioscurides and his wife Cleopatra,
dated 138 - 137 B.C.[35] The bunched drapery motif
at the top of the veil is also characteristic of
Hellenistic veiled female heads, e.g., those from
Andros, Tralles, and Cyprus.[36] The _pudicitia_ seems
to have gone out of fashion as a female portrait
type by the late Augustan period.[37]

Fundilia Type

 This statuary type is reproduced on the full-
length funerary relief from the Via Tiburtina now
in the Museo Nazionale Romano (8). The woman at
the left is depicted in a variation of the pose
of the so-called "Large Herculaneum Woman" type,
the most famous example of which is the statue of
a woman, now in Dresden, found in the theater at
Herculaneum.[38] This type, generally attributed to
the latter part of the fourth century B.C., was

35. J. Marcadé, _Au Musée de Délos_, BEFAR 215 (Paris
 1969) 131-134, 325-328.

36. Collignon, _Statues funéraires_ 180-181, figs.
 110, 110 bis.

37. Bieber, "Palliati" 392.

38. M. Bieber, "The Copies of the Herculaneum Women,"
 ProcAmPhilSoc 106 (1962) 111-134, esp. 111-113,
 figs. la-b (Dresden statue).

widely copied, and is known in a large number of
variants, dating from the Hellenistic period to
Roman times. The woman in the Terme relief
adheres to a specific variation best known from
the portrait of Fundilia in Copenhagen, of Tiberian
date.[39]

In both the Dresden and Fundilia variations
the woman's right arm is bent and left arm is
lowered. Part of the palla is pulled from the left
shoulder to a point between the breasts and then
falls diagonally across the body and over the left
forearm. The Fundilia type differs, however, from
the Dresden type in that the palla does not fall
directly from the left shoulder to the left knee,
but is tucked into a band wrapped around the waist;
this band is fastened beneath the left armpit and
then falls over the left arm.

No replicas of the Fundilia variation are known
prior to the time of Tiberius,[40] with the exception

39. Poulsen, Portraits romains I, 114, no. 78, pls.
 134-138.

40. A copy of the Fundilia type with a Flavian por-
 trait head is in the Museo Torlonia in Rome. A.
 Hekler, "Römische weibliche Gewandstatuen,"
 Münchener Archäologische Studien dem Andenken
 Adolf Furtwängler gewidmet (Munich 1909) 142.

of the Terme relief; both the relief and the Fundilia
portrait may be based on an Augustan prototype which
does not survive. A truncated version of the Fun-
dilia variation appears in one bust-length funerary
relief, in Ostia (56), where the head is veiled.
The Ostia relief, like the Terme relief, may be dated
13 B.C. - A.D. 5.

Berlin Type

The full-length relief from the Via Tiburtina
(8) also reproduces a second statuary type. The
woman at the right is a near replica of a head-
less draped statue in Berlin, datable to the fourth
century B.C.[41] There are, however, small differ-
ences between the Berlin and Terme pieces. The
woman on the funerary relief is veiled, unlike her
counterpart in Berlin, and the folds of the Terme
palla are more numerous and more complex. This
complicated drapery style has, as we have seen,
parallels in Augustan statues and reliefs.[42] The

41. Horn, Gewandstatuen 18, pl. 14.1. Staatliche
 Museen zu Berlin. Kurze Beschreibung der antiken
 Skulpturen im Alten Museum⁵ (Berlin and Leipzig
 1922) 47, no. 583, pl. 44.

42. Schmidt, Frauenstatuen 1-19.

palla of the Berlin type is pulled diagonally from
the right shoulder across the breasts; the upper and
lower edges of the garment are draped over the left
forearm. The right arm is held beside the right
thigh and is completely enveloped by the palla; a
part of the palla is gathered up and held in the
covered right hand.

It is impossible to determine if any of the
bust-length funerary portraits are based on the
Berlin type, because the chief features of the type
are below bust level and not included in the trun-
cated representations. A variant of the Berlin
type, with covered right hand placed approximately
at the center of the chest between the collarbones,
does, however, appear in five bust-length reliefs,
all of the Augustan period (30 B.C. - A.D. 5):

Cat. nos. 41, 52, 59, 87, 88.

The variation may date to the Augustan period.[43]

The Heroic Type

In contrast to the hundreds of draped portraits

43. Covered hands do, of course, appear in Greek
statuary, especially from the fourth century B.C.
on, but there is no exact parallel for this vari-
ation earlier than the time of Augustus. Cf.
Horn, Gewandstatuen 16ff.

on Roman funerary reliefs, only a handful of representations of heroic nudity survive:

Cat. nos. 49, 55, 88.

In each case the portrait represents a young man posed frontally, with a mantle thrown over his left shoulder, and a sword held in one hand. The bust-length portraits are variations of a well-known Greek motif which is reproduced only once on a full-length funerary relief. The relief is on the Via Appia near Forte Appio shortly before the fourth milestone (Fig. 96).[44] Like the multi-figure reliefs, the Via Appia relief is of Luna marble and of Augustan date. In the bust-length reliefs the position of the arm holding the sword has been changed in order to incorporate the motif within the truncated representation. A similar variation on a known type has been noted in connection with the covered, raised hand of the bust-length female portraits of the Berlin type.

The heroic motif of a nude male with a chlamys over his left shoulder was used repeatedly in Greek statuary over the course of several centuries. A

44. F. Castagnoli, Appia antica (Milan 1956) fig. 31. H. Oehler, Untersuchungen zu den männlichen römischen Mantelstatuen I (Berlin 1961) 40. D. E. E. and F. S. Kleiner, "A Heroic Funerary Relief on the Via Appia," AA 90 (1975) 250-265.

statuary type similar to that on the full-length
Via Appia relief occurs as early as the third
quarter of the fifth century B.C. in the statue of
Diomedes created by Cresilas or his circle.[45] The
type was popular in first century B.C. Italy to
judge from such statues as the so-called Sextus
Pompeius in the Louvre, from Monte Porzio near
Tusculum,[46] and a statue in the cortile of the
Palazzo Mattei in Rome.[47]

The heroically nude funerary portrait is con-
fined to reliefs of Augustan date, but an inter-
esting forerunner of the type is represented on a
travertine relief datable to the second quarter of
the first century B.C. (39). The young man, Lucius
Septumius, has a mantle over his left shoulder and
a sword in his left hand, but is clothed in a tunic.
Although a common formal pattern lies behind this
representation and the nude portraits, the artist
or patron of the Republican relief rejected nudity

45. A. Maiuri, Il Diomede di Cuma (Rome 1930). G.
 Lippold, Die griechische Plastik (Munich 1950)
 184. L. Rocchetti, "Diomede," EAA 3 (1960) 108-110.

46. West, Porträt-Plastik I, 91-92. Oehler, Mantel-
 statuen 62. F. Carinci, Sculture di Palazzo
 Mattei, StMisc 20 (1972) 28-29, 31.

47. Carinci, StMisc 20 (1972) 26-32, no. 5, pls. 35-37.

in favor of a more conservative representation. The elderly Publius Gessius on a relief in Boston (41) is also depicted in a similar posture, but wears a cuirass as well as a mantle.

Because heroic representations are so rare on the Roman funerary reliefs, it is interesting to note the identity of the persons represented. Lucius Septumius is cited as an eques (39) and Lucius Appuleius, the heroic youth at the center of the bust-length relief in Mentana (55) is a tribunus militum. Both are freeborn sons of freedmen, and it is likely that the central figures in the Museo Nuovo (49) and Copenhagen (88) reliefs are also military officers and sons of enfranchised slaves. Since only free-born men could serve in the Roman army,[48] it is not surprising that these youths, whose fathers were ineligible for military service, were portrayed as officers on their family sepulcral monuments, thus immortalizing the higher rank they had attained in life.[49]

48. Treggiari, Roman Freedmen 67–68. Duff, Freedmen 66. L. R. Taylor, "Freedmen and Freeborn in the Epitaphs of Imperial Rome," AJP 82 (1961) 113–132.

49. Publius Gessius (41) was a freeborn patron.

Combinations of Statuary Types

The individual statuary types could be, and
were, combined in a large variety of ways, ranging
from such simple multiplications of a single sta-
tuary type as, e.g., two or more togati with arm
slings:

Cat. nos. 1, 4, 5, 35;
or two palliatae with arm slings:

Cat. nos. 9, 10;
to quite complicated groupings. Combinations of the
two variant toga types are preserved:

Cat. nos. 2, 7, 72;
as are examples of two or more togati and palliatae
with arm slings:

Cat. nos. 14, 16, 21, 27, 29, 30, 38, 42, 43,
46, 47, 54, 61, 73, 75, 77.
One or two togati are sometimes combined with a
pudicitia type:

Cat. nos. 11, 23, 37, 69;
and the Fundilia and Berlin types are juxtaposed on
one relief (8). Probably the best example of the
combination of various statuary types is a five-
figure relief in Copenhagen (88) where two togati
with arm slings, one palliata with arm sling, one

variant of the Berlin type, and one heroic type are represented.

Sometimes, in order to portray a husband and wife in a _dextrarum iunctio_, the standard arm sling and togatus and palliata variants were altered to allow for the representation of the hand clasp:

Cat. nos. 13, 18, 28, 31, 34, 60, 65, 68, 70,
80, 81, 83, 85, 87, 90, 92.

Other times, because the hands are not represented, the reliance on a statuary type is less obvious:

Cat. nos. 3, 6, 19, 20, 22, 24, 25, 32, 33,
36, 40, 48, 51, 60, 67, 68, 69, 70,
78, 85, 92.

In most of these cases, actual busts are represented, and this too is a form of statuary replication. In general, however, the funerary portraits are reproductions or truncated versions of known full-length statuary types and the deviation from these types is minimal.

Models in Relief

Three of the full-length reliefs in which a man, wife, and child are depicted may be based upon representations in relief rather than on statues in

the round. These reliefs are Cat. nos. 64 (Villa
San Michele, Capri), 65 (Museo Nazionale Romano),
and 66 (Villa Doria Pamphili). The Capri relief
shows a frontal, veiled palliata and her young son;
the son, dressed in a tunic and wearing a bulla,
turns toward his father, whose figure is not pre-
served. In the Terme relief (65) a togatus is
joined in a dextrarum iunctio with his wife, of whom
only the right hand survives. Their young son stands
between them, dressed in a tunic; he turns toward his
mother and raises his left arm, probably to grasp part
of her palla in his left hand. In the Villa Doria Pam-
phili relief (66) a young girl in a long, girded tunic
is shown between her father, dressed in a toga, and her
mother, dressed in a palla and long tunic. The daugh-
ter holds a bird in her right hand and, like the boy
in the Terme relief, turns toward the mother and grasps
a part of the palla in her raised left hand.

This configuration of a husband and wife
flanking their young child has precedents in Greek
funerary stelae. A mid fourth-century B.C. relief
in Budapest,[50] possibly from a Boeotian workshop,

50. A. Hekler, Die Sammlung antiker Skulpturen (Buda-
pest 1929) 36-37, no. 25. H. Diepolder, Die
attischen Grabreliefs des 5. und 4. Jahrhunderts
v. Chr. (Berlin 1931) 55, pl. 49.2.

depicts a nude bearded man with a mantle over his left shoulder and a woman in a chiton and mantle joining hands in a _dextrarum iunctio._ A nude boy, identified as a servant, clings to the man's right leg. The configuration is similar to that of the Terme relief (65).

A second fourth-century relief, from Athens,[51] represents a young girl, Eukoline, flanked by her mother, Protonoë, and her father, Onesimos; a second woman appears in the background. Eukoline holds a bird in her right hand, turns toward her mother and looks up into her face. The scale and relationship of the figures in the Attic relief are similar to those of the figures in the Doria Pamphili relief (66). Both daughters are represented at the correct height for their age. Eukoline, who is about ten years old, reaches to her mother's breast. The child in the Doria Pamphili relief, who is only about five, is as tall as her mother's upper thigh..

The realistic representation of child's or servant's size is characteristic both of Classical

51. A. Conze, _Die attischen Grabreliefs_ II (Berlin 1900) 245, no. 1131, pl. 238.

Greek funerary stelae and of the Roman sepulcral
reliefs. In Hellenistic funerary stelae, however,
size is determined by the relative importance of
those depicted. Children and servants are repre-
sented in diminutive scale, while their parents
or masters are large and massive. In a relief from
Ephesus, now in the Ephesus Museum,[52] two tiny
servants, a boy and a girl, reach only to the knees
of the man and woman they flank. Servants usually
flank their masters, the male servant on the side
of the man, the girl on the side of the woman.[53]
Sometimes the servants are placed between the two
adults, but they are frontally posed and do not
turn toward their masters.[54] The Classical Greek
reliefs are far closer to the Roman reliefs than
are the Hellenistic examples.

It is difficult to believe, however, that
Classical Greek reliefs served as models for the

52. E. Atalay, "Ein späthellenistisches Grabrelief
 aus Ephesos," AA 88 (1973) 231-243.

53. For the iconography of these servant figures on
 Hellenistic funerary reliefs, see Atalay, AA 88
 (1973) 231ff., with bibliography.

54. For two reliefs from the Greek East where the
 small figures are flanked by larger ones, see
 G. Petzl and A. Linfert, "Disjecta membra einer
 hellenistischen Grabstele," RA (1974) 33-41,
 figs. 1 and 4.

funerary reliefs of Roman freedmen, especially when
models were available in contemporary Rome. Close
approximations of the man, woman, and child config-
urations on the Roman funerary reliefs may be found
on the Ara Pacis Augustae (13 - 9 B.C.).[55] In the
Imperial procession of the south frieze of the pre-
cinct wall, several children are flanked by their
parents. These groups have been identified by some
as Agrippa, Julia, and their son, Lucius Caesar;
Antonia the Younger, Drusus, and their son, Ger-
manicus; and Antonia the Elder, Lucius Domitius
Ahenobarbus, and their children Domitius and Domitia.[56]
These family groups are aligned in the foreground

55. E. Petersen, Ara Pacis Augustae (Vienna 1902).
 F. Studniczka, "Zur Ara Pacis," AbhLeipzig 27
 (1909) 909ff. G. Moretti, Ara Pacis Augustae
 (Rome 1948). I. S. Ryberg, "The Procession of
 the Ara Pacis," MAAR 19 (1949) 79-101. J. M. C.
 Toynbee, "The Ara Pacis Reconsidered and Histor-
 ical Art in Roman Italy," ProcBrAcad 39 (1953)
 81ff. Simon, Ara Pacis, with other bibliography.

56. These identifications have been disputed. Family
 groups are also represented among the magistrates
 and senators on the north frieze. In the center
 of the relief an infant is flanked by a woman and
 a man. A second man, in the background, holds
 the child's hand. A boy dressed as a camillus
 and a togate girl holding a laurel spray accompany
 other adults in the procession. Simon, Ara Pacis
 pls. 16a and 17a.

of the relief; the composition is complicated, how-
ever, by the interaction of figures in the background
with some members of the family groups. In one case
an unidentified woman stands behind the boy usually
identified as Lucius Caesar and places her hand upon
his head. In the first two Imperial groups cited the
son grasps his father's toga, and Domitius pulls on
the cloak of his uncle Drusus. This unusual, anec-
dotal motif, absent in the Greek stelae and in Roman
free-standing statuary, is reproduced on the funerary
reliefs in the Museo Nazionale Romano (65) and the
Villa Doria Pamphili (66).

The Ara Pacis Augustae was one of the major
commissions of Augustus's principate and echoes of
its reliefs have been found as far away as Carthage.[57]
None of the Roman funerary reliefs with full-length
portrait groups including children is earlier than,
or more than a decade later than, the Ara Pacis.

57. A relief from Carthage, now in the Louvre, repro-
duces the central motif of the Tellus-Italia
panel of the Ara Pacis. Moretti, Ara Pacis Augustae
233, fig. 174. Toynbee, ProcBrAcad 39 (1953) 81,
pl. 14. Simon, Ara Pacis 26, pl. 32.2. G. M. A.
Richter, Three Critical Periods in Greek Sculpture
(Oxford 1951) 62, fig. 141. H. Möbius, "Der Silber-
teller von Aquileja," Festschrift für Friedrich
Matz (Mainz 1962) 83. F. Matz, "Zum Silberteller
aus Aquileia in Wien," MarbWPr (1964) 29, pl. 15.

This can hardly be coincidental and it seems likely
that the Ara Pacis served as a model for some less
ambitious family portraits, notably the three full-
length reliefs discussed here (64, 65, 66).

In any case, Augustus placed a new emphasis on
the Roman family, in part through legislation to en-
courage marriage and child-bearing (lex Iulia de
maritandis ordinibus and lex Papia Poppaea).[58]
After the death of Marcellus in 23 or 22 B.C.,
Augustus chose the young brothers Caius and Lucius
Caesar as his heirs. Denarii were minted in Rome
between ca. 17 and 13 B.C. with the profile por-
traits of Caius and Lucius flanking their mother
Julia.[59] The children were also included in Imperial
statuary groups which were distributed throughout the
Empire,[60] and these groups, certainly abundant in

58. E. Ciccotti, Profilo di Augusto. Con un appendice
 sulle leggi matrimoniali di Augusto (Turin 1938).

59. BMC,Republic II, 95, nos. 4648-4649. E. H. Swift,
 "A Group of Roman Imperial Portraits at Corinth,
 Part III," AJA 25 (1921) 351, fig. 4c.

60. The inscribed statue bases have been collected by
 C. Hanson and F. P. Johnson, "On Certain Portrait
 Inscriptions," AJA 50 (1946) 389-400. On the por-
 trait statues of Caius and Lucius Caesar, see
 Swift, AJA 25 (1921) 337-363. F. Chamoux, "Un por-
 trait de Thasos. Lucius Caesar," MonPiot 44 (1950)
 83-96. F. Chamoux, "Gaius Caesar," BCH 74 (1950)
 250-264. E. Simon, "Das neugefundene Bildnis des
 Gaius Caesar in Mainz," Mainzer Zeitschrift 58
 (1963) 1-18. Zanker, Actium-Typus 47-51.

the capital, may have provided a thematic model for
the inclusion of children in the group portrait
reliefs. It is interesting to note that all of the
bust-length reliefs in which a father and mother
flank a single child are of Augustan date:

 Cat. nos. 67, 68, 69, 70, 82, 85.
In some other Augustan reliefs with bust-length
portraits, the child is placed to the right or left
of his parents:

 Cat. nos. 71, 81, 84, 90, 92.
In the case of the full-length reliefs with family
portraits (64, 65, 66), the Ara Pacis may have
furnished a formal as well as a thematic model.

Chapter Eight: Conclusion

In the foregoing chapters and in the Catalogue
which follows, ninety-two Roman funerary reliefs
with group portraits have, for the first time, been
collected and treated as a distinct body of material.
Formerly, discussions of these monuments had been
confined to catalogue entries in museum publications
and to passing references in studies of Roman por-
traiture and funerary art. Individual examinations
of the materials used, of the coiffures, and of the
portrait and drapery styles, have permitted a fairly
narrow dating of each relief and of the series as a
whole.

The earliest portrait reliefs are datable to
the second quarter of the first century B.C. - the
time of the first portraits of moneyers' ancestors
on Roman coins. Some of these Republican pieces are
among the most ambitious of the entire series, e.g.,
the full-length portraits of a man and his wife from
the Via Statilia (11), the Occius family relief with
its pendant representations of bull's heads, sacri-
ficing figures, and rosettes (38), and the Tenuta

Cappelletti relief with portraits of Lucius Septum-
ius and his family set into three aediculas with
columns, pediments, and acroteria (39). Neverthe-
less, such portrait reliefs enjoyed their greatest
popularity during the last decades of the first
century B.C. and the beginning of the first century
A.D., during the principate of Augustus. Over 85%
of the reliefs may be dated between 30 B.C. and
A.D. 5. After this date, funerary portrait reliefs
are rare in the capital, although inscribed epitaphs
to freedmen continued to be erected in great num-
bers. By the late Augustan period, portrait reliefs
were no longer in vogue among the Roman freedmen.

The reliefs were situated in tomb facades and,
in some cases, perhaps in columbarium niches. Sev-
eral of the reliefs were excavated together with
architectural members and most of the slabs bear
marks which indicate that they were once attached
to buildings. Two bust-length reliefs (9 and 40)
are still in situ in the facades of two tombs lining
the ancient Via Coelimontana (Fig. 40b) and give us
a good idea of how most of the portraits were dis-
played in antiquity. Certain reliefs which are

unframed or are not of rectangular format may have
been set into interior niches in columbaria, as
was a second century A.D. relief still in place
(Fig. 93). In no instance were any of the portrait
reliefs set up as free-standing monuments, as were
Greek funerary stelae.

The ninety-two reliefs are relatively homo-
geneous in format, despite minor variations. The
overwhelming majority of the surviving pieces is
of horizontal orientation and comprises bust-length
portraits of up to six individuals. Nine reliefs
are vertically oriented and portray up to three
full-length figures. In almost all cases the por-
traits are aligned shoulder to shoulder and framed
by unarticulated borders or borders with simple
moldings. In some cases, however, the portraits
are set into tondi (20, 48, 78) or separate aediculas
(39), or divided by columns or pilasters (71, 72, 86).
In a few instances, the portraits are accompanied by
representations of tools or other attributes which
tell us about the profession of the deceased (3, 51,
59).

The individual portraits, whether full- or bust-

length, are all approximately life-size and appear as a series of statues aligned side by side. It has been shown that the portraits are in fact based upon specific statuary types in almost all cases and that many of the most popular free-standing types of the time - togatus with arm sling, pudicitia, etc. - are reproduced in the reliefs.

The portraits were accompanied by inscriptions and many of these survive. The epitaphs state the names of those portrayed, thereby proclaiming the freedmen's new status as Roman citizens with Roman names. The inscriptions sometimes also cite the relationships among the figures (e.g., pater, 71; uxor, 12 and 71), their professions (e.g., medicus, 45; pistor, 12), which individuals are still alive (5, 23, 70, 82, 85), etc. Most important, the epitaphs prove that these funerary reliefs were commissioned exclusively by enfranchised slaves and their freeborn offspring, although portraits of the patron or patroness are sometimes also included. In some cases it is clear that the patron married a former slave (20, 34, 41) or that the patron was himself formerly a slave (44). The inscriptions also clarify

the ties that bind the figures in the group por-
traits; these ties are primarily familial, but
group portraits were also commissioned by con-
liberti, freedmen who had served the same master
and sometimes adopted a common profession. The
depiction of living persons in the reliefs indi-
cates that such bonds were not broken by death.

In recent years much has been written about
Roman art of the late Republic and early Empire from
the sociological point of view, especially regarding
the differing artistic tastes of different types of
Roman patrons. Bianchi Bandinelli and others have
sought to demonstrate the differing stylistic and
iconographical character of monuments commissioned
by the old Roman senatorial families, by the Augustan
court, by plebeian artisans and professionals in the
capital, by provincial magistrates, etc.[1] Because
those who commissioned the funerary portraits col-
lected here are all from the same stratum of Roman
society, one contribution of this study to the history
of Roman art has been to confirm that different

1. See esp. R. Bianchi Bandinelli, Rome, the Center
of Power (New York 1970) 51-105. Bianchi Bandi-
nelli et al., Sculture municipali dell'area sabel-
lica tra l'età di Cesare e quella di Nerone, StMisc
10 (1966).

classes of patrons did indeed have specific artistic
tastes that were not shared by other classes. This
study of funerary portraiture has also led to a
clearer characterization of the art of late Repub-
lican and Augustan freedmen. We have noted above
all the conservative character of their funerary
portraits. Only very rarely are male nudes depicted
(49, 55, 88) and female nudes are never represented.
The reliefs are entirely free of mythological and
allegorical overtones. The portraits are straight-
forward representations of Roman men, women and
children in the everyday dress of Roman citizens −
togas, pallas, tunics, − sometimes accompanied by
tools, pets, etc. The subtleties and pretensions
of aristocratic iconography are notably absent −
approximations to deities, mythological figures,
Hellenistic generals, Greek athletes, etc. The
freedmen are represented as simple people in a
simple manner. The epitaphs are likewise unpretent-
ious; only once (32) is an accompanying inscription
more elaborate than a factual statement of names,
ranks, and circumstances of the commission (e.g.,
ex testamento, 8 and 41; de suo fecit, 55).

We have also noted a conservative tendency with
respect to fashion and artistic style. Although the
coiffures, e.g., follow aristocratic models, specific
hairstyles are often adopted belatedly and retained
much longer. The standard late Republican male
hairstyle - closely cropped hair receding at the
temples - which was introduced during the first half
of the first century B.C. and essentially abandoned
in upper-class circles by the time of Augustus,
still appears regularly at the end of the century in
the funerary reliefs of freedmen. The women are
somewhat more au courant, but Republican female coif-
fures are still depicted in many Augustan reliefs.

In a similar fashion new portrait styles are
slow to appear in the reliefs and Republican tra-
ditions have a long afterlife. Even during the late
Republic, the more emotional, heroic, hellenistische
Stil of Republican portraiture was never used for
portraits of libertini. The more objective sachliche
Stil in which the major interest is the recording of
the deceased's appearance, including such unflattering
features as blemishes, lines, etc., dominates the
early reliefs and never dies out, even after the

introduction of a more classicizing style during
the early years of the Augustan principate. It is
interesting that it is the Roman sachliche Stil that
was favored by the freedmen who were themselves of
Greek origin and who had only recently gained citiz-
enship and taken on Roman names. The portraits
actually appear to be likenesses of Romans rather
than of Greeks, and this phenomenon can only be ex-
plained by the fact that the portraits are types
based on current and earlier aristocratic models
rather than upon the physiognomies of those portrayed.

New fashions in clothing were also adopted
hesitantly. The toga with sinus and umbo, already
present on the processional reliefs of the Ara Pacis
Augustae, 13 - 9 B.C., is rarely seen on even the
latest funerary reliefs, 13 B.C. - A.D. 5. Only
Marcus Gratidius Libanus (34) wears a toga which is
fully comparable to the most up-to-date garments
worn by the men of the Augustan court.

The very format of the group portraits - static,
frontal images set side by side - tended to remain
the same from the beginning of the series through
the time of Augustus. It is only in the latest

examples that anecdotal motifs such as the child
tugging at its parent's garment (65, 66) appear.
Indeed, almost all the reliefs in which strict
frontality is broken by turned heads or a dextrarum
iunctio date to the Augustan period, and portraits
of small children are almost exclusively restricted
to the latest reliefs. The early reliefs bear por-
traits of selected adults - heads of households and
their wives, and occasionally, their adult sons; in
the late reliefs whole families are depicted in
several cases.

The fact that such reliefs were executed solely
for the freedman class in Rome is very important and
we have suggested the motives that might have been
behind these commissions. The libertini were not
entitled to keep armaria with imagines of their
illustrious ancestors nor did they even have legitim-
ate genealogies, as did the noble families. By
Roman law slaves lost their parents when they were
taken into bondage and when freed took the names of
their Roman patrons. It is, in a sense, their new
legitimacy as families that the libertini wished to
commemorate by commissioning group funerary portraits.

The public display of images accompanied by tri-
partite Roman names was a symbol of their newly
won freedom.

The study of these funerary reliefs has thus
provided significant insight into the art and life
of the Roman freedmen of the late Republic and
early Empire, but it has also served to underline
one of the chief features of Roman art as a whole –
the simultaneous coexistence of different artistic
modes. The entire class of monuments we have
studied represents, in itself, a special artistic
mode confined to a single class of Roman patrons, a
mode of funerary commemoration which has no parallel
in the monuments commissioned by the aristocracy or
the freeborn middle class. Nevertheless, as Bianchi
Bandinelli has shown, the Roman portrait was tradit-
ionally an artistic form tied specifically to the
patrician class.[2] The adoption of this mode of com-
memoration by the freedmen underscores once again
the dependence of the funerary reliefs upon upper-

2. Bianchi Bandinelli, Center of Power 71ff. Bianchi
 Bandinelli, "Sulla formazione del ritratto romano"
 (1957), reprinted in Archeologia e cultura (Milan
 1961) 172-188.

class models.

The funerary reliefs themselves also exhibit
stylistic dichotomies; we have cited both old-
fashioned and up-to-date features in the reliefs of
all periods and even within individual reliefs. One
relief in the Ny Carlsberg Glyptothek (88) illus-
trates this phenomenon perhaps better than any
other. Five figures are represented and five dif-
ferent statuary types are used - a togatus without
arm sling, a variant of the Berlin female type, a
heroic man, a palliata with arm sling, and a togatus
with arm sling. Early Augustan Melonenfrisur and
nodus coiffures appear side by side with late Repub-
lican male hairstyles and a youthful male coiffure
best paralleled in portraits of the emperor himself.
Republican sachliche Stil and early Augustan Toten-
maskentyp portraits are juxtaposed with classicizing
mid-Augustan heads, and so on. This heterogeneity
of types and styles is especially significant because
these funerary images are, as we have shown, very
likely the first and only portraits commissioned by
those represented. We can be confident that we are

not dealing with copies of older portraits, a factor
which complicates the study of aristocratic por-
traiture. In these reliefs the old and the new,
realism and classicism, regularly appear together
as elsewhere in Roman art.

Chapter Nine: Catalogue

 The catalogue comprises ninety-two entries,
numbered consecutively, and organized under the
following categories:

Two-Figure Reliefs	34 reliefs, 1 - 34
Type A: Two Men	7 reliefs, 1 - 7
Full-Length Portraits	1 relief, 1
Bust-Length Portraits	6 reliefs, 2 - 7
Type B: Two Women	3 reliefs, 8 - 10
Full-Length Portraits	1 relief, 8
Bust-Length Portraits	2 reliefs, 9 - 10
Type C: One Man, One Woman	24 reliefs, 11 - 34
Full-Length Portraits	3 reliefs, 11 - 13
Bust-Length Portraits	21 reliefs, 14 - 34
Three-Figure Reliefs	37 reliefs, 35 - 71
Type D: Three Men	2 reliefs, 35 - 36
Bust-Length Portraits	2 reliefs, 35 - 36
Type E: Two Men, One Woman	22 reliefs, 37 - 58
Full-Length Portraits	1 relief, 37
Bust-Length Portraits	21 reliefs, 38 - 58
Type F: Two Women, One Man	5 reliefs, 59 - 63
Bust-Length Portraits	5 reliefs, 59 - 63

Type G: One Man, One Woman, One Child	8 reliefs, 64 – 71
Full-Length Portraits	3 reliefs, 64 – 66
Bust-Length Portraits	5 reliefs, 67 – 71
Four-Figure Reliefs	14 reliefs, 72 – 85
Type H: Four Men	1 relief, 72
Bust-Length Portraits	1 relief, 72
Type I: Three Men, One Woman	5 reliefs, 73 – 77
Bust-Length Portraits	5 reliefs, 73 – 77
Type J: Two Men, Two Women	3 reliefs, 78 – 80
Bust-Length Portraits	3 reliefs, 78 – 80
Type K: Two Men, One Woman, One Child	2 reliefs, 81 – 82
Bust-Length Portraits	2 reliefs, 81 – 82
Type L: Two Women, One Man, One Child	2 reliefs, 83 – 84
Bust-Length Portraits	2 reliefs, 83 – 84
Type M: One Man, One Woman, Two Children	1 relief, 85
Bust-Length Portraits	1 relief, 85
Five-Figure Reliefs	5 reliefs, 86 – 90
Type N: Three Men, Two Women	3 reliefs, 86 – 88
Bust-Length Portraits	3 reliefs, 86 – 88
Type O: Three Women, Two Men	1 relief, 89
Bust-Length Portraits	1 relief, 89

Type P: Two Men, Two Women,

One Child 1 relief, __90__

 Bust-Length Portraits 1 relief, __90__

Six-Figure Reliefs 2 reliefs, __91__ - __92__

 Type Q: Four Men, Two Women 1 relief, __91__

 Bust-Length Portraits 1 relief, __91__

 Type R: Three Men, Two Women,

One Child 1 relief, __92__

 Bust-Length Portraits 1 relief, __92__

Within each subdivision of each category, the
entries are listed chronologically. In the case of
contemporary reliefs, the pieces are listed alphabetic-
ally by city, museum, etc. For each entry the following
data are given: present location and inventory number,
material, dimensions, provenance, inscription, date (and
latest features of the relief which justify the date
given), photographic negatives, and bibliography. When
the relevant information is unknown or unavailable, it
is so stated. (Almost all pieces cited as of unknown
provenance were probably found in the city of Rome or
its environs, but the specific findspot is not recorded.)
Catalogue and figure numbers are identical; every piece
is illustrated.

Two-Figure Reliefs

Type A: Two Men

Full-Length Portraits

1. Rome, Museo Nazionale, giardino, inv. 109034.
Material: Marble.
Dimensions: H - 1.48m.; W - 1.20m.
Provenance: Unknown.
Inscription: None.
Date: 30 - 13 B.C. Latest features: Early Augustan
 drapery style; Luna marble.
Negatives: DFK 72.II.4-6; 73.18.9A-12A. DAIR 37.812-
 814.
Bibliography: Vessberg, Studien 197, 269. Bieber,
 "Palliati" 388.

Bust-Length Portraits

2. Leningrad, Hermitage, inv. A888.
Material: Marble.
Dimensions: H - 0.635m.; L - 1.00m.
Provenance: Rome.

Inscription: None.

Date: 30 - 13 B.C. Latest features: Early Augustan
 portrait, drapery, and hairstyles.

Negatives: Museum photographs.

Bibliography: N. Koehne, Sammlung Monferrand (in
 Russian) (Moscow 1853) 24, pl. 3. A. Voščinina,
 "Rimskij rel'ef-portret dvuch brat'ev v Sobranii
 Ermitaža," Festschrift V. D. Blavatskogo (Mos-
 cow 1966) 63-69. A. Voščinina, Musée de l'Ermi-
 tage. Le portrait romain (Leningrad 1974) 136,
 no. 1.

3. London, British Museum, inv. 1954.12-14.1.

Material: Marble.

Dimensions: H - 0.685m.; L - 0.80m.

Provenance: Frascati, Villa Muti.

Inscription: P.LICINIVS.P.L. P.LICINIVS.P.L.
 PHILONIC[VS] DEMETRIVS.PATRONO.
 FECIT

Date: 30 - 13 B.C. Latest features: Early Augustan
 portrait style and early Augustan coiffure of
 man at left.

Negatives: Museum photographs.

Bibliography: C. C. Vermeule, "Some Notes on Ancient

Dies and Coining Methods," NCirc (1953) 450-
451; (1954) 101-103. B. Ashmole, "A Relief of
Two Greek Freedmen," BMQ 21 (1957) 71-72. W. H.
Manning, "A Relief of Two Greek Freedmen," BMQ
29 (1964-65) 25-28.

4. Rome, Palazzo Mattei, atrio.

Material: Marble.

Dimensions: H - 0.53m.; L - 0.85m.

Provenance: Unknown.

Inscription: None.

Date: 30 - 13 B.C. Latest features: Early Augustan
 portrait, drapery, and hairstyles.

Negative: GabFotNaz E57167.

Bibliography: Matz-Duhn III, 163, no. 3827. T. Bot-
 ticelli, "Rilievi funerari con busti-ritratto,"
 StMisc 20 (1972) 50, no. 11.

5. Rome, Villa Doria Pamphili, Columbarium minor.

Material: Travertine.

Dimensions: H - 0.58m.; L - 0.92m.

Provenance: Unknown.

Inscription:

 ●.L.VISELLIVS.L.L.V●.L.VISELLIVS.L.L.L.PAMPHI.
 CIL VI, 29029.

Date: 30 - 13 B.C. Latest features: Early Augustan
 portrait, drapery, and hairstyles.
Negatives: DFK 73.8.15A; 73.11.23-25. DAIR 37.988.
Bibliography: Matz-Duhn III, 165, no. 3846. Vess-
 berg, Studien 197, 270.

6. Rome, Via di Porta S. Sebastiano no. 9, Horti
 degli Scipioni.
Material: Marble.
Dimensions: Unavailable.
Provenance: Unknown.
Inscription: None.
Date: 30 - 13 B.C. Latest features: Early Augustan
 portrait, drapery, and hairstyles.
Negatives: DFK 73.13.22-23. DAIR 37.947.
Bibliography: Unpublished.

7. Rome, Via Appia.
Material: Marble.
Dimensions: H - 0.575m.; L - 1.56m.
Provenance: Rome, Via Appia.
Inscription: None.
Date: 13 B.C. - A.D. 5. Latest feature: Mid-
 Augustan drapery style.

Negative: DFK 72.I.6.

Bibliography: Unpublished.

Type B: Two Women

Full-Length Portraits

<u>8</u>. Rome, Museo Nazionale, giardino, inv. 121324.

Material: Marble.

Dimensions: H - 1.78m.; W - 1.20m.

Provenance: Rome, Via Tiburtina, no. 410 (km. 6).

Inscriptions:]ALLIAE.M.F.ALFENA[TI]/FILIAE

 EX.[T]ESTAMENTO/ARBIT[RA]TV.EARV[M].QVAE.FVNERIS.

 ARBITRAE.FVERVN[T]/L.ALFENATIS.FELICIS.LIB.

Date: 13 B.C. - A.D. 5. Latest features: Mid-

 Augustan drapery style; mid-Augustan coiffure

 of woman at right.

Negatives: DFK 72.II.10; 73.18.3A-6A.

Bibliography: C. Caprino, <u>NSc</u> (1944-45) 73-77.

 Schmidt, <u>Frauenstatuen</u> 6-7.

Bust-Length Portraits

<u>9</u>. Rome, Tomb at corner of Via Statilia and Via di

S. Croce in Gerusalemme.

Material: Travertine.

Dimensions: Unavailable.

Provenance: In situ.

Inscription: CAE[]A PLOTIA

APOLLONIA

ĊIL I, 2527c.

Date: 75 - 50 B.C. Latest features: Late Repub-
lican portrait, drapery, and hairstyles.

Negatives: DFK 72.19.14-16. DAIR 30.583.

Bibliography: F. Fornari, NSc (1917) 174-179, 274.
L. Cantarelli, BullComm (1917) 237-242. E.
Gatti, NSc (1919) 38. A. M. Colini, "I sepolcri
e gli acquedotti repubblicani di via Statilia,"
Capitolium 18 (1943) 268-279. Nash, Pictorial
Dictionary2 II, 349.

10. Krakow, Muzeum Narodowe annex Czartoryski,
inv. DMNK Cz. 2034.

Material: Marble.

Dimensions: H - 0.61m.; L - 0.90m.

Provenance: Rome.

Inscription: ĊALPVRNIA.SALVIA CALPVRNIA.HILARA
[SP]VRIVS.NICEPO[R.HIC.ES]T. SIBI.ET.PATRO[NIS.]
SITVS POSVIT.EMAGENES

Date: 13 B.C. – A.D. 5. Latest feature: Mid-
 Augustan coiffure of woman at right.

Negative: Museum photograph.

Bibliography: A. Sadurska, "Deux inscriptions latines
 inédites," Klio 52 (1970) 383ff. A. Sadurska,
 Les portraits romains dans les collections
 polonaises (Corpus Signorum Imperii Romani,
 Pologne, I) (Warsaw 1972) 15-16, no. 4.

Type C: One Man, One Woman

Full-Length Portraits

11. Rome, Museo del Palazzo dei Conservatori,
 Braccio Nuovo, inv. 2142.

Material: Palombino.

Dimensions: H – 1.81m.; W – 0.95m.

Provenance: Rome, Via Statilia.

Inscription: None.

Date: 75 – 50 B.C. Latest features: Late Repub-
 lican portrait, drapery, and hairstyles.

Negatives: DAIR 29.168-172.

Bibliography: A. M. Colini, "Bassorilievo funerario
 di via Statilia," BullComm 54 (1926) 177-182.

Goethert, <u>Republik</u> 50. Horn, <u>Gewandstatuen</u> 81.
Poulsen, <u>Probleme</u> 6, 24, no. 8. Mustilli,
<u>Museo</u> <u>Mussolini</u> 102, no. 9. Vessberg, <u>Studien</u>
186ff., 211-212, 249-250, 265. Schweitzer,
<u>Bildniskunst</u> 85, 87, 89. H. von Heintze, <u>Helbig</u>[4]
II, 427, no. 1631. Gazda, "Etruscan Influence"
867ff.

<u>12</u>. Rome, Museo del Palazzo dei Conservatori, Museo
 Nuovo.
Material: Marble.
Dimensions: H - 2.06m.; W - 1.18m.
Provenance: Rome, Tomb of Eurysaces, outside Porta
 Maggiore.
Inscription: FVIT.ATISTIA.VXOR.MIHEI/FEMINA.OPITVMA.
 VEIXSIT/QVOIVS.CORPORIS.RELIQVIAE/QVOD.SVPERANT.
 SVNT.IN/HOC.PANARIO
 <u>CIL</u> I, 1206. Degrassi, <u>ILLRP</u> no. 805a.
Date: 13 B.C. - A.D. 5. Latest features: Mid-
 Augustan drapery style; mid-Augustan coiffure
 of woman.
Negatives: DAIR 32.1402; 33.749; 34.111-113.
 FotUn 1137.
Bibliography: L. Grifi, <u>Brevi</u> <u>cenni</u> <u>di</u> <u>un</u> <u>monumento</u>

scoperto a Porta Maggiore (Rome 1838). G.
Melchiorri, Intorno al monumento sepolcrale di
Marco Vergilio Eurisace (Rome 1838). L. Canina,
AnnInst 12 (1838) 202-230. E. Caetani Lovatelli,
"Il sepolcro di Eurisace fuori della Porta
Maggiore a Roma," Passeggiate nella Roma antica
(Rome 1909) 153-176. H. Kähler, Rom und seine
Welt (Munich 1960) 161-165. Nash, Pictorial
Dictionary[2] II, 329-332. Schmidt, Frauenstatuen
9-10. P. Ciancio Rossetto, Il sepolcro del
fornaio Marco Virgilio Eurisace a Porta Mag-
giore (I monumenti romani 5) (Rome 1973).

13. Rome, Museo Nazionale, chiostro.
Material: Marble.
Dimensions: H - 1.54m.; W - 0.56m.
Provenance: Unknown.
Inscription: None.
Date: 13 B.C. - A.D. 5. Latest features: Mid-
 Augustan toga form and drapery style.
Negatives: DFK 73.31.22A-23A.
Bibliography: Unpublished.

Bust-Length Portraits

14. Rome, Museo del Palazzo dei Conservatori,
 Museo Nuovo, inv. 2279.

Material: Travertine.

Dimensions: H - 0.95m.; L - 1.10m.

Provenance: Rome, Via del Mortaro.

Inscription: BLAESIVS.C.L.BLAESIA.A.L.

Date: 75 - 50 B.C. Latest features: Late Repub-
 lican portrait, drapery, and hairstyles.

Negative: DAIR 36.1245.

Bibliography: BullComm 13 (1885) 180, no. 2. Mus-
 tilli, Museo Mussolini 176-177, no. 60. Vess-
 berg, Studien 183-184, 265. Gazda, "Etruscan
 Influence" 859ff.

15. Rome, Museo del Palazzo dei Conservatori, giardino,
 inv. 2282.

Material: Travertine.

Dimensions: H - 0.60m.; L - 1.03m.

Provenance: Unknown.

Inscription: None.

Date: 75 - 50 B.C. Latest features: Late Repub-
 lican portrait, drapery, and hairstyles.

Bibliography: H. P. L'Orange, "Zum frührömischen
 Frauenporträt," RömMitt 44 (1929) 173ff. Zadoks,
 Ancestral Portraiture 70. Mustilli, Museo Musso-
 lini 176, no. 59. Vessberg, Studien 184-185,
 265. Gazda, "Etruscan Influence" 862-863.

16. Rome, Museo Nazionale, giardino, inv. 125813.
Material: Travertine.
Dimensions: H - 0.975m.; L - 1.22m.
Provenance: Unknown.
Inscription: AELIVS.Q.L.PRAECO.ET.DESIGNATO[
 INFRI.PXIIX[]LICINIA.CN.L.ATHENA
Date: 75 - 50 B.C. Latest features: Late Repub-
 lican portrait, drapery, and hairstyles.
Negatives: DFK 72.22.25-29.
Bibliography: Vessberg, Studien 186-187. Bieber,
 "Palliati" 416.

17. Rome, Villa Wolkonsky.
Material: Travertine.
Dimensions: H - 0.40m.; L - 0.60m.
Provenance: Rome, Tor Sanguigna.
Inscription: P.SALLVSTIVS.P.Q.L. SALLVSTIA.P.Q.L.
 SALVIVS DIONISIA
 CIL VI, 25787.

Date: Ca. 40 B.C. Latest feature: Hairstyle of
 woman.

Negative: DFK 72.33.25.

Bibliography: Matz-Duhn III, 166, no. 3853.
 Altmann, Grabaltäre 199.

18. Berlin, Altes Museum, inv. 840.

Material: Marble.

Dimensions: H - 0.64m.; L - 0.99m.

Provenance: Rome, Via Appia.

Inscription: P.AIEDIVS.P.L. AIEDIA.P.L.

 AMPHIO FAVSTA.MELIOR

 CIL VI, 11284-5.

Date: 30 - 13 B.C. Latest features: Early Augustan
 portrait and drapery styles; early Augustan
 coiffure of woman.

Negative: DAIR 52.128.

Bibliography: Zadoks, Ancestral Portraiture 76.
 West, Porträt-Plastik I, 53, 99. G. Rodenwaldt,
 Kunst um Augustus (Berlin 1943) 30-31. C. Blümel,
 Römische Skulpturen (Berlin 1946) 13. Vessberg,
 Studien 203-204, 272.

<u>19</u>. Florence, Galleria degli Uffizi, inv. 78.

Material: Marble.

Dimensions: H' - 0.61m; L - 0.86m.

Provenance: Unknown.

Inscription: None.

Date: 30 - 13 B.C. Latest features: Early Augustan
 portrait and hairstyles.

Negatives: DFK 72.21.16-21. Museum negative 10756.

Bibliography: G. Mansuelli, <u>Gallerie</u> <u>degli</u> <u>Uffizi</u>.
 <u>Le</u> <u>sculture</u> (Rome 1958) I, 201, no. 198.

<u>20</u>. London, British Museum, inv. 2275.

Material: Marble.

Dimensions: H - 0.64m.; L - 0.97m.

Provenance: Rome, Trastevere.

Inscription:

 L.ANTISTIVS.CN.F.HOR.SAECVLO ANTISTIA

 SALIVS.ALBANVS.IDEM.MAG'.SALIORVM L.L.PLVTIA

 RVFVS.L.ANTHVS.L.IMAGINES.DE.SVO.FECERVNT.

 PATRONO.ET'.PATRONAE.PROMERITIS/EORVM

 <u>CIL</u> VI,2170.

Date: 30 - 13 B.C. Latest feature: Early Augustan
 coiffure of woman.

Negatives: Museum photographs.

Bibliography: A. H. Smith, <u>Br</u>. <u>Mus</u>. <u>Cat</u>. <u>Sculp</u>.
 III (1904) 289-290, no. 2275. E. Strong, "A
 Note on Two Roman Sepulchral Reliefs," <u>JRS</u> 4
 (1914) 147-152, 156. Vessberg, <u>Studien</u> 204-205,
 272.

<u>21</u>. Lucerne, Art Market, 1961.
Material: Marble.
Dimensions: H - 0.58m.; L - 1.03m.
Provenance: Unknown.
Inscription:]ELI[]C.F.AEM.FABI[
Date: 30 - 13 B.C. Latest features: Early Augustan
 portrait and drapery styles; early Augustan
 coiffure of man.
Negative: Ars Antiqua, Lucerne photograph.
Bibliography: E. Berger, <u>Ars</u> <u>Antiqua</u>, <u>Auktion</u> 3
 (Lucerne, April 29, 1961) 18, no. 30.

<u>22</u>. New York, Metropolitan Museum of Art, inv.
 09.221.2.
Material: Marble.
Dimensions: H - 0.51m.; L - 0.72m.
Provenance: Rome.
Inscription: Modern.

Date: 13 B.C. - A.D. 5. Latest feature: Mid-
 Augustan coiffure of woman.
Negative: Museum photograph.
Bibliography: E. Robinson, MMABull 5 (1910) 237.
 G. M. A. Richter, Roman Portraits (New York
 1948) no. 6.

23. Rome, Museo Nazionale, giardino.
Material: Marble.
Dimensions: H - 0.65m.; L - 0.705m.
Provenance: Rome, Via Portuense.
Inscription: STAGLA.M.L/AMMIA/P.VATERI.C.L./
 PTOLEMAE/VIVIT
Date: 30 - 13 B.C. Latest features: Early Augustan
 portrait and drapery styles.
Negatives: DFK 72.22.31-33; 73.18.29A-31A.
Bibliography: D. Vaglieri, NSc (1908) 327.

24. Rome, Museo Nazionale, chiostro, ala III,
 inv. 841.
Material: Marble.
Dimensions: H - 0.65m.; L - 0.72m.
Inscription: CN.POMPEIO.CN.L.PROTHESILAVO/NVMONIA.
 L.L.MEGISTHE.SIBI.ET.VIRO.SVO

CIL VI, 24500.

Date: 13 B.C. – A.D. 5. Latest feature: Mid-
 Augustan coiffure of woman.

Negatives: DFK 72.24.8A. GabFotNaz F2507.

Bibliography: Vessberg, Studien 199, 270.

 Schweitzer, Bildniskunst 114.

25. Rome, Museo Nazionale, chiostro, ala III, inv.
 80714.

Material: Marble.

Dimensions: H – 0.535m.; L – 0.865m.

Provenance: Unknown.

Inscription: A.PINARIVS.A.L.ANTEROS.OPPIA.Ɔ.L.
 MYRSINE

 CIL VI, 24190.

Date: 13 B.C. – A.D. 5. Latest feature: Mid-
 Augustan coiffure of woman.

Negatives: DFK 72.24.10A–13A. DAIR 8100.

Bibliography: Matz–Duhn III, 164, no. 3840. Vess-
 berg, Studien 199, 270. Schweitzer, Bildnis-
 kunst 133.

26. Rome, Palazzo Mattei, cortile.

Material: Marble.

Dimensions: H - 0.60m.; L - 0.85m.

Provenance: Unknown.

Inscription: L.TAMPIO.L.L.TAMPIA.L.L.

>CIL VI, 27101.

Date: 30 - 13 B.C. Latest features: Early Augustan
portrait, drapery, and hairstyles.

Negatives: DFK 72.20.21. DAIR 29.407.

Bibliography: Matz-Duhn III, 163, no. 3834. T. Bot-
ticelli, "Rilievi funerari con busti-ritratto,"
StMisc 20 (1972) 46-47, no. 2.

27. Rome, Palazzo Mattei, cortile.

Material: Marble.

Dimensions: H - 0.45m.; L - 0.80m.

Provenance: Unknown.

Inscription: None.

Date: 30 - 13 B.C. Latest features: Early Augustan
portrait, drapery, and hairstyles.

Negatives: DFK 72.20.25. DAIR 29.411.

Bibliography: Matz-Duhn III, 163, no. 3829. T. Bot-
ticelli, "Rilievi funerari con busti-ritratto,"
StMisc 20 (1972) 49, no. 7.

28. Rome, Villa Medici.

Material: Marble.

Dimensions: H - 0.83m.; L - 0.85m.

Provenance: Unknown.

Inscription: Illegible.

Date: 30 - 13 B.C. Latest features: Early Augustan
 drapery style; Luna marble.

Negative: École Française de Rome photograph.

Bibliography: Matz-Duhn III, 165, no. 3845. M.
 Cagiano de Azevedo, Le antichità di Villa
 Medici (Rome 1951) 92-93, no. 163.

29. Rome, Via Appia.

Material: Marble.

Dimensions: H - 0.54m.; L - 1.23m.

Provenance: Rome, Via Appia.

Inscription: None.

Date: 30 - 13 B.C. Latest features: Early Augustan
 drapery style; Luna marble.

Negative: DFK 72.I.4.

Bibliography: Unpublished.

30. Rome, Via Cassia, near "Tomba di Nerone."

Material: Marble.

Dimensions: Unavailable.

Provenance: Rome, Via Cassia.

Inscription: None.

Date: 30 - 13 B.C. Latest features: Early Augustan
 portrait and drapery styles; early Augustan
 coiffure of man.

Negative: DAIR 38.1303.

Bibliography: Unpublished.

31. Rome, Via Satricana, Casale di S. Palomba.

Material: Marble.

Dimensions: H - 0.85m.; L - 1.35m.

Provenance: Rome, Via Satricana.

Inscription: None.

Date: 30 - 13 B.C. Latest features: Early Augustan
 drapery style; Luna marble.

Negative: Soprintendenza alle Antichità, Rome,
 photograph.

Bibliography: G. M. De Rossi, Forma Italiae I,9
 (Rome 1970) 102, fig. 193.

32. London, ex Lansdowne collection.

Material: Marble.

Dimensions: H - 0.41m.; L - 0.51m.

Provenance: Rome, a vineyard near the Via Appia.

Inscription: HANC.TALEM/CONIVGEM.QVAM/PRAEFESTINAS/
FATVS.PEREMIT/QVAM.FORS.TRIBVIT/FORTVNA.ADEMIT/
CASVS.DOMINATVR/QVA.PROPTER.HOS/PES.SPERA.PAV/
CA.ADEPTE.VIVE/QVIETVS.TEQVE.H/MINEM.COGNOSCAS/
OMNIA.DESPICIES/DEVM.MANIVM/SACRVM.PARCE/ITA.
TE.DEIS.SVPERIS/ATQVE.INFERIS/PARCANT/VALE.

Date: 13 B.C. - A. D. 5. Latest feature: Mid-
Augustan portrait style.

Negative: EA 3053.

Bibliography: Michaelis, Ancient Marbles 442, no.
23. Lansdowne Catalogue 52, 106, no. 76. C. C.
Vermeule, "Notes on a New Edition of Michaelis:
Ancient Marbles in Great Britain," AJA 59 (1955)
139.

33. Rome, Museo Nazionale, giardino.

Material: Marble.

Dimensions: H - 0.62m.; L - 0.81m.

Provenance: Unknown.

Inscription:]TVMVS.CVST.SEDE[

Date: 13 B.C. - A.D. 5. Latest features: Mid-
Augustan drapery style; mid-Augustan coiffure
of woman.

Negative: DFK 72.22.34.

Bibliography: Unpublished.

<u>34</u>. Rome, Musei Vaticani, Sala dei Busti, inv. 592.

Material: Marble.

Dimensions: H - 0.68m.; L - 0.90m.

Provenance: Unknown.

Inscription (lost):

> GRATIDIA.M.L.CHRITE M.GRATIDIVS.LIBANVS
>
> <u>CIL</u> VI, 35397.

Date: 13 B.C. - A.D. 5. Latest features: Mid-
Augustan toga form and drapery style.

Negatives: DFK 72.26.29-30; 73.20.4; 73.21.6-7.

Alinari 6602.

Bibliography: Amelung, <u>Skulpturen</u> II, 572ff., no.
388. C. Huelsen, "Die Grabgruppe eines römischen
Ehepaares im Vatikan," <u>RhM</u> N.F. 68 (1913) 16-21,
reprinted in H. von Heintze (ed.), <u>Römische
Porträts</u> (Darmstadt 1974) 102-108. H. von Heintze,
<u>Helbig</u>[4] I, 143-144, no. 199, with bibliography.

Three-Figure Reliefs

Type D: Three Men

Bust-Length Portraits

35. Rome, Museo Capitolino.

Material: Marble.

Dimensions: H - 0.60m.; L - 1.85m.

Provenance: Unknown.

Inscription: VIV VIV

Date: 30 - 13 B.C. Latest features: Early Augustan
 drapery style; early Augustan portrait style and
 coiffure of man at left.

Negative: Museum photograph.

Bibliography: Stuart Jones, Capitoline 64-65, no. 5.

36. Rome, Museo del Palazzo dei Conservatori, Museo
 Nuovo, inv. 2898.

Material: Marble.

Dimensions: H - 0.59m.; L - 0.96m.

Provenance: Rome, Via Appia 103, Villa Casale.

Inscription: APEMANTO.THALERO.FRATRIB.VLIADI[
 CIL VI, 12098.

Date: 30 - 13 B.C. Latest features: Early Augustan
 portrait and drapery styles; early Augustan
 coiffure of man in center.

Negative: DFK 72.VI.20.

Bibliography: Matz-Duhn III, 160, no. 3812.

Type E: Two Men, One Woman

Full-Length Portraits

37. Rome, Galleria Borghese.
Material: Marble.
Dimensions: Unavailable.
Provenance: Unknown.
Inscription: None.
Date: 30 - 13 B.C. Latest feature: Early Augustan
 drapery style.
Negative: Alinari 27481.
Bibliography: R. Herbig, "Zwei Strömungen späthel-
 lenistischer Malerei," Die Antike 7 (1931) 153-
 154. Wilson, Clothing 152. P. della Pergola,
 The Borghese Gallery in Rome[4] (Itinerari dei
 Musei, Gallerie e Monumenti d'Italia 43) (Rome
 1955) 18, no. 188. Bieber, "Palliati" 385. P.
 della Pergola, Villa Borghese (Rome 1962) 81,
 no. 107. Schmidt, Frauenstatuen 21.

Bust-Length Portraits

38. Rome, Museo Nazionale, giardino, inv. 125583.

Material: Travertine.

Dimensions: H - 0.745m.; L - 2.405m.

Provenance: Fara Sabina (Rieti).

Inscription:

L.OCCIVS.L.F. L.OCCIVS.L.L. OCCIA.L.L.AGATHEA

PAL. ARISTO]ET.SVEIS.FECIT

Date: 75 - 50 B.C. Latest features: Late Repub-
 lican portrait, drapery, and hairstyles.

Negatives: DFK 72.II.11-14; 73.18.20A-28A.

Bibliography: B. M. Felletti-Maj, NSc (1950) 61-63.

39. Rome, Museo Nazionale, chiostro, ala III, Inv. 125655.

Material: Travertine.

Dimensions: H - 0.63m.; L - 1.55m.

Provenance: Rome, Via Praenestina, Tenuta Cappelletti.

Inscription: MAG.CAPITOLINVS.QVINQ.L.SEPTVMIVS.L.F.
 ARN.EQVES.HIRTVLEIA.L.F.

 Degrassi, ILLRP no. 697. Degrassi, Imagines no. 260.

Date: 75 - 50 B.C. Latest features: Late Repub-
 lican portrait, drapery, and hairstyles.

Negatives: DFK 73.7.4-11. DAIR 38.12.

Bibliography: P. E. Arias, NSc (1939) 83-85. C. Pietran-
 geli, BullComm (1946-48) 239. C. Nicolet, L'ordre
 équestre à l'époque républicaine, BEFAR 207 (Paris
 1966) I, 244-245.

40. Rome, Tomb at corner of Via Statilia and Via di
 S. Croce in Gerusalemme.

Material: Travertine.

Dimensions: Unavailable.

Provenance: In situ.

Inscription:

CLODIAE.N.L.STACTE.N.CLODIVS.N.L.	C.ANNAE.C.F.
L.MARCIVS.L.F.PAL.ARMITRVPHO	PAL.
M.ANNIVS.M.L.HILARVS	QVINCTIONIS
HOC.M[O]NVM[ENT]VM.HE[R]EDES	
]VR	

CIL I, 2527b. Degrassi, ILLRP no. 952.

Date: 75 - 50 B.C. Latest features: Late Repub-
 lican portrait, drapery, and hairstyles.

Negatives: DAIR 30.584. FotUn 3269.

Bibliography: F. Fornari, NSc (1917) 174-179, 274. L.
 Cantarelli, BullComm (1917) 237-242. E. Gatti, NSc
 (1919) 38. A. M. Colini, "I sepolcri e gli acque-
 dotti repubblicani di via Statilia," Capitolium 18
 (1943) 268-279. Nash, Pictorial Dictionary2 II, 349.
 Toynbee, Death and Burial 117-118, figs. 29-30.

41. Boston, Museum of Fine Arts, inv. 37.100.

Material: Marble.

Dimensions: H - 0.65m.; L - 2.045m.

Provenance: Unknown.

Inscription: EX.TESTAM[ENTO] ARBIT[RATV]

 P.GESSI.P.L. GESSIA

 PRIMI FAVSTA

GESSIA.P.L.FAVSTA.P.GESSIVS.P.F.ROM.P.GESSIVS.P.L.
PRIMVS

Degrassi, ILLRP no. 503. Degrassi, Imagines no. 219.

Date: 30 - 13 B.C. Latest features: Early Augustan portrait, drapery, and hairstyles.

Negatives: Museum photographs.

Bibliography: O. Vessberg, "Gessiernas gravrelief," Konsthistorisk Tidskrift (1937) 19ff. Poulsen, Probleme 23-24. L. Caskey, "A Roman Tomb Relief," BullMusFineArts 35 (1937) 20ff. Vessberg, Studien 190-191, 268-269. M. Rostovtzeff, The Social and Economic History of the Hellenistic World II (Oxford 1941) 992, pl. 106. Hiesinger, "Portraiture" 812-813. Winkes, "Physiognomia" 912-913.

42. Geneva, Musée d'Art et d'Histoire, inv. 1315.

Material: Travertine.

Dimensions: H - 0.65m.; L - unavailable.

Provenance: Rome, Via Appia, so-called Tomb of Sallust.

Inscription: None.

Date: 30 - 13 B.C. Latest features: Early Augustan

portrait, drapery, and hairstyles.

Negative: Museum photograph.

Bibliography: W. Fol, Catalogue du Musée Fol (Geneva
1874) 285, no. 1315. W. Deonna, RA (1919) 114.
W. Deonna, Catalogue des sculptures antiques
(Geneva 1924) 128, no. 161.

43. Narni, Municipio.

Material: Marble.

Dimensions: Unavailable.

Provenance: Unknown.

Inscription: C.LATVEDIVS.C.F.C.LATVEDIVS.C.F.PETTER.
The relief is stylistically akin to the Roman examples.
The nomen, Latuedius, may, however, be Umbrian.

Date: 30 - 13 B.C. Latest features: Early Augustan
portrait, drapery, and hairstyles.

Negative: DAIR 69.2780.

Bibliography: Unpublished.

44. Palermo, Museo Nazionale, inv. 761.

Material: Marble.

Dimensions: H - 0.76m.; L - 1.43m.

Provenance: Unknown.

Inscription:

CN.GEMINIVS.CN.L.	CN.GEMINIVS.CN.L.	GEMINIA.CN.L.
APOLLONIVS	AESCHINVS.PATRONVS	PRIMA

CIL VI, 18991.

Date: 30 - 13 B.C. Latest features: Early Augustan
portrait and drapery styles; early Augustan
coiffure of woman.

Negative: Soprintendenza alle Antichità, Palermo,
photograph.

Bibliography: N. Bonacasa, _Ritratti greci e romani
della Sicilia_ (Palermo 1964) 21, no. 21.

45. Paris, Musée du Louvre.

Material: Marble.

Dimensions: Unavailable.

Provenance: Frascati.

Inscription:

A.CLODIVS.TERTIVS A.CLODIVS.METRODORVS CLODIA.A.L.HILARA
 MEDICVS MEDICVS

CIL VI, 9574.

Date: 30 - 13 B.C. Latest features: Early Augustan
drapery style; early Augustan coiffure of woman.

Negative: Museum photograph.

Bibliography: Zadoks, _Ancestral Portraiture_ 57, 75.
Vessberg, _Studien_ 201, 271.

46. Rome, Collection Morelli.

Material: Marble.

Provenance: Rome, Via Flaminia 71.

Inscription: THILA.L. P.ANNIVS.P.L.XENO. STRA[

Date: 30 - 13 B.C. Latest features: Early Augustan
 portrait and drapery styles.

Negatives: DAIR 33.1572-1575.

Bibliography: Matz-Duhn III, 160, no. 3810.

47. Rome, Museo Capitolino, inv. 1908.

Material: Marble.

Dimensions: H⸱ - 0.58m.; L - 0.995m.

Provenance: Unknown.

Inscription: C.RVPILIVS.C.L.A[

Date: 30 - 13 B.C. Latest features: Early Augustan
 portrait and drapery styles.

Negatives: DFK 72.21.3-9. DAIR 32.237-238.

Bibliography: Stuart Jones, Capitoline 122, no. 48A.
 Goethert, Republik 23. Vessberg, Studien 187-
 188, 265.

48. Rome, Museo del Palazzo dei Conservatori, Museo
 Nuovo, inv. 2230.

Material: Marble.

Dimensions: H⸱ - 0.85m.; L - 1.90m.

Provenance: Rome, Via Flaminia.

Inscription:

 [B]ENNIVS.L.Ↄ.L. BENNIA.L.L. L.BENNI[VS]

 BASSVS MVSA ANIC[

 CIL VI, 13552.

Date: 30 - 13 B.C. Latest features: Early Augustan portrait and drapery styles.

Negative: DAIR 28.70.

Bibliography: G. Fiorelli, NSc (1878) 35. BullComm 6 (1878) 285, no. 7. C. L. Visconti and V. Vespignani, BullComm 8 (1880) 182, no. 6. Mustilli, Museo Mussolini 180, no. 77. Vessberg, Studien 204-205, 272. H. von Heintze, Helbig[4] II, 514-515, no. 1738.

49. Rome, Museo del Palazzo dei Conservatori, Museo Nuovo, inv. 2897.

Material: Marble.

Dimensions: Unavailable.

Provenance: Unknown.

Inscription: None.

Date: 30 - 13 B.C. Latest features: Early Augustan portrait and drapery styles; early Augustan coiffure of woman.

Negative: DFK 72.VI.16.

Bibliography: Unpublished.

50. Rome, Museo Nazionale, chiostro, ala III, inv.
 196630.

Material: Marble.

Dimensions: H - 0.605m.; L - 1.50m.

Provenance: Rome, Via Appia.

Inscription: None.

Date: 30 - 13 B.C. Latest features: Early Augustan
 portrait and drapery styles.

Negatives: DFK 72.II.16-19.

Bibliography: Unpublished.

51. Rome, Musei Vaticani, Galleria Lapidaria no. 31c.

Material: Marble.

Dimensions: H - 0.47m.; L - 1.02m.

Provenance: Unknown.

Inscription: A.ANTESTIVS.A.L. ANTESTIA A.ANTESTIVS
 ANTIOCHVS RVFA A.L.NICIA
 To left, A.ANTESTIVS.A.A.L./SALVIVS
 CIL VI, 11896.

Date: 30 - 13 B.C. Latest feature: Early Augustan
 portrait style.

Negatives: DAIR 997; 43.455-457.

Bibliography: Amelung, Skulpturen I, 193, no. 31c.
 Zadoks, Ancestral Portraiture 57, 75. Vessberg,
 Studien 203, 271.

<u>52</u>. Rome, Palazzo Mattei, cortile.

Material: Marble.

Dimensions: H - 0.60m.; L - 1.10m.

Provenance: Unknown.

Inscription: None.

Date: 30 - 13 B.C. Latest features: Early Augustan
 portrait and drapery styles.

Negatives: DFK 72.20.23. DAIR 29.408.

Bibliography: Matz-Duhn III, 163, no. 3831. T. Bot-
 ticelli, "Rilievi funerari con busti-ritratto,"
 <u>StMisc</u> 20 (1972) 47-48, no. 4.

<u>53</u>. Rome, Tor' Sapienza.

Material: Marble.

Dimensions: Unavailable.

Provenance: Unknown.

Inscription: None.

Date: 30 - 13 B.C. Latest feature: Early Augustan
 coiffure of man at left.

Negative: DFK 72.20.34.

Bibliography: Unpublished.

<u>54</u>. Rome, Via Appia.

Material: Marble.

Dimensions: **H - 0.56m.; L - 2.10m.**

Provenance: Rome, Via Appia.

Inscription: None.

Date: 30 - 13 B.C. Latest features: Early Augustan
 drapery style; early Augustan portrait style and
 coiffure of young man at right.

Negatives: DFK 72.I.16-18.

Bibliography: Unpublished.

55. Mentana, Piazza Garibaldi.

Material: Marble.

Dimensions: Unavailable.

Provenance: Unknown.

Inscription:

 L.APPVLEIVS.L.L. L.APPVLEIVS.L.F. APPVLEIA.L.L.

 ASCLEPIADES TR.MIL. SOPHANVBA

 DE.SVO.FECIT

 CIL XIV,3948.

Date: 13 B.C. - A.D. 5. Latest features: Mid-
 Augustan coiffures of young man and woman.

Negatives: DFK 72.20.26-28.

Bibliography: D. and F. Kleiner, AA 90 (1975) 258-260.

56. Ostia, Magazzini, inv. 625.

Material: Marble.

Dimensions: H - 0.655m.; L - 1.30m.

Provenance: Ostia.

Inscription: None.

Date: 13 B.C. - A.D. 5. Latest features: Mid-
Augustan drapery style; mid-Augustan coiffure
of woman.

Negative: GabFotNaz E85385.

Bibliography: Calza, Ritratti 34, no. 36.

57. Rome, Palazzo Colonna.

Material: Marble.

Dimensions: H - 0.64m.; L - 1.385m.

Provenance: Unknown.

Inscription: MANLIA.T.L. T.MANLIVS.T.L.

 RVFA STEPHANVS.PA[

CIL VI, 21961.

Date: 13 B.C. - A.D. 5. Latest feature: Mid-
Augustan coiffure of woman.

Negative: DAIR 33.1713.

Bibliography: Matz-Duhn III, 161, no. 3816. Vess-
berg, Studien 198ff., 269. Schweitzer, Bild-
niskunst.132.

58. Rome, Palazzo Colonna.

Material: Marble.

Dimensions: Unavailable.

Provenance: Unknown.

Inscription: None.

Date: 13 B.C. - A.D. 5. Latest features: Mid-
Augustan drapery style; mid-Augustan coiffure
of woman.

Negative: DAIR 33.1714.

Bibliography: Unpublished.

Type F: Two Women, One Man

Bust-Length Portraits

59. London, British Museum.

Material: Marble.

Dimensions: H - 0.61m.; L - 1.63m.

Provenance: Rome, near Porta Capena.

Inscription: L.AMPVDIVS.L.ET.Ɔ.L.PHILOMVSVS

CIL VI, 595; 34044.

Date: 13 B.C. - A.D. 5. Latest feature: Mid-
Augustan coiffure of young woman.

Negatives: Museum photographs.

Bibliography: A. H. Smith, "L. Ampudius Philomusus,"
JRS 8 (1918) 179-182. Goethert, Republik 45.
Vessberg, Studien 203, 247, 271.

<u>60</u>. Rome, Museo Nazionale, chiostro, ala III,
 inv. 80728.

Material: Marble.

Dimensions: H - 0.605m.; L - 1.45m.

Provenance: Unknown.

Inscription: None.

Date: 30 - 13 B.C. Latest features: Early Augustan
 portrait and hairstyles.

Negatives: DFK 73.7.31-37. DAIR 6538.

Bibliography: Matz-Duhn III, 164, no. 3842. Goethert,
 <u>Republik</u> 49. Zadoks, <u>Ancestral</u> <u>Portraiture</u> 72-
 73. Vessberg, <u>Studien</u> 198-199, 270.

<u>61</u>. Rome, Palazzo Mattei, cortile.

Material: Travertine.

Dimensions: H - 0.47m.; L - 1.10m.

Provenance: Unknown.

Inscription: None.

Date: 30 - 13 B.C. Latest features: Early Augustan
 coiffures of women.

Negatives: DFK 72.20.20. DAIR 29.409.

Bibliography: Matz-Duhn III, 164, no. 3835. T. Bot-
 ticelli, "Rilievi funerari con busti-ritratto,"
 <u>StMisc</u> 20 (1972) 45-46, no. 1.

62. Rome, Tor' Sapienza.
Material: Marble.
Dimensions: Unavailable.
Provenance: Unknown.
Inscription: None.
Date: 30 - 13 B.C. Latest features: Early Augustan
 portrait, drapery, and hairstyles.
Negatives: DFK 72.20.30-33. DAIR 71.280.
Bibliography: Unpublished.

63. Rome, Museo Nazionale, chiostro, ala III.
Material: Marble.
Dimensions: H - 0.87m.; L - 1.82m.
Provenance: Rome, Via Appia.
Inscription:

 C.RABIRIVS.POST.L RABIRIA VSIA.PRIMA.SAC
 HERMODORVS DEMARIS ISIDIS
 CIL VI, 2246.
Date: 13 B.C. - A.D. 5; third figure recut, Flavian.
 Latest features: Mid-Augustan portrait and
 drapery styles; mid-Augustan coiffure of
 woman at center.
Negatives: DFK 72.II.27-29; 73.6.23A-25A. DAIR
 42.681-687. Alinari 28823.
Bibliography: Vessberg, Studien 191ff., 267.

Type G: One Man, One Woman, One Child

Full-Length Portraits

64. Capri, Villa San Michele, chapel.

Material: Marble.

Dimensions: H - 1.71m.; W - unavailable.

Provenance: Rome.

Inscription: None.

Date: 13 B.C. - A.D. 5. Latest features: Mid-
Augustan portrait and drapery styles.

Negative: I. Vetti, Naples.

Bibliography: J. Oliv, Axel Munthe's San Michele.
A Guide for Visitors (Malmö 1954) without
pagination. A. Andrén, "Classical Antiquities
of the Villa San Michele," Opuscula Romana 5
(1965) 135, no. 25.

65. Rome, Museo Nazionale, giardino.

Material: Marble.

Dimensions: H - 1.81m.; W - 0.67m.

Provenance: Unknown.

Inscription: None.

Date: 13 B.C. - A.D. 5. Latest features: Mid-

Augustan portrait style and coiffure of child.

Negatives: DFK 72.II.36; 72.22.23; 73.18.14A–16A.

DAIR 38.1661–1662.

Bibliography: Unpublished.

<u>66</u>. Rome, Villa Doria Pamphili.

Material: Marble.

Dimensions: Unavailable.

Provenance: Unknown.

Inscription: None.

Date: 13 B.C. – A.D. 5. Latest features: Mid-Augustan drapery style; mid-Augustan portrait style of child.

Negatives: DAIR 62.641–644; 62.651–652.

Bibliography: Matz-Duhn III, 154, no. 3796.

Schmidt, <u>Frauenstatuen</u> 5–6.

<u>Bust-Length</u> <u>Portraits</u>

<u>67</u>. Rome, Musei Vaticani, Galleria Lapidaria, no. 39a.

Material: Marble.

Dimensions: H – 0.56m.; L – 0.69m.

Provenance: Unknown.

Inscription: C.LIVIVS.C.L.ALEXANDER

APOLLONI.AEMILIA.L.L.CLVCERA

CIL VI, 21381.

Date: 13 B.C. – A.D. 5. Latest feature: Mid-
Augustan coiffure of woman.

Negative: DAIR 43.445.

Bibliography: Amelung, Skulpturen I, 196-197, no.
39a. Altmann, Grabaltäre 19.

68. Rome, Musei Vaticani, Galleria Lapidaria,
inv. 9398.

Material: Marble.

Dimensions: H – 0.75m.; L – 0.96m.

Provenance: Unknown.

Inscription: Modern.

Date: 13 B.C. – A.D. 5. Latest features: Mid-
Augustan portrait and drapery styles.

Negative: DAIR 43.425.

Bibliography: Amelung, Skulpturen I, 225-226, no.
80a. Vessberg, Studien 198, 203. P. L. Williams,
"Two Roman Reliefs in Renaissance Disguise,"
JWCI 4 (1940-41) 47-66. Buschor, Bildnis 63.
H. von Heintze, Helbig[4] I, 295, no. 389.

69. Rome, Musei Vaticani, Museo Chiaramonti, inv.
2109.

Material: Marble.

Dimensions: H - 0.75m.; L - 0.945m.

Provenance: Unknown.

Inscription: L.VIBIVS.L.F.TRO.VECILIA.Ɔ.L.HILAE

 L.VIBIVS.FELICIO.FELIX.VIBIA.L.L.PRIMA

CIL VI, 28774.

Date: 13 B.C. - A.D. 5. Latest features: Mid-
 Augustan drapery style; mid-Augustan portrait
 style of boy; mid-Augustan coiffure of woman.

Negatives: DAIR 36.686. Alinari 26984.

Bibliography: Altmann, Grabaltäre 199. Amelung,
 Skulpturen I, 348, no. 60E. Zadoks, Ancestral
 Portraiture 56. Goethert, Republik 46. Vess-
 berg, Studien 201-202, 271. Buschor, Bildnis
 56, 64. H. von Heintze, Helbig[4] I, 291-292,
 no. 381.

70. Rome, Musei Vaticani, ex Museo Lateranense,
 inv. 10490.

Material: Travertine.

Dimensions: H - 0.61m.; L - 1.83m.

Provenance: Unknown.

Inscription: M.L.EPICTES/L.NVMENIVS/TRVPHERA/
 MELISSA/EVROPA/VIVIT

CIL VI, 17204.

Date: 13 B.C. - A.D. 5. Latest feature: Mid-
 Augustan portrait style of child.
Negatives: Museum photographs. EA 2214.
Bibliography: Benndorf-Schöne 319, no. 454. Vess-
 berg, Studien 190, 267. Schweitzer, Bildnis-
 kunst 133. Giuliano, Ritratti 1, no. 1. H.
 von Heintze, Helbig[4] I, 816-817, no. 1135.

71. Rome, Musei Vaticani, ex Museo Lateranense,
 inv. 10491.
Material: Marble.
Dimensions: H - 0.61m.; L - 1.42m.
Provenance: Rome, Conservatori delle Mendicanti.
Inscription:

 P.SERVILIVS.Q.F. Q.SERVILIVS.Q.L. SEMPRONIA
 GLOBVLVS.F. HILARVS.PATER C.L.EVNE.VXOR
 CIL VI, 26410.
Date: 13 B.C. - A.D. 5. Latest feature: Mid-
 Augustan coiffure of woman.
Negatives: Museum photographs. DAIR 7533.
Bibliography: Benndorf-Schöne 15, no. 23. Altmann,
 Grabaltäre 199. Vessberg, Studien 192, 201.
 Giuliano, Ritratti 3, no. 3. H. von Heintze,
 Helbig[4] I, 812-813, no. 1132.

Four-Figure Reliefs

Type H: Four Men

Bust-Length Portraits

<u>72</u>. Rome, Palazzo Colonna.

Material: Marble.

Dimensions: Unavailable.

Provenance: Unknown.

Inscription:]TI.TYRO.L.L.]TYRO.L.L.

Date: 30 - 13 B.C.; recut in modern times. Latest
 features: Early Augustan drapery and hairstyles.

Negatives: DAIR 33.1715-1716.

Bibliography: Matz-Duhn III, 161, nos. 3817-3818.

Type I: Three Men, One Woman

Bust-Length Portraits

<u>73</u>. Rome, Museo Nazionale, chiostro.

Material: Travertine.

Dimensions: H - 0.59m.; L - 1.10m.

Provenance: Rome, near Acquedotto Felice.

Inscription: A.FONTEIO.A.A.L.PHILEM/A.FONTEIVS.

A.L.SABDA/A.FONTEIVS.A.L.SECVND/FONTEIA.A.L.

FLORA/LIBERTI.PATRONO/A.FONTEIVS.A.ET.Ͻ.L.

VERNA

CIL VI, 18520.

Date: 75 - 50 B.C. Latest features: Late Repub-
lican portrait, drapery, and hairstyles.

Negatives: DFK 73.6.3A-5A; 73.31.15A-18A.

Bibliography: R. Lanciani, BullComm (1880) 142-143.

74. Rome, Museo Nazionale, giardino.

Material: Travertine.

Dimensions: H - 0.64m.; L - 1.15m.

Provenance: Unknown.

Date: Ca. 40 B.C. Latest feature: Portrait style
of the end of the Republic.

Negative: DFK 73.18.13A.

Bibliography: Unpublished.

75. Rome, Villa Wolkonsky.

Material: Travertine.

Dimensions: H - 0.605m.; L - 1.51m.

Provenance: Unknown.

Inscription: None.

Date: Ca. 40 B.C. Latest feature: Portrait style

of the end of the Republic.

Negatives: DFK 72.33.16-20.

Bibliography: Matz-Duhn III, 166, no. 3854.

76. Copenhagen, Ny Carlsberg Glyptothek, inv. 762.

Material: Marble.

Dimensions: H - 0.62m.; L - 1.25m.

Provenance: Rome.

Inscription: None.

Date: 30 - 13 B.C. Latest features: Early Augustan
 portrait, drapery, and hairstyles.

Negative: Museum photograph.

Bibliography: Goethert, Republik 43. Poulsen, Por-
 traits romains I, 135, no. 116.

77. Rome, Villa Celimontana.

Material: Marble.

Dimensions: H - 0.58m.; L - 0.86m. and 0.86m.

Provenance: Unknown.

Inscription: None.

Date: 30 - 13 B.C. Latest features: Early Augustan
 portrait, drapery, and hairstyles.

Negatives: DAIR 52.126; 66.600.

Bibliography: Vessberg, Studien 187-188, 266-267.

Type J: Two Men, Two Women

Bust-Length Portraits

78. Rome, Museo del Palazzo dei Conservatori,
 Museo Nuovo, inv. 2306.

Material: Marble.

Dimensions: H - 0.60m.; L - 1.81m.

Provenance: Rome, Via Biberatica.

Inscription: None.

Date: 30 - 13 B.C. Latest features: Early Augustan
 portrait and hairstyles.

Negatives: DAIR 34.1687-1690; 35.740.

Bibliography: C. Ricci, Capitolium 5 (1929-30) 541.
 G. Lugli, Dedalo 10 (1929-30) 550. W. Technau,
 AA (1930) 365ff. Mustilli, Museo Mussolini 110,
 no. 21. Vessberg, Studien 204-205, 272.

79. Rome, Museo Nazionale, chiostro, ala III,
 inv. 196629.

Material: Marble.

Dimensions: H - 0.585m.; L - 2.36m.

Provenance: Rome, Via Appia.

Inscription: None.

Date: 30 - 13 B.C. Latest features: Early Augustan
 portrait and drapery styles.

Negatives: DFK 72.II.15; 73.6.26A-28A.

Bibliography: Vessberg, Studien 199, 271.

80. Rome, Museo Nazionale, chiostro, ala III,
 inv. 196632.

Material: Marble.

Dimensions: H - 0.59m.; L - 2.355m.

Provenance: Rome, Via Appia.

Inscription: None.

Date: 13 B.C. - A.D. 5. Latest features: Mid-
 Augustan portrait and drapery styles; mid-
 Augustan coiffure of young woman.

Negatives: DFK 72.II.22-26. DAIR 42.688-696.

Bibliography: Unpublished.

Type K: Two Men, One Woman, One Child

Bust-Length Portraits

81. Rome, Musei Vaticani, Museo Chiaramonti, no. 13a.

Material: Travertine.

Dimensions: H - 0.66m.; L - 1.62m.

Provenance: Rome, Via Appia no. 36.

Inscription: P.AEL.VERVS.ET.AEL.MASNATE.F.AEL.VERVS.
VERO.PATRI.F. (The abbreviation of the nomen in-
dicates a 2nd century A.D. date for the inscription,
which is a later addition to the Augustan relief.)
CIL VI, 10808.

Date: 30 - 13 B.C. Latest features: Early Augustan
portrait, drapery, and hairstyles.

Negatives: DFK 72.IV.22. DAIR 405.

Bibliography: Amelung, Skulpturen I, 321-322, no. 13a.

82. Rome, S. Giovanni in Laterano, chiostro, no. 103.
Material: Travertine.
Dimensions: H - 0.63m.; L - 1.85m.
Provenance: Rome, Tor Pignattara.
Inscription: VIVIT VIVIT
C.GAVIVS.C.L.DARDANVS C.GAVIVS.SPV.F.RVFVS
VIVIT DVO.FRATRES.FABREI.TIGN.
GAVIA.C.C.L.ASIA C.GAVIVS.C.L.SALVIVS
CIL VI, 9411.

Date: 30 - 13 B.C. Latest features: Early Augustan
portrait, drapery, and hairstyles.

Negative: DAIR 6537.

Bibliography: Matz-Duhn III, 162, no. 3824. Vessberg,
Studien 186-187, 267. E. Josi, Il chiostro lateran-
ense (Vatican 1970) 15, no. 103.

Type <u>L</u>: Two <u>Women</u>, <u>One</u> <u>Man</u>, <u>One</u> <u>Child</u>

<u>Bust-Length</u> <u>Portraits</u>

<u>83</u>. Rome, Museo Nazionale, chiostro, ala III,
 inv. 126107.

Material: Travertine.

Dimensions: H — 0.53m.; L — 0.60m.

Provenance: Rome, Esquiline hill, interior of a
 columbarium.

Inscription: None.

Date: 75 — 50 B.C. Latest features: Late Repub-
 lican portrait, drapery, and hairstyles.

Negatives: DFK 72.24.6A; 73.18.32A-35A. DAIR
 37.1149.

Bibliography: E. Brizio, <u>Pitture e sepolcri sull'</u>
 <u>Esquilino</u> (Rome 1876) 134. H. P. L'Orange,
 "Zum frühromischen Frauenporträt," <u>RömMitt</u> 44
 (1929) 174. Vessberg, <u>Studien</u> 185-186, 266.

<u>84</u>. Rome, Via Po, no. 1a.

Material: Marble.

Dimensions: Unavailable.

Provenance: Rome, Via Salaria.

Inscription: ANTONIA.P.L.RVFA.C.VETTIVS.Ɔ.L.

NICEPHOR.C.VETTIVS.C.F.SECVNDVS.VETTIA.C.L.

CALYBE

Date: 13 B.C. - A.D. 5. Latest features: Mid-
Augustan portrait and drapery styles; mid-
Augustan coiffures of two women.

Bibliography: W. von Sydow, AA 88 (1973) 620,
fig. 62.

Type M: One Man, One Woman, Two Children

Bust-Length Portraits

85. Rome, Museo Nazionale, chiostro, ala III,
inv. 125830.

Material: Travertine.

Dimensions: H - 0.90m.; L - 0.91m.

Provenance: Aguzzano (Via Tiburtina).

Inscription: Θ.L.VETTIVS.Ɔ.L.ALEXAND/Θ.VETTIA.L.F.
POLLA/VETTIA.L.L.ELEVTHERIS/VETTIA.Ɔ.L.HOSPITA

Date: 13 B.C. - A.D. 5. Latest feature: Mid-
Augustan portrait style of girl at right.

Negatives: DFK 72.24.7A.

Bibliography: B. M. Felletti Maj, NSc (1950) 84-85.

Five-Figure Reliefs

Type N: Three Men, Two Women

Bust-Length Portraits

<u>86</u>. Rome, Museo Nazionale, chiostro, ala III,
 inv. 196631.

Material: Marble.

Dimensions: H - 0.595m.; L - 2.77m.

Provenance: Rome, Via Appia.

Inscription: None.

Date: 30 - 13 B.C. Latest features: Early Augustan
 portrait and drapery styles.

Negatives: DFK 72.II.20-21. Alinari 41882.

Bibliography: Unpublished.

<u>87</u>. Copenhagen, Ny Carlsberg Glyptothek, inv. 2431.

Material: Marble.

Dimensions: H - 0.95m.; L - 1.96m.

Provenance: Rome, Via Appia, Villa Casale.

Inscription: C.SERVILIVS SCAEVIA M.SCAEVIVS

SERVILIA.I.L CHRESTE HOSPES

PHILOMVSVS MVTILIA.SERVI M.EPIDIVS

L.EVPHRANTE CHRESTVS

SCAEVIA M.SCAEVIVS

ITALIA STEPHANVS

C.SERVILIVS L.HIRRIVS

GRATVS

CIL VI, 26421.

Date: 13 B.C. - A.D. 5. Latest feature: Mid-
Augustan drapery style.

Negative: Museum photograph.

Bibliography: Matz-Duhn III, 160, no. 3811.
Goethert, Republik 43. Poulsen, Portraits
romains I, 135, no. 115.

88. Copenhagen, Ny Carlsberg Glyptothek, inv. 2799.

Material: Marble.

Dimensions: H - 0.74m.; L - 1.85m.

Provenance: Unknown.

Inscription: None.

Date: 13 B.C. - A.D. 5. Latest features: Mid-
Augustan drapery style; mid-Augustan portrait
style and coiffure of young man in center.

Negatives: Museum photograph. EA 3049-3051.

Bibliography: Michaelis, Ancient Marbles 442, no. 21. Altmann, Grabaltäre 199. Lansdowne Catalogue 50, no. 73. Zadoks, Ancestral Portraiture 56, 73. Poulsen, Portraits romains I, 133-134, no. 114.

Type O: Three Women, Two Men

Bust-Length Portraits

89. Rome, Musei Vaticani, ex Museo Lateranense, inv. 10464.

Material: Marble.

Dimensions: H - 0.62m.; L - 2.125m.

Provenance: Unknown.

Inscription: FVRIA.Ɔ.L.P.FVRIVS.P.L.FVRIA.Ɔ.L. FVRIA.Ɔ.L.C.SVLPICIVS.C.L.

CIL VI, 18795.

Date: 13 B.C. - A.D. 5. Latest features: Mid-Augustan portrait and drapery styles.

Negatives: Museum photographs. Alinari 29910; 47305.

Bibliography: Benndorf-Schöne 330, no. 467. Alt-

...ann, Grabaltäre 199. West, Porträt-Plastik I,
141. Goethert, Republik 38ff. Vessberg,
Studien 199-200, 232, 270. Schweitzer, Bildnis-
kunst 36. Giuliano, Ritratti 2, no. 2. Buschor,
Bildnis 63. H. von Heintze, Helbig[4] I, 818, no.
1139.

Type P: Two Men, Two Women, One Child

Bust-Length Portraits

90. Rome, Via di Portico di Ottavia.

Material: Marble.

Dimensions: Unavailable.

Provenance: Rome, Via Appia.

Inscription: None.

Date: 13 B.C. – A.D. 5. Latest features: Mid-
 Augustan portrait style of young man and
 young woman; mid-Augustan coiffure of young
 woman.

Negatives: DFK 73.29.6-11.

Bibliography: Matz-Duhn III, no. 3825.

Six-Figure Reliefs

Type Q: Four Men, Two Women

Bust-Length Portraits

91. Rome, Museo del Palazzo dei Conservatori,
 Museo Nuovo, inv. 2231.

Material: Marble.

Dimensions: H – 0.58m.; L – 2.30m.

Provenance: Rome, Via Flaminia.

Inscription: None.

Date: 30 – 13 B.C. Latest features: Early Augustan
 portrait, drapery, and hairstyles.

Negatives: DAIR 28.73; 36.523.

Bibliography: BullComm (1877) 271, no. 15. Mustilli,
 Museo Mussolini 179, no. 74. Vessberg, Studien
 200, 271. Schweitzer, Bildniskunst 36. H. von
 Heintze, Helbig[4] II, 518, no. 1740.

Type R: Three Men, Two Women, One Child

Bust-Length Portraits

<u>92</u>. Rome, Villa Wolkonsky.

Material: Travertine.

Dimensions: H - 0.64m.; L - 1.99m.

Provenance: Rome, Villa Wolkonsky, facade of a
 columbarium.

Inscription:

M.SERVILIVS M.SERVILIVS SERVILIA
PHILARCVRVS.L PHILOSTRATVS.L ANATOLE.L
 FRVGI

SERVILIA M.SERVILIVS LVCINI
THAIS.L MENOPHILVS.L

<u>CIL</u> VI, 26375.

Date: 30 - 13 B.C. Latest features: Early Augustan
 drapery style; early Augustan coiffures of
 women.

Negatives: DFK 72.33.8-15.

Bibliography: R. Lanciani, <u>BullComm</u> (1881) 198-201.
 R. Lanciani, <u>NSc</u> (1881) 137. Altmann, <u>Grab-</u>
 <u>altäre</u> 196.

Addenda

Two group portrait reliefs of this period, which were brought to my attention after this study was completed, are published in the following two volumes:

C. Vermeule and N. Neuerburg, Catalogue of the Ancient Art in the J. Paul Getty Museum (Malibu 1973) 37-38, no. 83, fig. 83.

G. Moretti, Nuove scoperte e acquisizioni nell' Etruria Meridionale. Museo Nazionale di Villa Giulia (Rome 1975) 251-253, pl. 78.

Abbreviations and Select Bibliography

Other studies which are not cited here in abbreviated form may be found in the footnotes and in the Catalogue (Chapter Nine).

Alinari - Fratelli Alinari negative, Via Babuino, Rome.

Altmann, Grabaltäre - W. Altmann, Die römischen Grab-
altäre der Kaiserzeit (Berlin 1905).

Amelung, Skulpturen I - W. Amelung, Die Skulpturen
des Vaticanischen Museums I (Berlin 1903).

Amelung, Skulpturen II - W. Amelung, Die Skulpturen
des Vaticanischen Museums II (Berlin 1908).

ANRW - H. Temporini (ed.), Aufstieg und Niedergang der
römischen Welt I,4 (Berlin 1973).

Benndorf-Schöne - O. Benndorf and R. Schöne, Die
antiken Bildwerke des Lateranischen Museums
(Leipzig 1867).

Bernoulli, RömIkon I - J. J. Bernoulli, Römische
Ikonographie I (Stuttgart 1882).

Bieber, "Palliati" - M. Bieber, "Roman Men in Greek
Himation (Romani Palliati). A Contribution to
the History of Copying," ProcAmPhilSoc 103
(1959) 374-417.

Blake, Roman Construction - M. E. Blake, Ancient
Roman Construction in Italy from the Prehistoric
Period to Augustus (Washington 1947).

Buschor, Bildnis - E. Buschor, Das hellenistische
 Bildnis (Munich 1971).

Calza, Ritratti - R. Calza, Scavi di Ostia V. I
 ritratti (Rome 1964).

Collignon, Statues funéraires - M. Collignon, Les
 statues funéraires dans l'art grec (Paris 1911).

Crawford, Coinage - M. H. Crawford, Roman Republican
 Coinage (Cambridge 1974).

DAIR - Deutsches Archäologisches Institut, Rome,
 negative, Via Sardegna, Rome.

Degrassi, ILLRP - A. Degrassi, Inscriptiones latinae
 liberae rei publicae I-II (Florence 1957-1963).

Degrassi, Imagines - A. Degrassi, Inscriptiones latinae
 liberae rei publicae. Imagines (Berlin 1965).

DFK - D. and F. Kleiner negative.

Dohrn, Arringatore - T. Dohrn, Der Arringatore, Monu-
 menta Artis Romanae VIII (Berlin 1968).

Duff, Freedmen - A. M. Duff, Freedmen in the Early
 Roman Empire (Oxford 1928).

EA - P. Arndt et al., Photographische Einzelaufnahmen
 antiker Skulpturen (Munich 1912ff.).

Felletti Maj, Ritratti - B. M. Felletti Maj, Museo
 Nazionale Romano. I ritratti (Rome 1953).

FotUn - Fototeca Unione negative, Via Angelo Masina, Rome.

Furnée-van Zwet, "Hair-dress" - L. Furnée-van Zwet, "Fashion in Women's Hair-dress in the First Century of the Roman Empire," BABesch 31 (1956) 1-22.

GabFotNaz - Gabinetto Fotografico Nazionale negative, Via in Miranda 5, Rome.

Gazda, "Etruscan Influence" - E. K. Gazda, "Etruscan Influence in the Funerary Reliefs of Late Republican Rome: A Study of Roman Vernacular Portraiture," ANRW I,4 (1973) 855-870.

Giuliano, Ritratti - A. Giuliano, Catalogo dei ritratti romani del Museo Profano Lateranense (Rome 1957).

Goethert, Republik - F. W. Goethert, Zur Kunst der römischen Republik (Berlin 1931).

Helbig[4] - H. Speier (ed.), W. Helbig, Führer durch die öffentlichen Sammlungen klassischer Altertümer in Rom[4] (Tübingen 1963ff.).

Hiesinger, "Portraiture" - U. W. Hiesinger, "Portraiture in the Roman Republic," ANRW I,4 (1973) 805-825.

Horn, Gewandstatuen - R. Horn, Stehende weibliche Gewandstatuen in der hellenistischen Plastik, RömMitt Erg.-H. 2 (Munich 1931)

Kaschnitz von Weinberg, Mittelmeerische Kunst - G.
 Kaschnitz von Weinberg, Mittelmeerische Kunst
 (Berlin 1965).

Lansdowne Catalogue - Catalogue of the Celebrated
 Collection of Ancient Marbles. The Property
 of the Most Honorable Marquess of Lansdowne.
 Auction. Messrs. Christie, Manson and Woods,
 March 5, 1930.

Lugli, Tecnica - G. Lugli, La tecnica edilizia
 romana (Rome 1957).

Matz-Duhn III - F. Matz and F. von Duhn, Antike
 Bildwerke in Rom III (Leipzig 1882).

Michaelis, Ancient Marbles - A. Michaelis, Ancient
 Marbles in Great Britain (Cambridge 1882).

Mustilli, Museo Mussolini - D. Mustilli, Il Museo
 Mussolini (Rome 1939).

Nash, Pictorial Dictionary[2] - E. Nash, Pictorial
 Dictionary of Ancient Rome[2] (London 1968).

Polaschek, "Haartracht" - K. Polaschek, "Studien zu
 einem Frauenkopf im Landesmuseum Trier und zur
 weiblichen Haartracht der iulisch-claudischen
 Zeit," TrZ 35 (1972) 141-210.

Polaschek, Mantelstatuen - K. Polaschek, Untersuch-
 ungen zu griechischen Mantelstatuen. Der Himation-
 typus mit Armschlinge (Berlin 1969).

Poulsen, Portraits romains I – V. Poulsen, Les portraits romains I (Copenhagen 1962).

Poulsen, Probleme – F. Poulsen, Probleme der römischen Ikonographie (Copenhagen 1937).

Richter, Portraits – G. M. A. Richter, The Portraits of the Greeks (London 1965).

Schmidt, Frauenstatuen – E. E. Schmidt, Römische Frauenstatuen (Munich 1967).

Schweitzer, Bildniskunst – B. Schweitzer, Die Bildniskunst der römischen Republik (Leipzig 1948).

Simon, Ara Pacis – E. Simon, Ara Pacis Augustae (Tübingen 1967).

Stuart Jones, Capitoline – H. Stuart Jones, A Catalogue of the Ancient Sculptures Preserved in the Municipal Collections of Rome. The Sculptures of the Museo Capitolino (Oxford 1912).

Toynbee, Death and Burial – J. M. C. Toynbee, Death and Burial in the Roman World (London 1971).

Treggiari, Roman Freedmen – S. Treggiari, Roman Freedmen during the Late Republic (Oxford 1969).

Vessberg, Studien – O. Vessberg, Studien zur Kunstgeschichte der römischen Republik (Lund and Leipzig 1941).

West, Porträt-Plastik I – R. West, Römische Porträt-Plastik I (Munich 1933).

Wilson, Clothing - L. M. Wilson, The Clothing of the
 Ancient Romans (Baltimore 1938).

Wilson, Toga - L. M. Wilson, The Roman Toga (Baltimore
 1924).

Winkes, "Physiognomia" - R. Winkes, "Physiognomia:
 Probleme der Charakterinterpretation römischer
 Porträts," ANRW I,4 (1973) 899-926.

Zadoks, Ancestral Portraiture - A. N. Zadoks-Josephus
 Jitta, Ancestral Portraiture in Rome (Amsterdam
 1932).

Zanker, Actium-Typus - P. Zanker, Studien zu den
 Augustus-Porträts I. Der Actium-Typus, AbhGött
 Dritte Folge Nr. 85 (1973).

Zehnacker, Moneta - H. Zehnacker, Moneta. Recherches
 sur l'organisation et l'art des émissions moné-
 taires de la République romaine (289 - 31 av.
 J.-C.), BEFAR 222 (Rome 1973).

Abbreviations of periodical publications are those
of the American Journal of Archaeology.

List <u>of</u> Illustrations <u>and</u> Photograph Credits

Fig. 1 – Rome, Museo Nazionale Romano. Funerary
relief of two men. (Cat. no. <u>1</u>).
DFK 72.II.4 (Fig. 1a); 72.II.5 (Fig. 1b); 72.II.6
(Fig. 1c).

Fig. 2 – Leningrad, Hermitage. Funerary relief of
two men. (Cat. no. <u>2</u>).
Photograph reproduced from <u>Festschrift</u> <u>V.D.</u>
<u>Blavatskogo</u> (Moscow 1966) 65, fig. 1.

Fig. 3 – London, British Museum. Funerary relief of
two men (Cat. no. <u>3</u>).
DAIR 60.1163.

Fig. 4 – Rome, Palazzo Mattei. Funerary relief of
two men. (Cat. no. <u>4</u>).
GabFotNaz E57167.

Fig. 5 – Rome, Villa Doria Pamphili. Funerary relief
of two men. (Cat. no. <u>5</u>).
DFK 73.11.17.

Fig. 6 – Rome, Horti degli Scipioni. Funerary relief
of two men. (Cat. no. <u>6</u>)
DFK 73.13.22.

Fig. 7 – Rome, Via Appia. Funerary relief of two men.
(Cat. no. <u>7</u>).
DFK 72.I.6.

Fig. 8 — Rome, Museo Nazionale Romano. Funerary
 relief of two women. (Cat. no. 8).
 DFK 72.II.10 (Fig. 8a); 73.18.4A (Fig. 8b);
 73.18.1A (Fig. 8c).

Fig. 9 — Rome, Tomb on Via Statilia. Funerary relief
 of two women. (Cat. no. 9).
 DFK 72.19.14.

Fig. 10 — Krakow, Museum Narodowe. Funerary relief
 of two women. (Cat. no. 10).
 Photograph reproduced from A. Sadurska, Corpus
 Signorum Imperii Romani, Pologne, I (Warsaw 1972)
 pl. 3, no. 4.

Fig. 11 — Rome, Museo del Palazzo dei Conservatori.
 Funerary relief of a man and woman. (Cat. no. 11).
 DAIR 29.172.

Fig. 12 — Rome, Museo del Palazzo dei Conservatori.
 Funerary relief of a man and woman. (Cat. no. 12).
 DAIR 32.1402 (Fig. 12a). DFK 73.29.18A (Fig. 12b).

Fig. 13 — Rome, Museo Nazionale Romano. Funerary
 relief of a man and woman. (Cat. no. 13).
 DFK 73.31.23A.

Fig. 14 — Rome, Museo del Palazzo dei Conservatori.
 Funerary relief of a man and woman. (Cat. no. 14).
 DAIR 36.1245.

Fig. 15 - Rome, Museo del Palazzo dei Conservatori.
Funerary relief of a man and woman. (Cat. no. 15).
Museum photograph.

Fig. 16 - Rome, Museo Nazionale Romano. Funerary
relief of a man and woman. (Cat. no. 16).
DFK 72.22.25 (Fig. 16a); 72.22.26 (Fig. 16b);
72.22.27 (Fig. 16c); 72.22.28 (Fig. 16d);
72.22.29 (Fig. 16e).

Fig. 17 - Rome, Villa Wolkonsky. Funerary relief of a
man and woman. (Cat. no. 17).
DFK 72.33.25.

Fig. 18 - Berlin, Altes Museum. Funerary relief of a
man and woman. (Cat. no. 18).
DAIR 52.128.

Fig. 19 - Florence, Galleria degli Uffizi. Funerary
relief of a man and woman. (Cat. no. 19).
DFK 72.21.16 (Fig. 19a); 72.21.17 (Fig. 19b);
72.21.20 (Fig. 19c).

Fig. 20 - London, British Museum. Funerary relief of
a man and woman. (Cat. no. 20).
Museum photograph.

Fig. 21 - Lucerne, Art Market, 1961. Funerary relief
of a man and woman. (Cat. no. 21).
Photograph reproduced from Ars Antiqua, Auktion
III (Lucerne 1961) no. 30.

Fig. 22 - New York, Metropolitan Museum of Art.
Funerary relief of a man and woman. (Cat. no. 22).
Museum photograph.

Fig. 23 - Rome, Museo Nazionale Romano. Funerary relief
of a man and woman. (Cat. no. 23).
DFK 72.22.30 (Fig. 23a); 73.18.29A (Fig. 23b);
73.18.30A (Fig. 23c).

Fig. 24 - Rome, Museo Nazionale Romano. Funerary relief
of a man and woman. (Cat. no. 24).
GabFotNaz F2507.

Fig. 25 - Rome, Museo Nazionale Romano. Funerary relief
of a man and woman. (Cat. no. 25).
DFK 72.24.10A (Fig. 25a); 72.33.35 (Fig. 25b).

Fig. 26 - Rome, Palazzo Mattei. Funerary relief of a
man and woman. (Cat. no. 26).
DAIR 29.407.

Fig. 27 - Rome, Palazzo Mattei. Funerary relief of a
man and woman. (Cat. no. 27).
DFK 72.20.25.

Fig. 28 - Rome, Villa Medici. Funerary relief of a
man and woman. (Cat. no. 28).
Photograph reproduced from M. Cagiano de Azevedo,
Le antichità di Villa Medici (Rome 1951) fig. 81.

Fig. 29 - Rome, Via Appia. Funerary relief of a man
and woman. (Cat. no. 29).
DFK 72.I.4.

Fig. 30 - Rome, Via Cassia. Funerary relief of a man
and woman. (Cat. no. 30).
DAIR 38.1303.

Fig. 31 - Rome, Via Satricana. Funerary relief of a
man and woman. (Cat. no. 31).
Photograph reproduced from G. M. De Rossi, Forma
Italiae I,9 (Rome 1970) 102, fig. 193.

Fig. 32 - London, ex Lansdowne House. Funerary relief
of a man and woman. (Cat. no. 32).
EA 3053.

Fig. 33 - Rome, Museo Nazionale Romano. Funerary relief
of a man and woman. (Cat. no. 33).
DFK 72.22.34.

Fig. 34 - Rome, Musei Vaticani. Funerary relief of a
man and woman. (Cat. no. 34).
Alinari 6602.

Fig. 35 - Rome, Museo Capitolino. Funerary relief of
three men. (Cat. no. 35).
Museum photograph.

Fig. 36 - Rome, Museo del Palazzo dei Conservatori.
Funerary relief of three men. (Cat. no. 36).
DFK 72.VI.20.

Fig. 37 - Rome, Galleria Borghese. Funerary relief of
two men and a woman. (Cat. no. 37).
Alinari 27481.

Fig. 38 - Rome, Museo Nazionale Romano. Funerary relief
of two men and a woman. (Cat. no. 38).
DFK 73.18.21A (Fig. 38a); 73.18.20A (Fig. 38b);
73.18.27A (Fig. 38c); 73.18.25A (Fig. 38d);
73.18.24A (Fig. 38e); 73.18.23A (Fig. 38f).

Fig. 39 - Rome, Museo Nazionale Romano. Funerary relief
of two men and a woman. (Cat. no. 39).
DFK 73.7.4 (Fig. 39a); 73.7.6 (Fig. 39b);
73.7.8 (Fig. 39c); 73.7.9 (Fig. 39d).

Fig. 40 - Rome, Tomb on Via Statilia. Funerary relief
of two men and a woman. (Cat. no. 40).
FotUnione 3269 (Fig. 40a). DFK 75.14.23 (Fig. 40b).

Fig. 41 - Boston, Museum of Fine Arts. Funerary relief
of two men and a woman. (Cat. no. 41).
Museum photograph.

Fig. 42 - Geneva, Musée d'Art et d'Histoire. Funerary
relief of two men and a woman. (Cat. no. 42).
Photograph reproduced from RA (1919) 113, fig. 21.

Fig. 43 - Narni, Municipio. Funerary relief of two men
and a woman. (Cat. no. 43).
DAIR 69.2780.

Fig. 44 - Palermo, Museo Nazionale. Funerary relief of
two men and a woman. (Cat. no. 44).
Museum photograph.

Fig. 45 – Paris, Musée du Louvre. Funerary relief of
two men and a woman. (Cat. no. 45).
DAIR 52.141.

Fig. 46 – Rome, Collection Morelli. Funerary relief
of two men and a woman. (Cat. no. 46).
DAIR 33.1572.

Fig. 47 – Rome, Museo Capitolino. Funerary relief of
two men and a woman. (Cat. no. 47).
DFK 72.21.7 (Fig. 47a). DAIR 32.237 (Fig. 42b);
32.238 (Fig. 47c).

Fig. 48 – Rome, Museo del Palazzo dei Conservatori.
Funerary relief of two men and a woman. (Cat. no. 48).
Photograph reproduced from Mustilli, Museo Mussolini
pl. 119, fig. 462.

Fig. 49 – Rome, Museo del Palazzo dei Conservatori.
Funerary relief of two men and a woman. (Cat. no. 49).
DFK 72.VI.16.

Fig. 50 – Rome, Museo Nazionale Romano. Funerary relief
of two men and a woman. (Cat. no. 50).
DFK 72.II.16 (Fig. 50a); 72.II.18 (Fig. 50b);
72.II.17 (Fig. 50c); 72.II.19 (Fig. 50d).

Fig. 51 – Rome, Musei Vaticani. Funerary relief of two
men and a woman. (Cat. no. 51).
DAIR 43.455.

Fig. 52 - Rome, Palazzo Mattei. Funerary relief of two
men and a woman. (Cat. no. 52).
DFK 72.20.23.

Fig. 53 - Rome, Tor' Sapienza. Funerary relief of two
men and a woman. (Cat. no. 53).
DFK 72.20.34.

Fig. 54 - Rome, Via Appia. Funerary relief of two men
and a woman. (Cat. no. 54).
DFK 72.I.16 (Fig. 54a); 72.I.18 (Fig. 54b).

Fig. 55 - Mentana, Piazza Garibaldi. Funerary relief
of two men and a woman. (Cat. no. 55).
DFK 72.20.26 (Fig. 55a); 72.20.27 (Fig. 55b).

Fig. 56 - Ostia, Magazzini. Funerary relief of two
men and a woman. (Cat. no. 56).
GabFotNaz E35385.

Fig. 57 - Rome, Palazzo Colonna. Funerary relief of
two men and a woman. (Cat. no. 57).
DAIR 33.1713.

Fig. 58 - Rome, Palazzo Colonna. Funerary relief of
two men and a woman. (Cat. no. 58).
DAIR 33.1714.

Fig. 59 - London, British Museum. Funerary relief of
two women and a man. (Cat. no. 59).
Museum photograph.

Fig. 60 - Rome, Museo Nazionale Romano. Funerary relief
of two women and a man. (Cat. no. 60).
DFK 73.7.31.

Fig. 61 - Rome, Palazzo Mattei. Funerary relief of two
women and a man. (Cat. no. 61).
DAIR 29.409.

Fig. 62 - Rome, Tor' Sapienza. Funerary relief of two
women and a man. (Cat. no. 62).
DFK 72.20.30.

Fig. 63 - Rome, Museo Nazionale Romano. Funerary relief
of two women and a man. (Cat. no. 63).
DFK 72.II.27 (Fig. 63a); 72.II.28 (Fig. 63b);
72.II.29 (Fig. 63c).

Fig. 64 - Capri, Villa San Michele. Funerary relief of
a man, woman and child. (Cat. no. 64).
Photograph reproduced from OpusRom 5 (1965) pl. 14.

Fig. 65 - Rome, Museo Nazionale Romano. Funerary relief
of a man, woman and child. (Cat. no. 65).
DFK 72.II.36 (Fig. 65a); 75.12.5A (Fig. 65b).

Fig. 66 - Rome, Villa Doria Pamphili. Funerary relief
of a man, woman and child. (Cat. no. 66).
DAIR 62.641.

Fig. 67 - Rome, Musei Vaticani. Funerary relief of a
man, woman and child. (Cat. no. 67).
DAIR 43.445.

Fig. 68 - Rome, Musei Vaticani. Funerary relief of a
man, woman and child. (Cat. no. 68).
DAIR 43.425.

Fig. 69 - Rome, Musei Vaticani. Funerary relief of a
man, woman and child. (Cat. no. 69).
Alinari 26984.

Fig. 70 - Rome, Musei Vaticani. Funerary relief of a
man, woman and child. (Cat. no. 70).
Fig. 70a is reproduced from Vessberg, Studien pl. 31.2.
Fig. 70b is reproduced from Giuliano, Ritratti pl.2,
fig. 1b.

Fig. 71 - Rome, Musei Vaticani. Funerary relief of a
man, woman and child. (Cat. no. 71).
Photograph reproduced from Giuliano, Ritratti pl. 1,
fig. 3a.

Fig. 72 - Rome, Palazzo Colonna. Funerary relief of four
men. (Cat. no. 72).
DAIR 33.1716 (Fig. 72a); 33.1715 (Fig. 72b).

Fig. 73 - Rome, Museo Nazionale Romano. Funerary relief
of three men and a woman. (Cat. no. 73).
DFK 75.15.34A (Fig. 73a); 73.6.3A (Fig.73b).

Fig. 74 - Rome, Museo Nazionale Romano. Funerary relief
of three men and a woman. (Cat. no. 74).
DFK 73.18.13A.

Fig. 75 – Rome, Villa Wolkonsky. Funerary relief of
three men and a woman. (Cat. no. 75).
DFK 72.33.16 (Fig. 75a); 72.33.17 (Fig. 75b);
72.33.18 (Fig. 75c); 72.33.19 (Fig. 75d); 72.33.20
(Fig. 75e).

Fig. 76 – Copenhagen, Ny Carlsberg Glyptothek. Funerary
relief of three men and a woman. (Cat. no. 76).
Museum photograph.

Fig. 77 – Rome, Villa Celimontana. Funerary relief of
three men and a woman. (Cat. no. 77).
DAIR 52.126A (Fig. 77a). Fig. 77b is reproduced
from Vessberg, Studien pl. 30.1.

Fig. 78 – Rome, Museo del Palazzo dei Conservatori.
Funerary relief of two men and two women. (Cat. no. 78).
DAIR 35.740.

Fig. 79 – Rome, Museo Nazionale Romano. Funerary relief
of two men and two women. (Cat. no. 79).
DFK 72.II.15 (Fig. 79a); 73.6.26A (Fig. 79b);
73.6.27A (Fig. 79c).

Fig. 80 – Rome, Museo Nazionale Romano. Funerary relief
of two men and two women. (Cat. no. 80).
DFK 72.II.22 (Fig. 80a); 72.II.23 (Fig. 80b);
72.II.24 (Fig. 80c); 72.II.25 (Fig. 80d); 72.II.26
(Fig. 80e).

Fig. 81 – Rome, Musei Vaticani. Funerary relief of
two men, a woman and a child. (Cat. no. 81).
DFK 72.IV.22.

Fig. 82 – Rome, S. Giovanni in Laterano. Funerary
relief of two men, a woman and a child. (Cat. no. 82).
DAIR 6537.

Fig. 83 – Rome, Museo Nazionale Romano. Funerary relief
of two women, a man and a child. (Cat. no. 83).
DFK 72.24.6A (Fig. 83a); 73.18.33A (Fig. 83b);
73.18.32A (Fig. 83c).

Fig 84 – Rome, Via Po, 1A. Funerary relief of two
women, a man and a child. (Cat. no. 84).
Photograph reproduced from AA 88 (1973) 620, fig. 62.

Fig. 85 – Rome, Museo Nazionale Romano. Funerary relief
of a man, woman and two children. (Cat. no. 85).
DFK 72.24.7A.

Fig. 86 – Rome, Museo Nazionale Romano. Funerary relief
of three men and two women. (Cat. no. 86).
DFK 72.II.20.

Fig. 87 – Copenhagen, Ny Carlsberg Glyptothek. Funerary
relief of three men and two women. (Cat. no. 87).
Museum photograph.

Fig. 88 – Copenhagen, Ny Carlsberg Glyptothek. Funerary
relief of three men and two women. (Cat. no. 88).
Museum photograph.

Fig. 89 — Rome, Musei Vaticani. Funerary relief of
three women and two men. (Cat. no. 89).
Alinari 24229.

Fig. 90 — Rome, Via di Portico di Ottavia. Funerary
relief of two men, two women and a child. (Cat. no. 90).
DFK 73.29.7 (Fig. 90a); 73.29.9 (Fig. 90b);
73.29.10 (Fig. 90c).

Fig. 91 — Rome, Museo del Palazzo dei Conservatori.
Funerary relief of four men and two women. (Cat. no. 91).
DAIR 36.523.

Fig. 92 — Rome, Villa Wolkonsky. Funerary relief of
three men, two women and a child. (Cat. no. 92).
DFK 72.33.8 (Fig. 92a); 72.33.9 (Fig. 92b); 72.33.15
(Fig. 92c); 72.33.10 (Fig. 92d); 72.33.11 (Fig. 92e);
72.33.12 (Fig. 92f); 72.33.14 (Fig. 92g).

Fig. 93 — Rome, Vigna Codini. Funerary relief of a man
and woman, from a columbarium niche.
Photograph reproduced from DissPontAcc 11 (1852)
pl. 10, fig. P.

Fig. 94 — Rome, Villa Wolkonsky. Funerary relief of a man.
DFK 72.33.26.

Fig. 95 — Rome, Museo Nazionale Romano. Funerary relief
of a man.
DFK 72.24.15A.

Fig. 96 — Rome, Via Appia. Funerary relief of a man.
DFK 72.I.5.

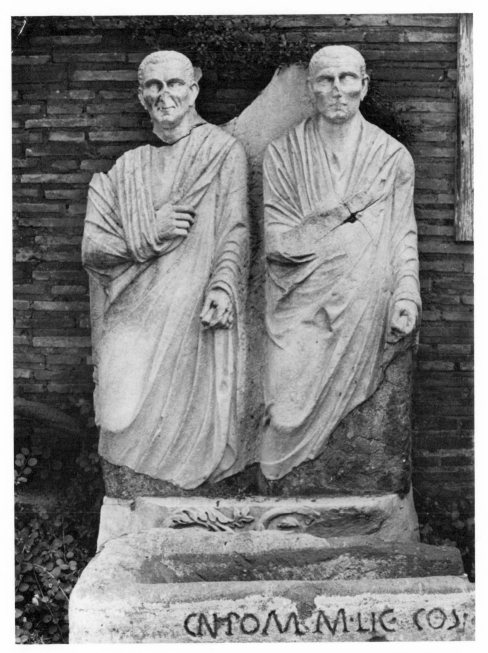

Fig. 1a

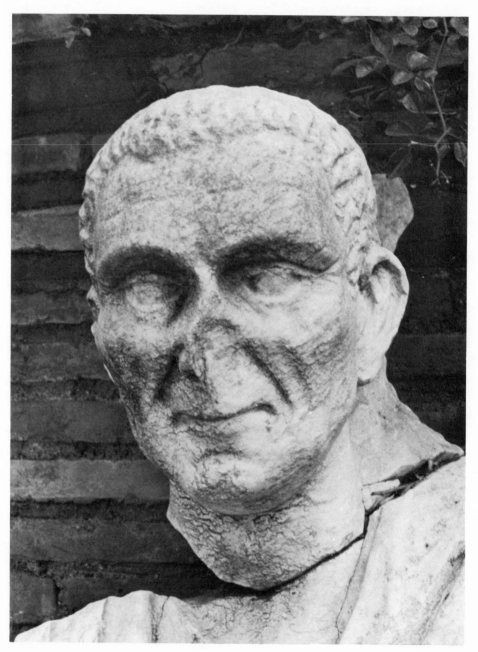

Fig. 1b

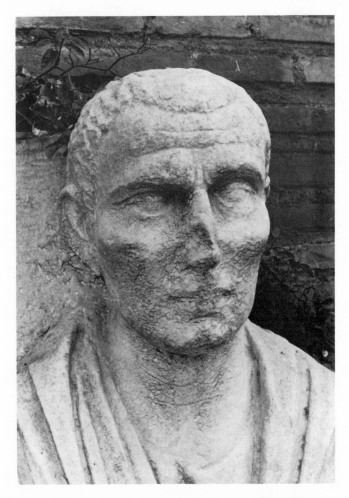

Fig. 1c

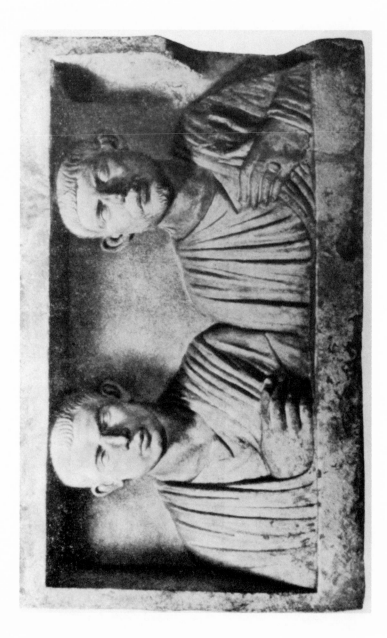

Fig. 2

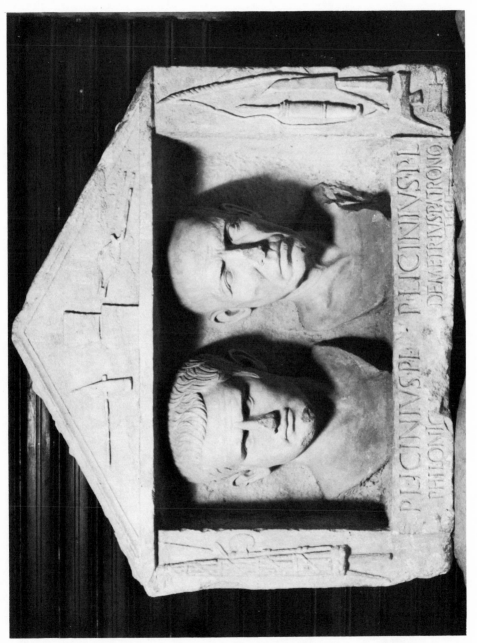

Fig. 3

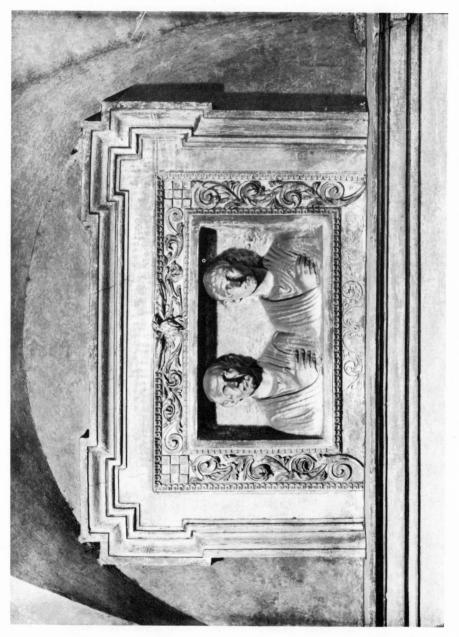

Fig. 4

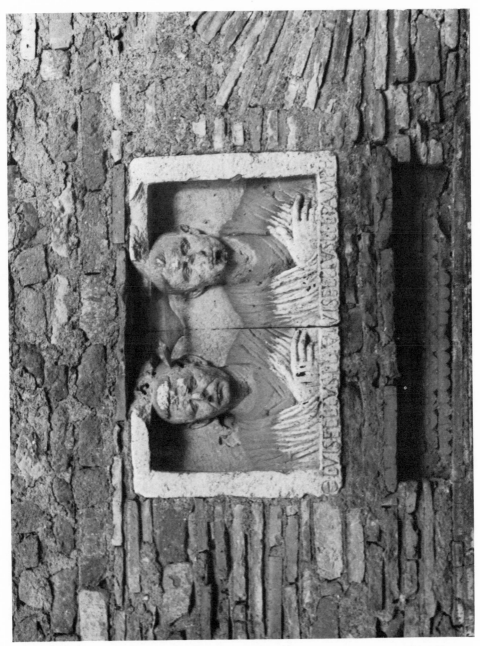

Fig. 5

Fig. 6

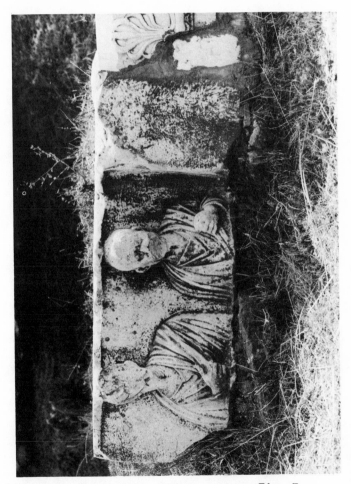

Fig. 7

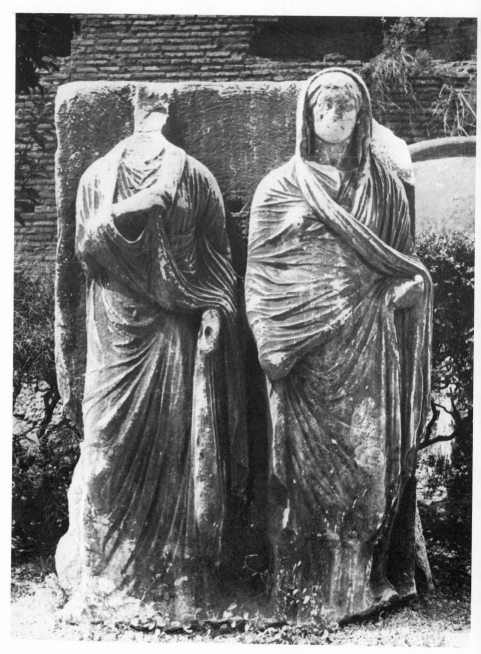

Fig. 8a

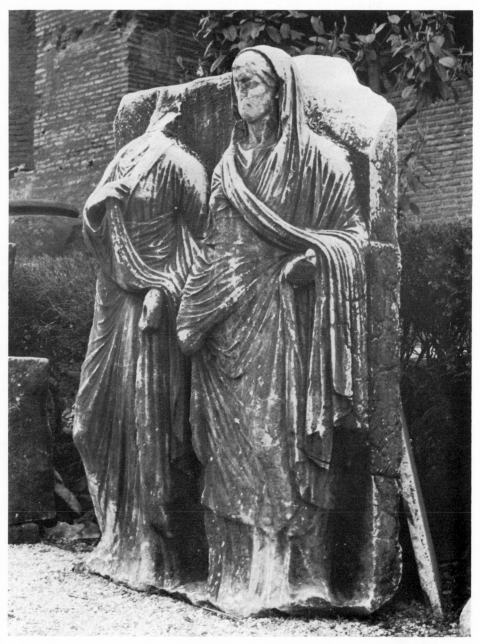

Fig. 8b

Fig. 8c

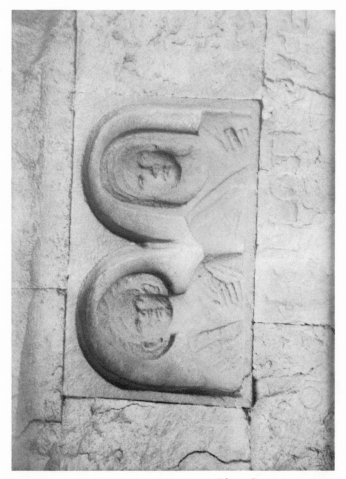

Fig. 9

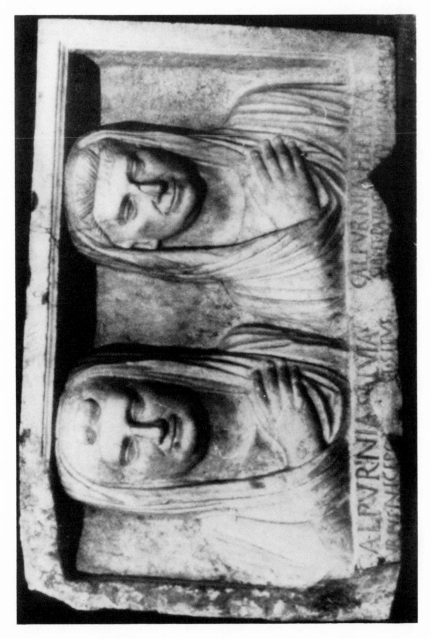

Fig. 10

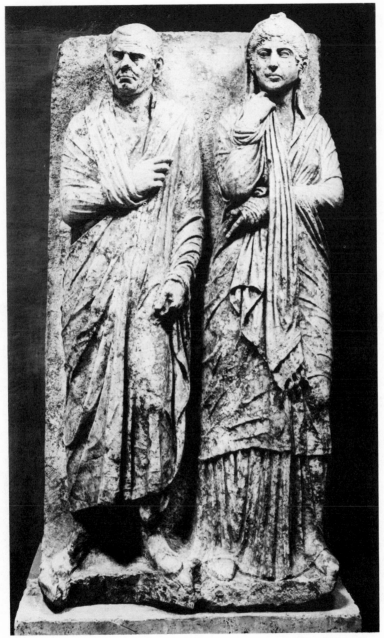

Fig. 11

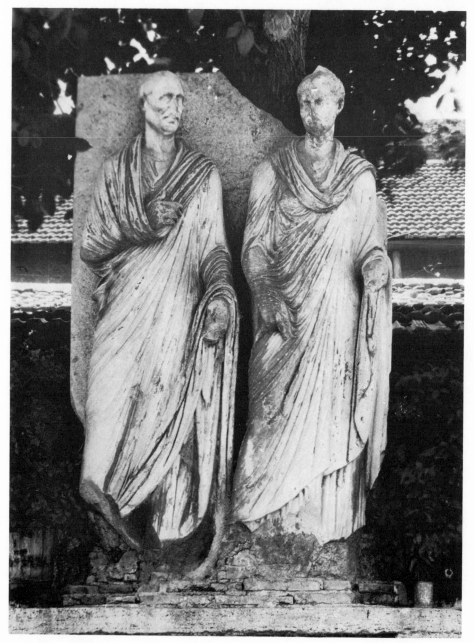

Fig. 12a

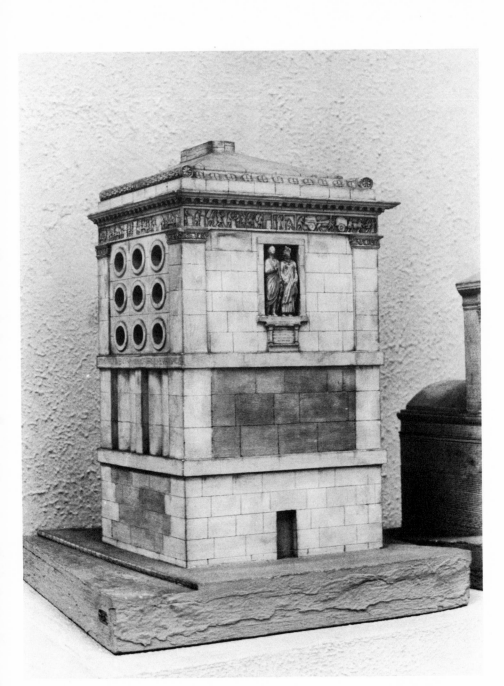

Fig. 12b

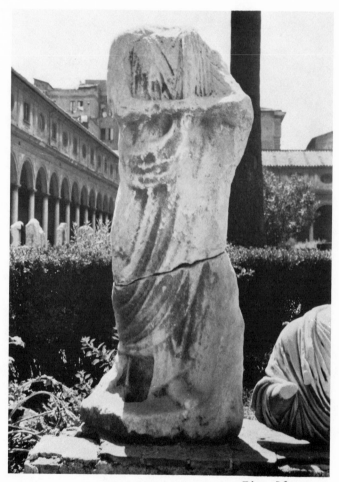

Fig. 13

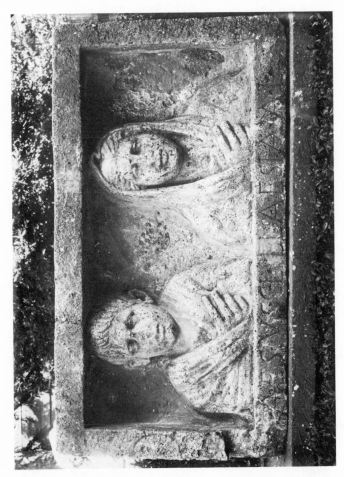

Fig. 14

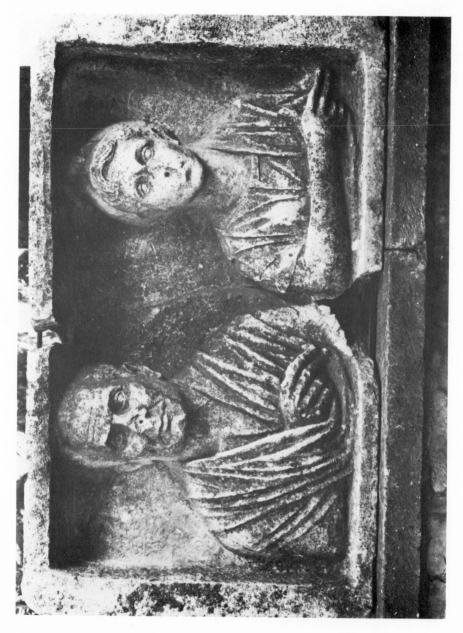

Fig. 15

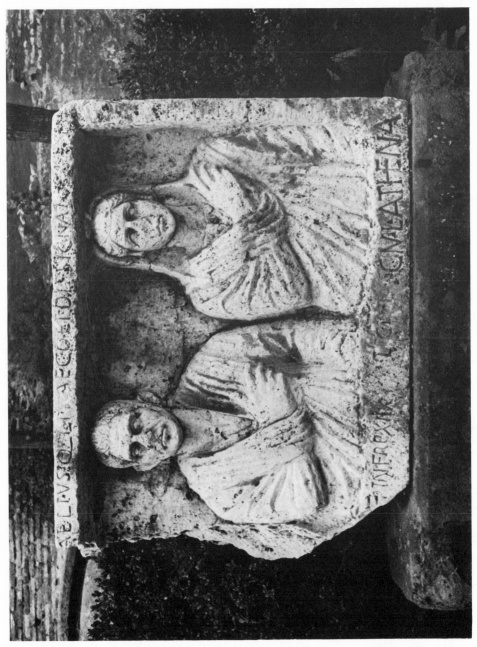

Fig. 16a

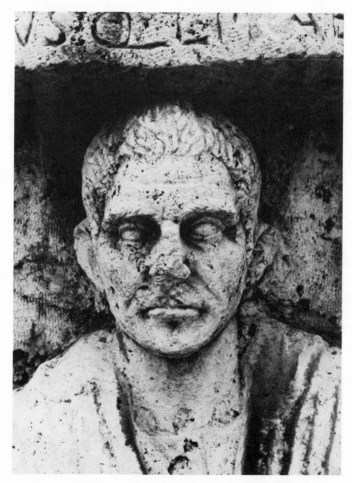

Fig. 16b

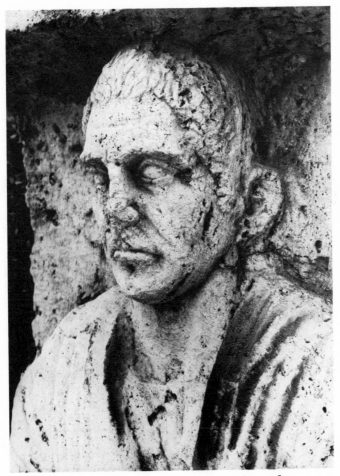

Fig. 16c

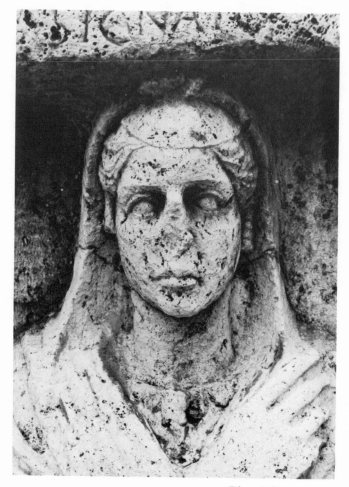

Fig. 16d

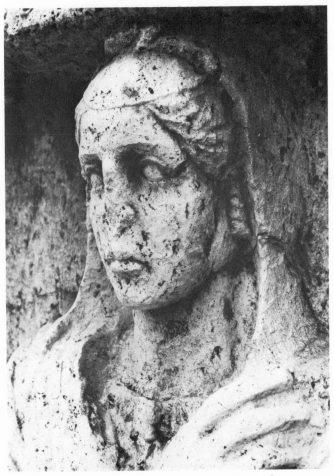

Fig. 16e

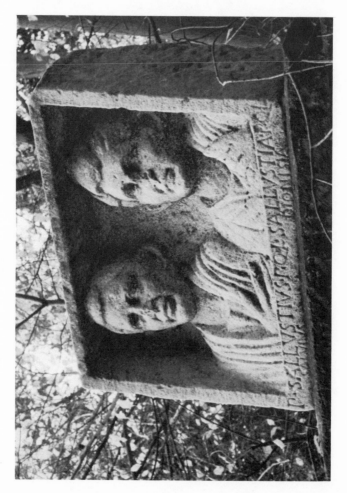

Fig. 17

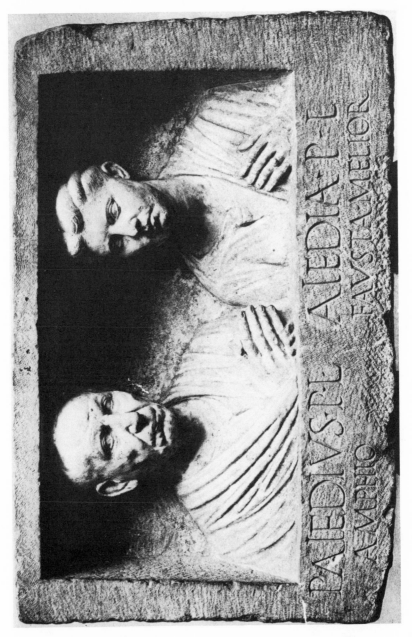

Fig. 18

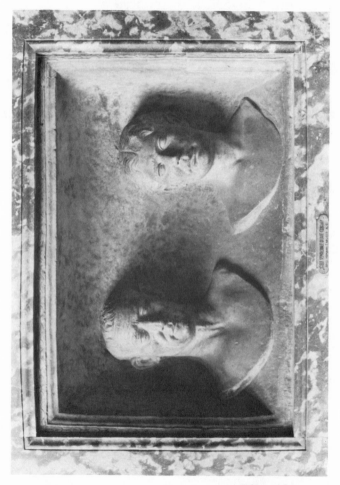

Fig. 19a

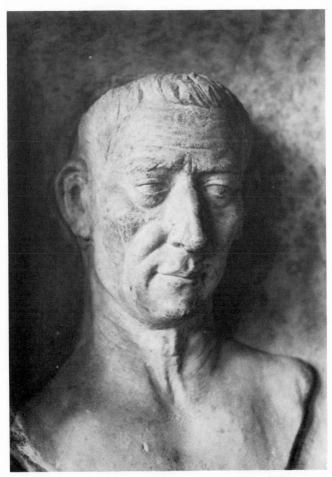

Fig. 19b

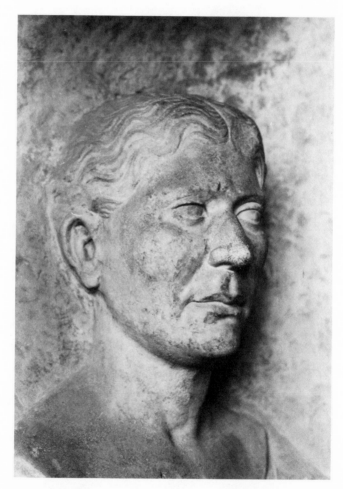

Fig. 19c

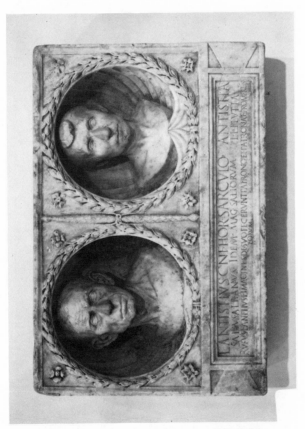

Fig. 20

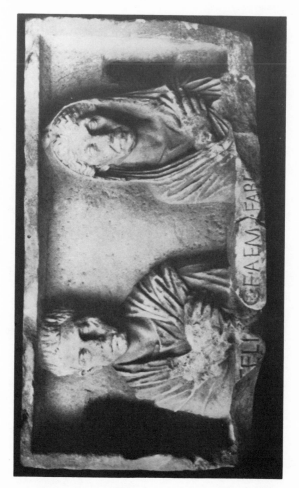

Fig. 21

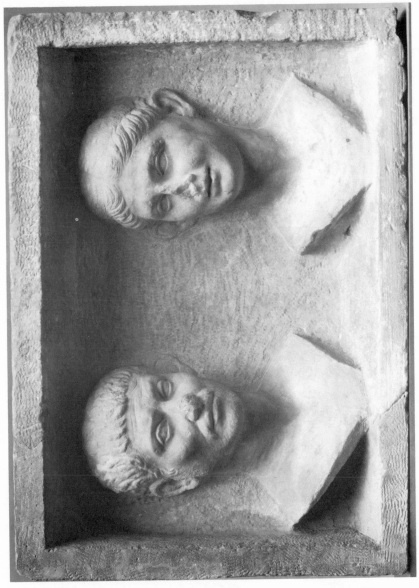

Fig. 22

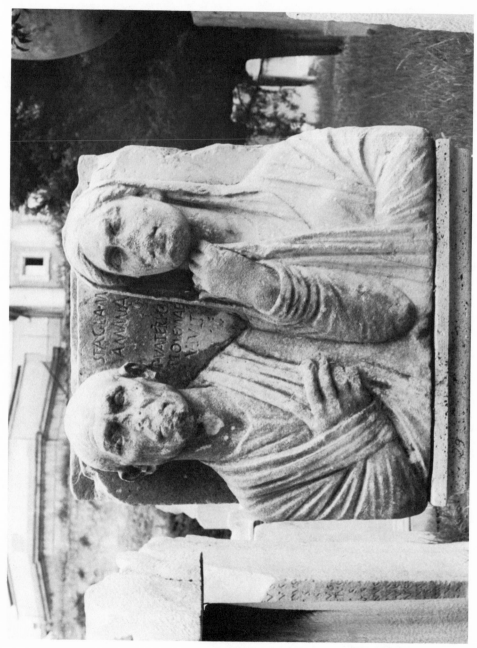

Fig. 23a

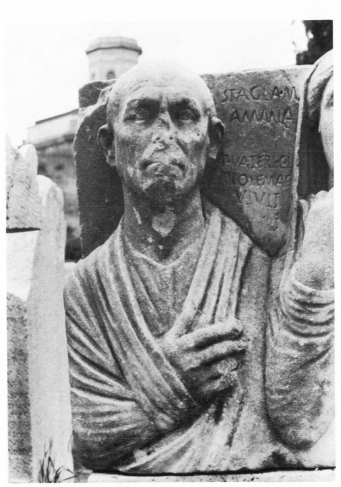

Fig. 23b

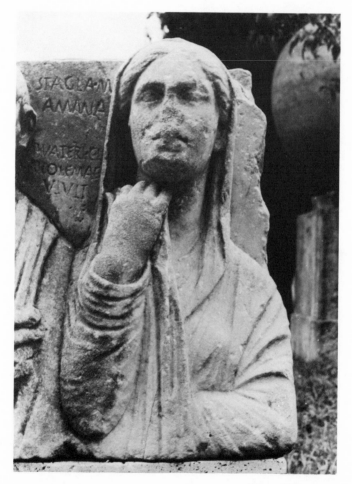

Fig. 23c

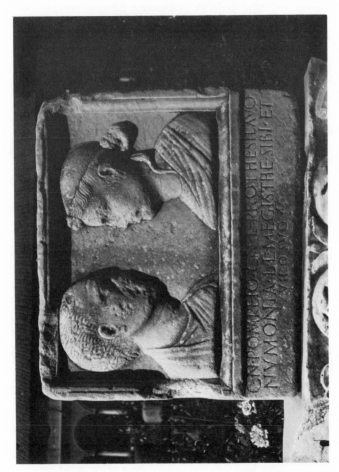

Fig. 24

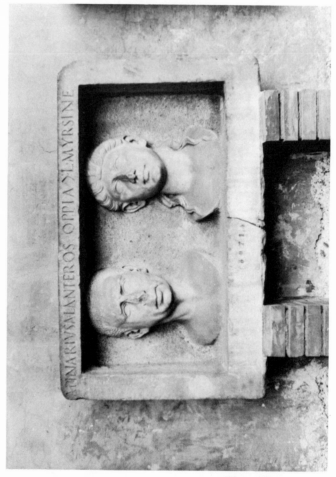

Fig. 25a

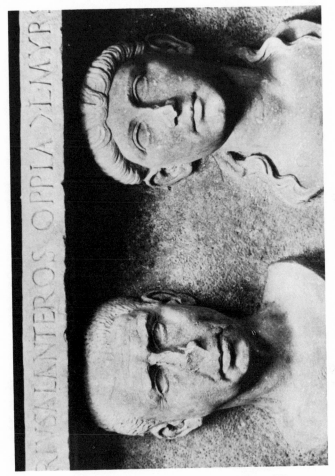

Fig. 25b

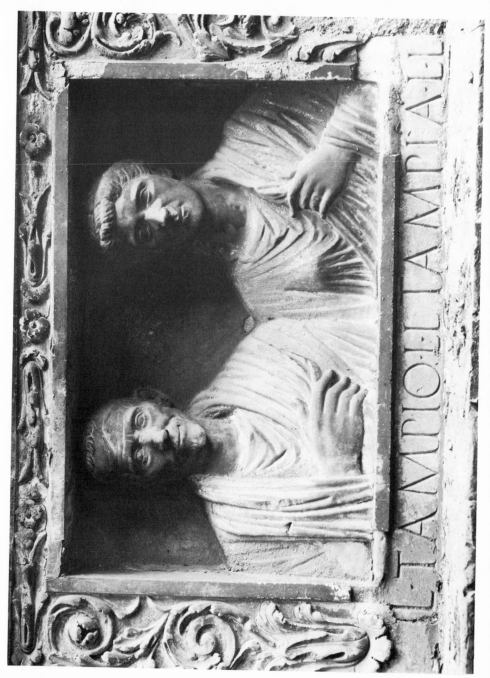

Fig. 26

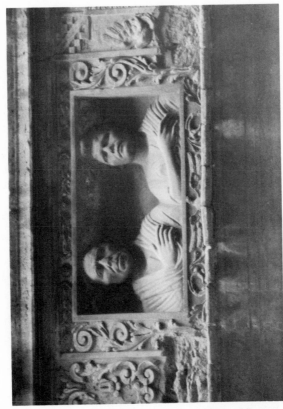

Fig. 27

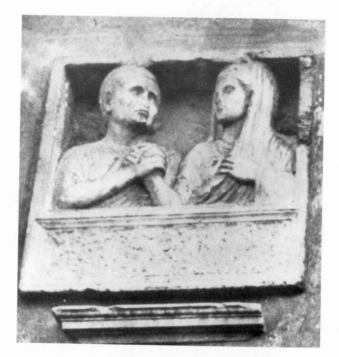

Fig. 28

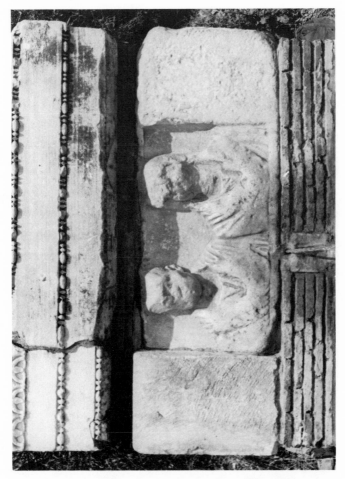

Fig. 29

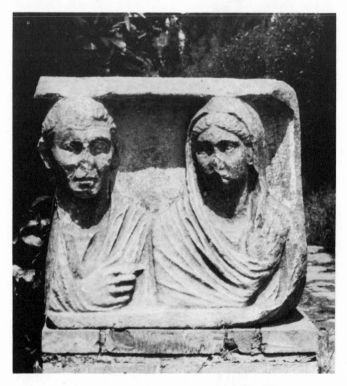

Fig. 30

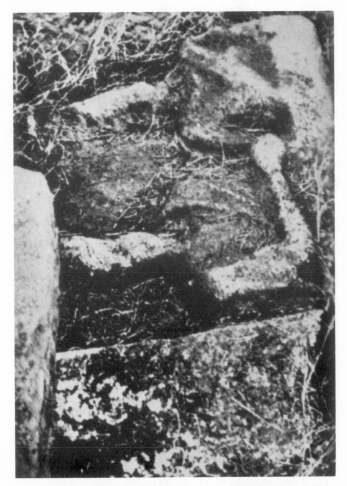

Fig. 31

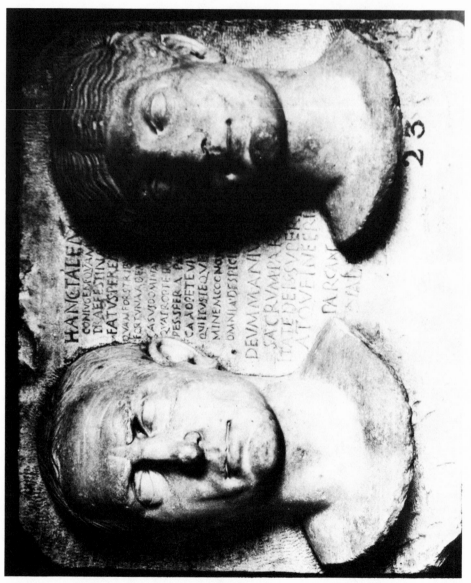

Fig. 32

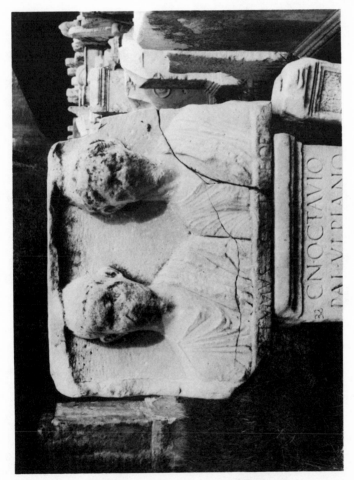

Fig. 33

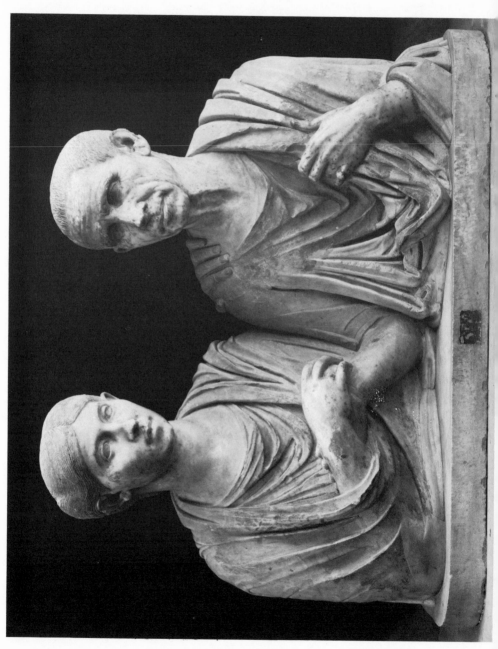

Fig. 34

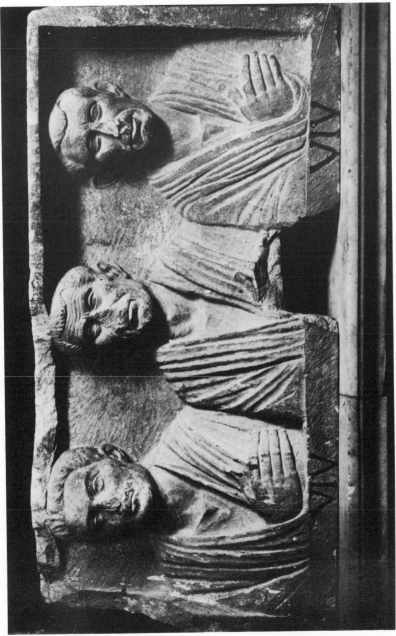

Fig. 35

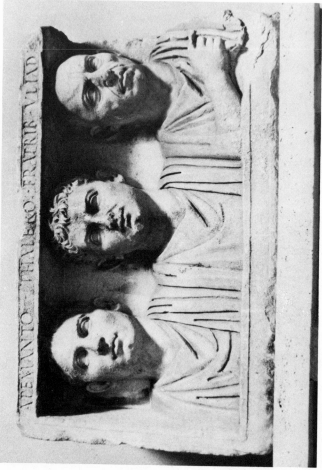

Fig. 36

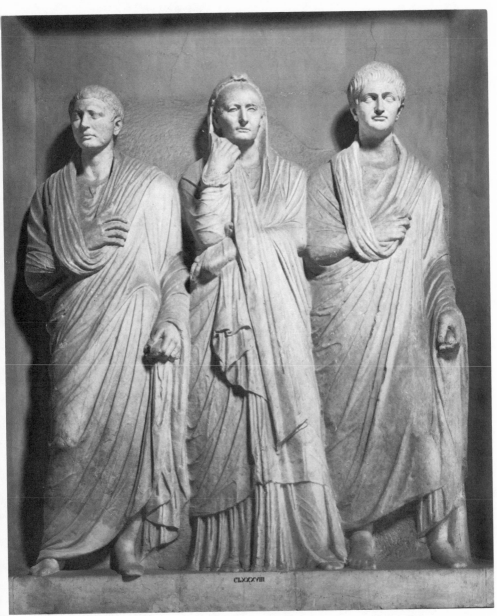

CLXXXVIII

Fig. 37

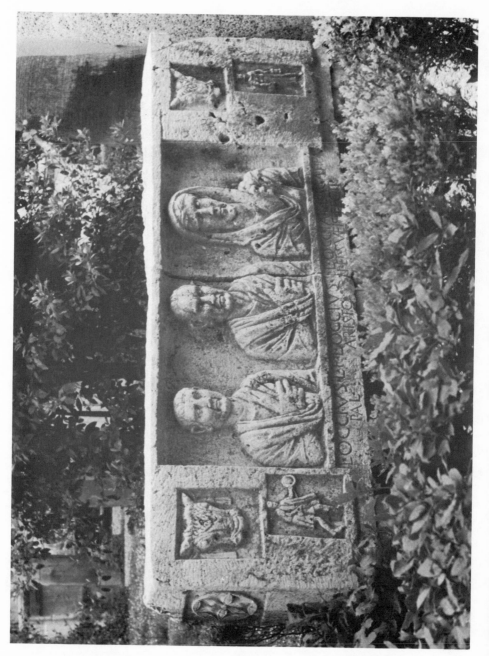

Fig. 38a

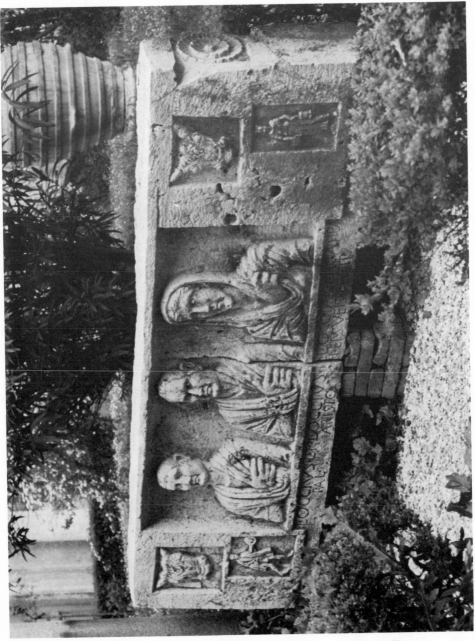

Fig. 38b

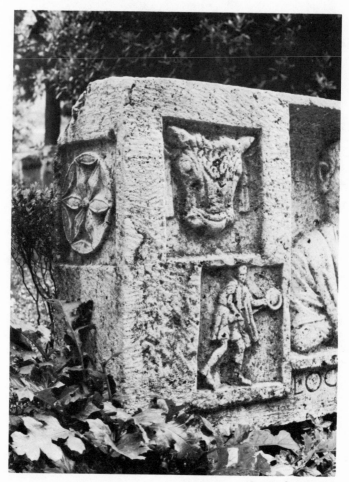

Fig. 38c

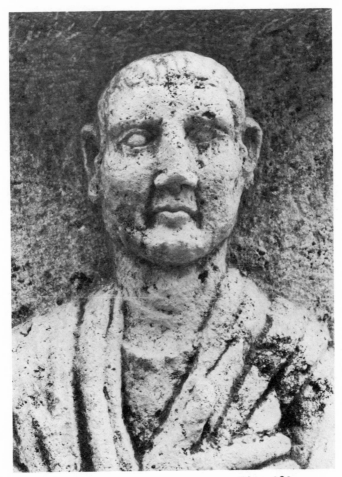

Fig. 38d

Fig. 38e

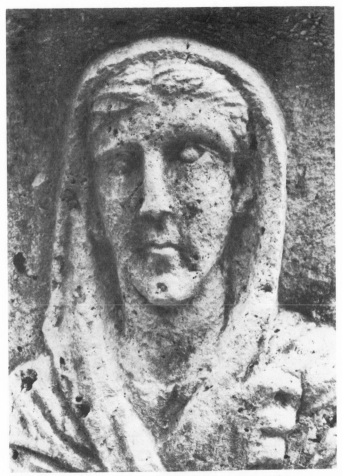

Fig. 38f

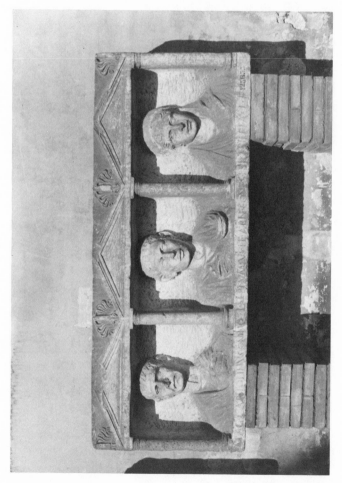

Fig. 39a

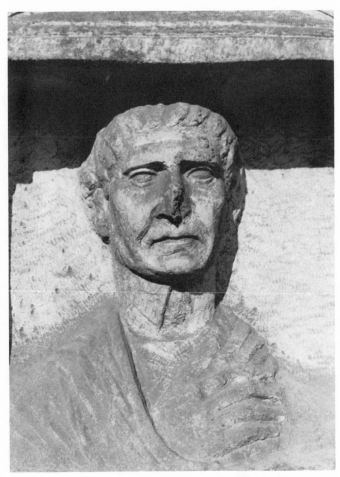

Fig. 39b

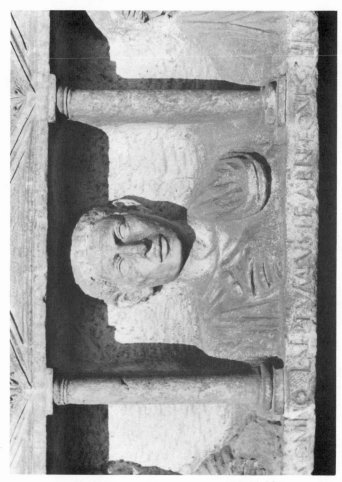

Fig. 39c

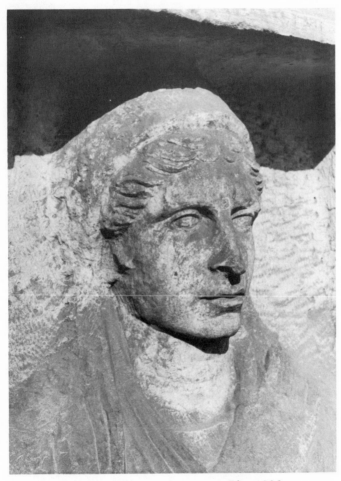

Fig. 39d

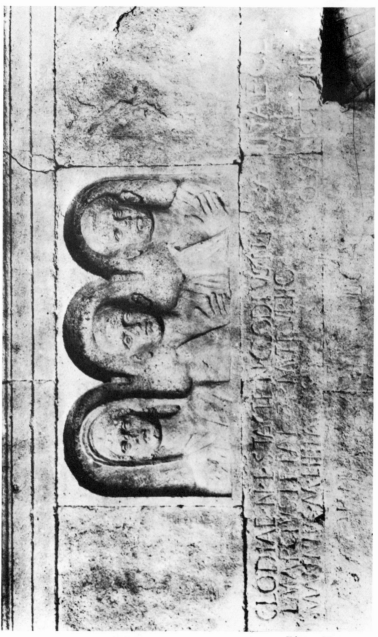

Fig. 40a

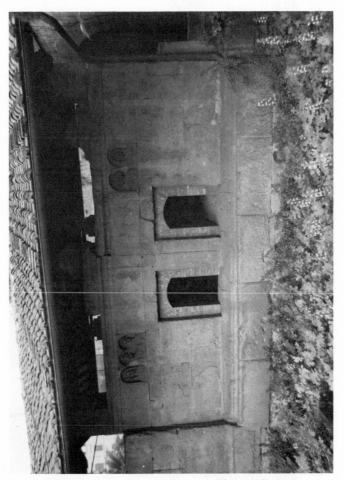

Fig. 40b

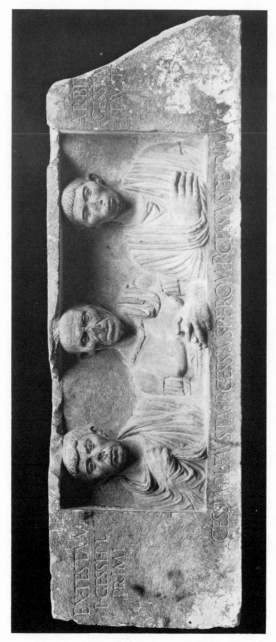

Fig. 41

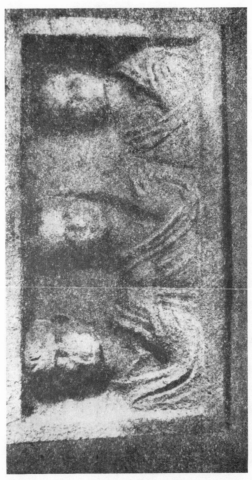

Fig. 42

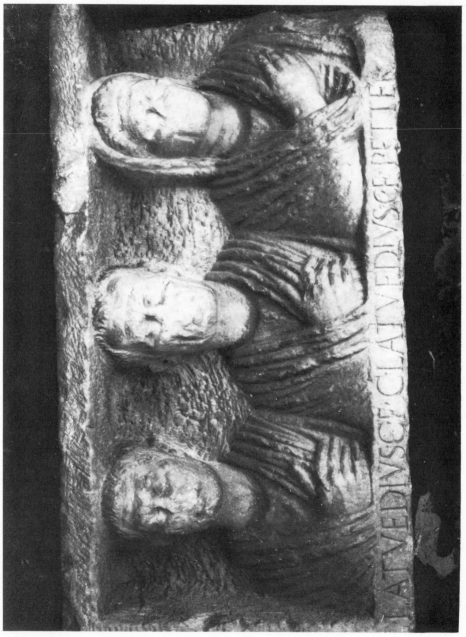

Fig. 43

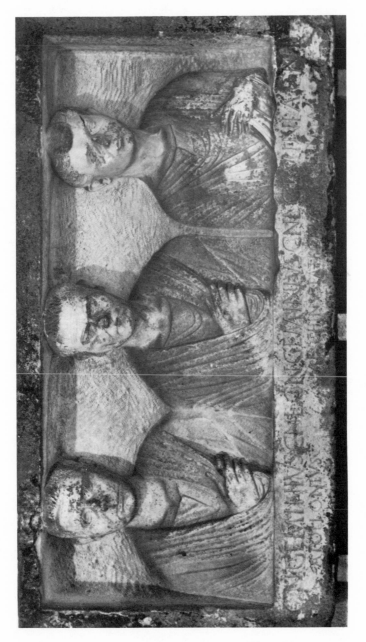

Fig. 44

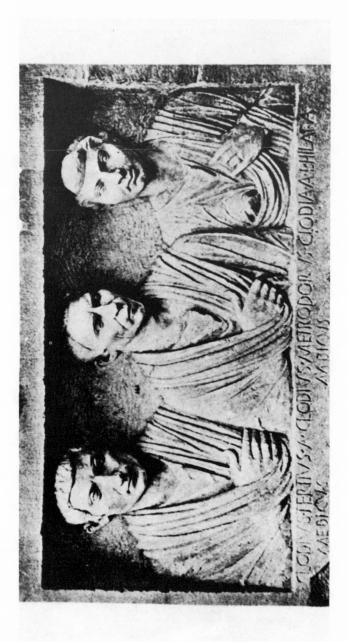

Fig. 45

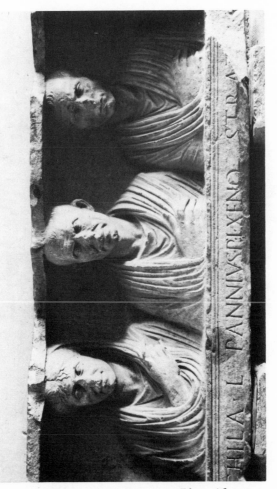

Fig. 46

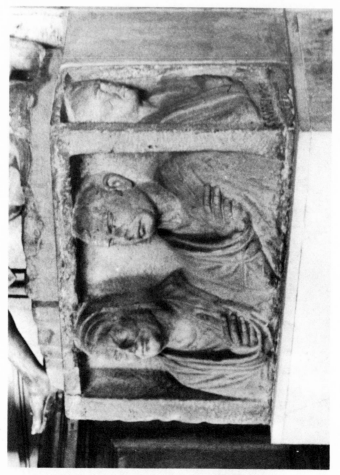

Fig. 47a

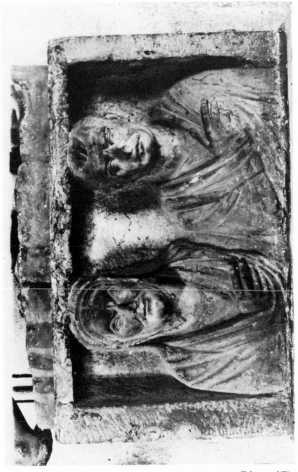

Fig. 47b

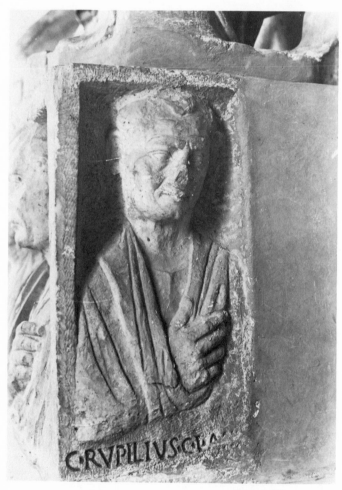

Fig. 47c

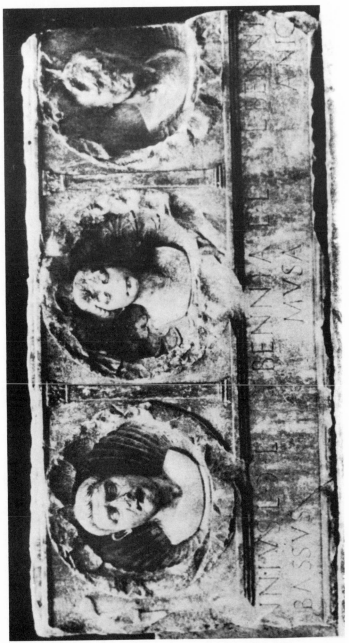

Fig. 48

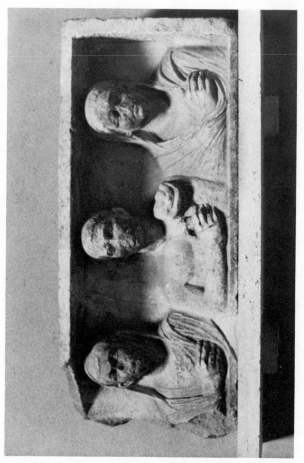

Fig. 49

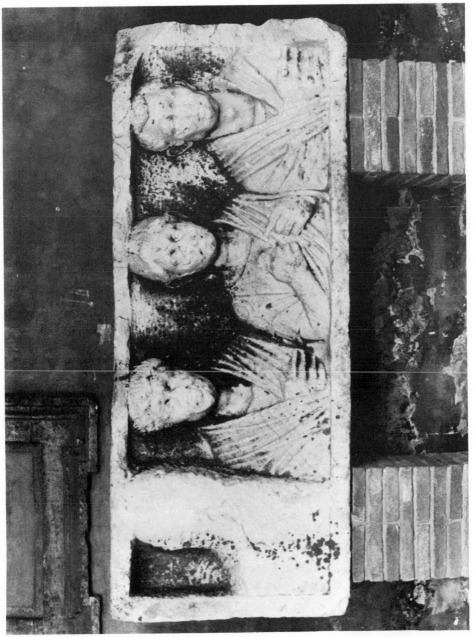

Fig. 50a

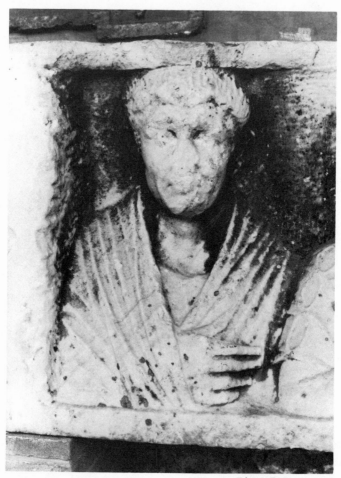

Fig. 50b

Fig. 50c

Fig. 50d

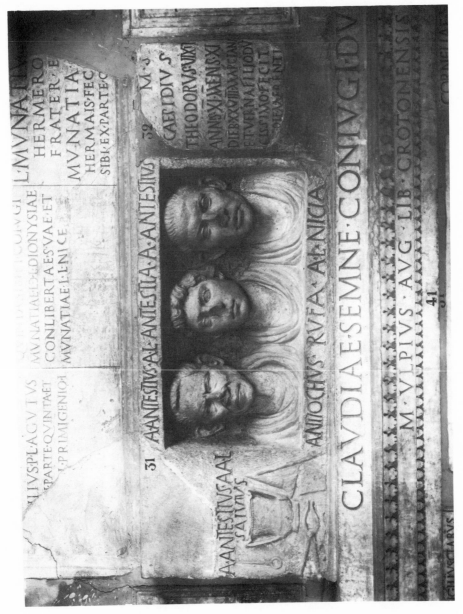

Fig. 51

Fig. 52

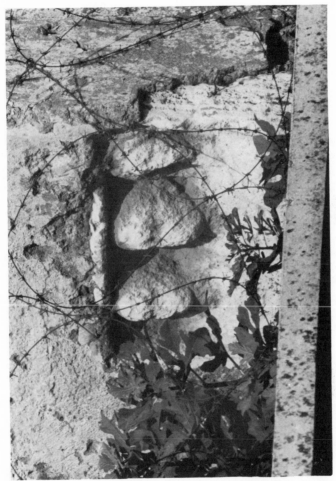

Fig. 53

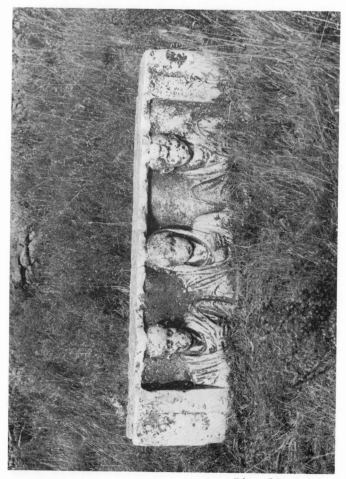

Fig. 54a

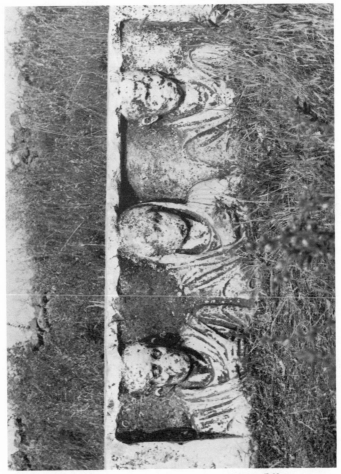

Fig. 54b

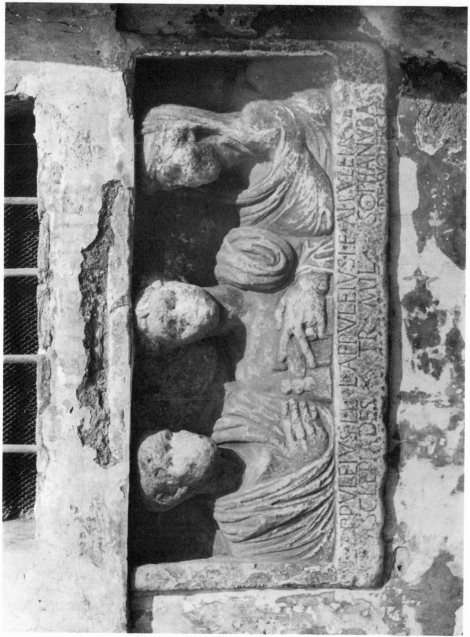

Fig. 55a

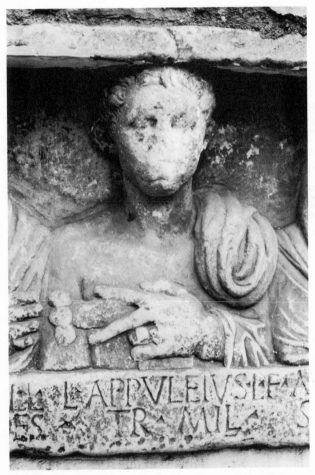

Fig. 55b

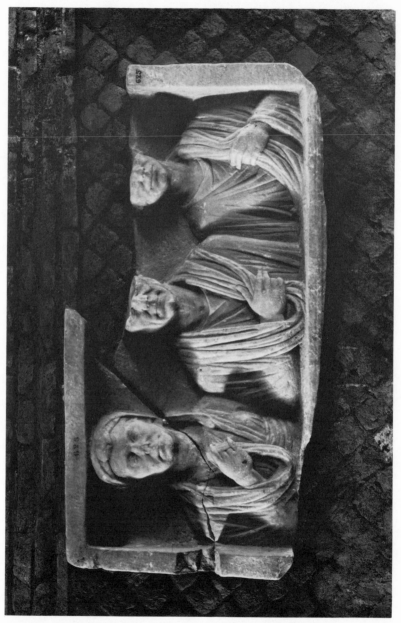

Fig. 56

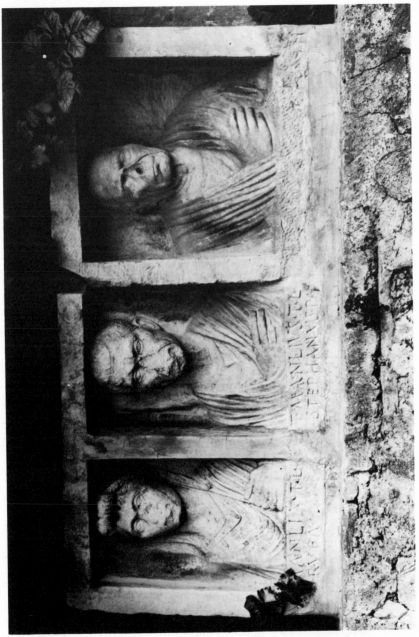

Fig. 57

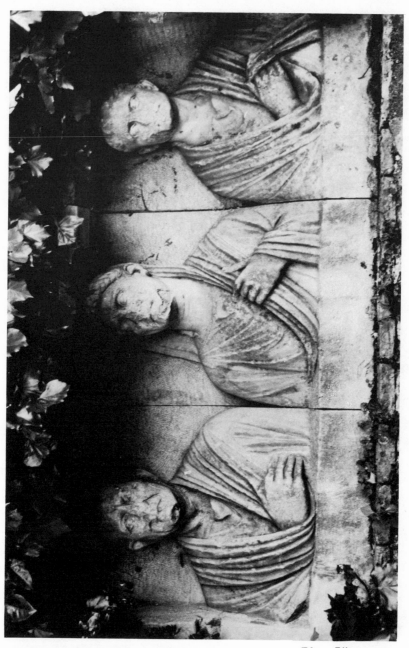

Fig. 58

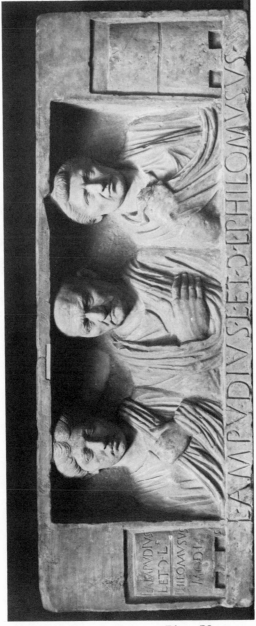

Fig. 59

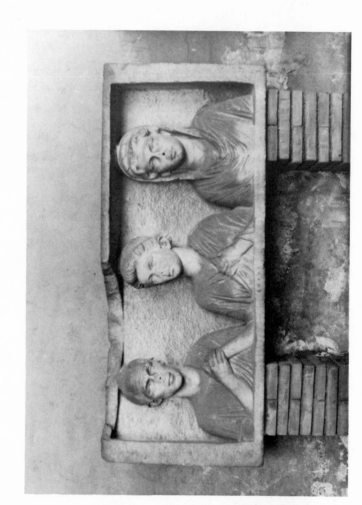

Fig. 60

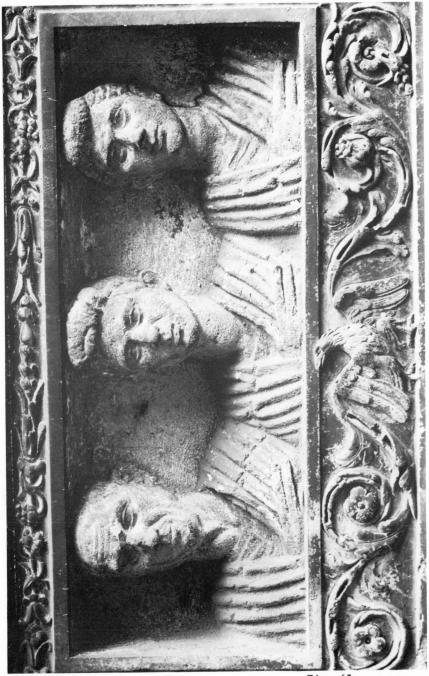

Fig. 61

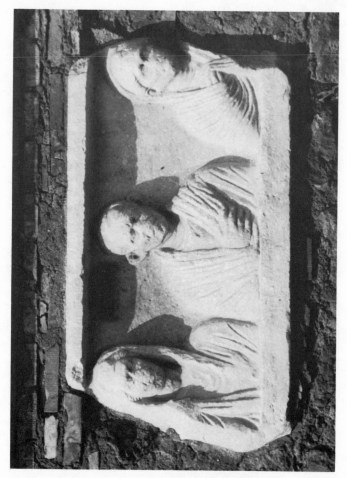

Fig. 62

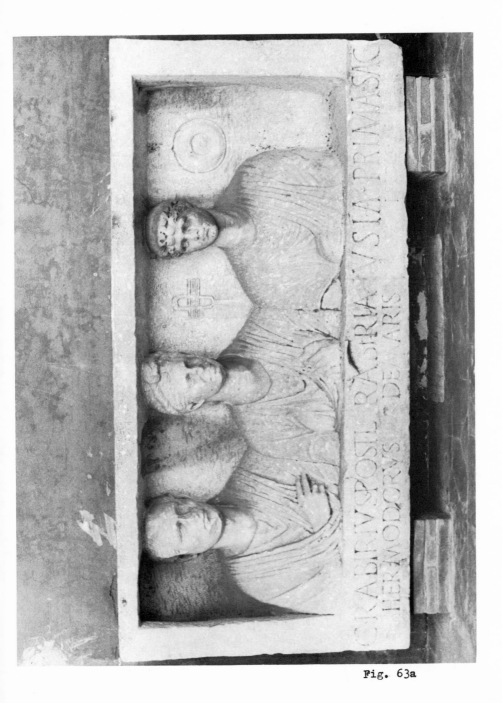

Fig. 63a

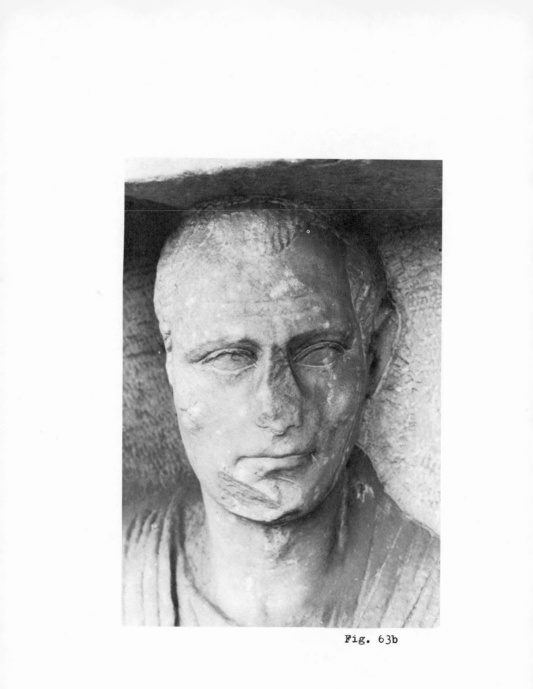

Fig. 63b

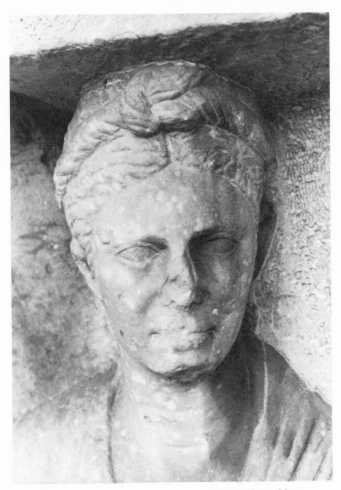

Fig. 63c

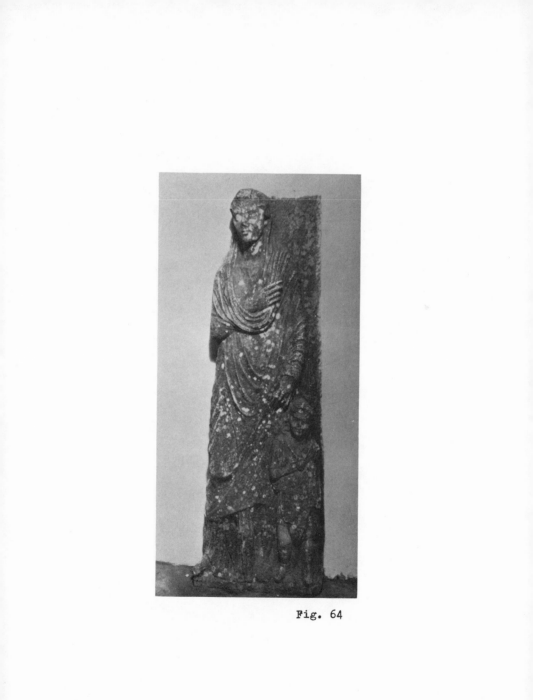

Fig. 64

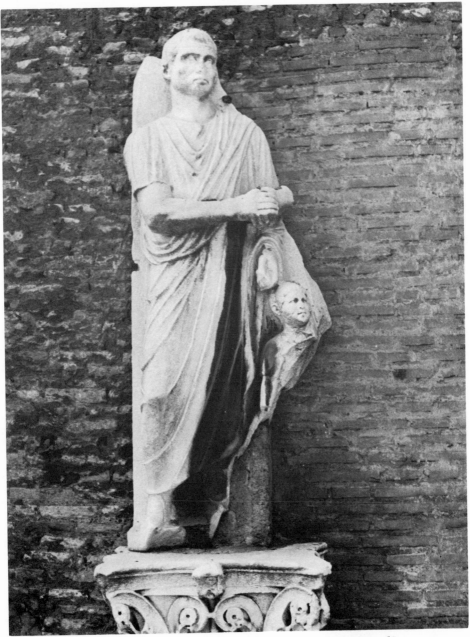

Fig. 65a

Fig. 65b

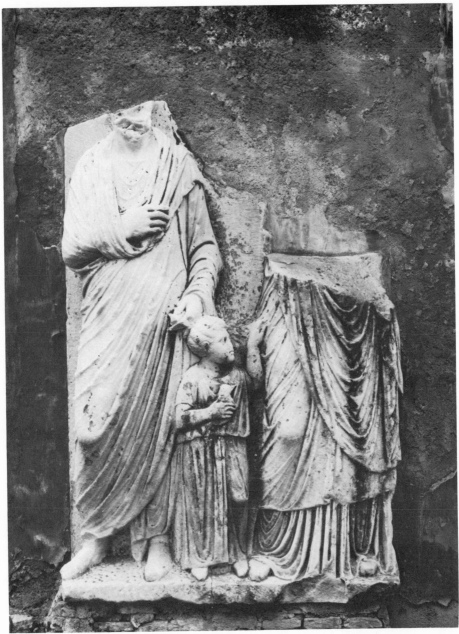

Fig. 66

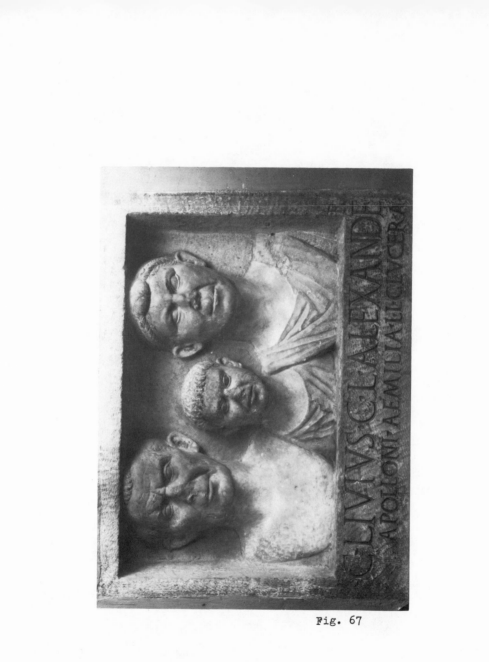

Fig. 67

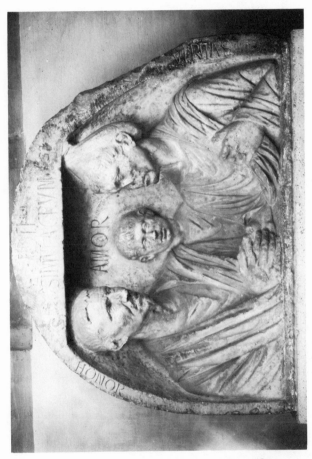

Fig. 68

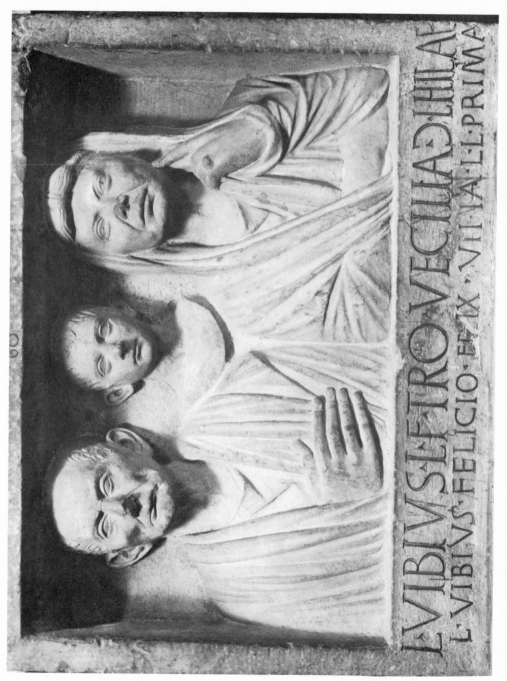

Fig. 69

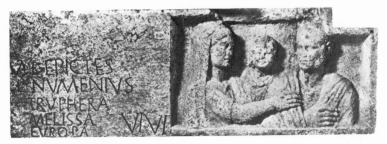

Fig. 70a

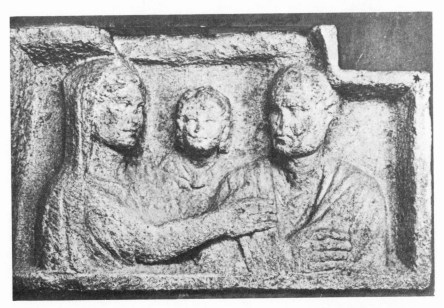

Fig. 70b

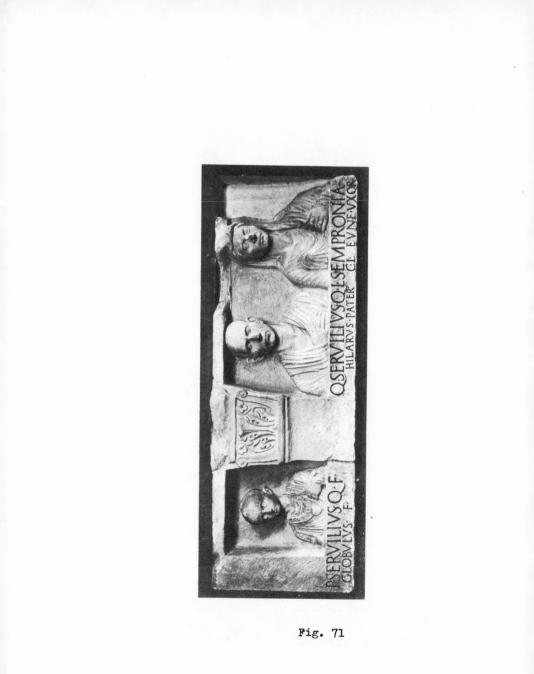

Fig. 71

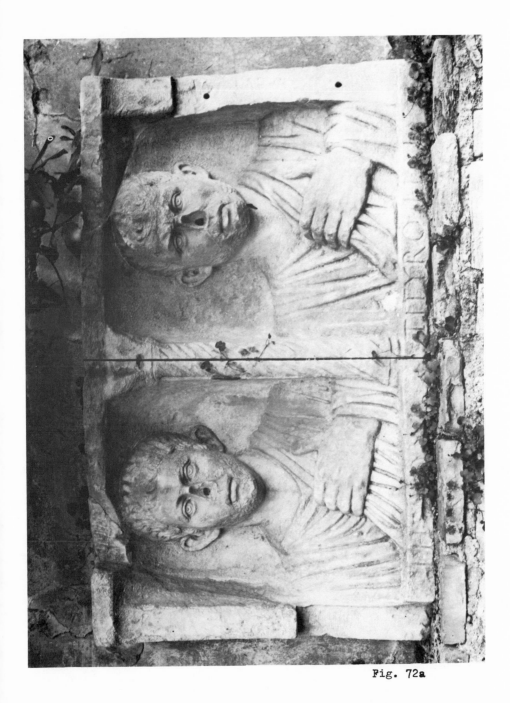

Fig. 72a

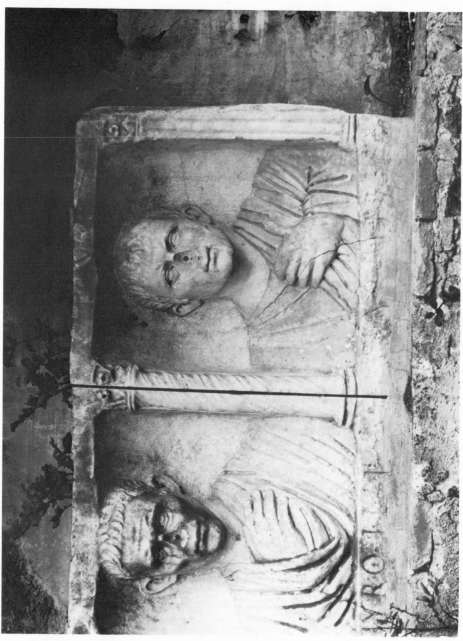

Fig. 72b

Fig. 73a

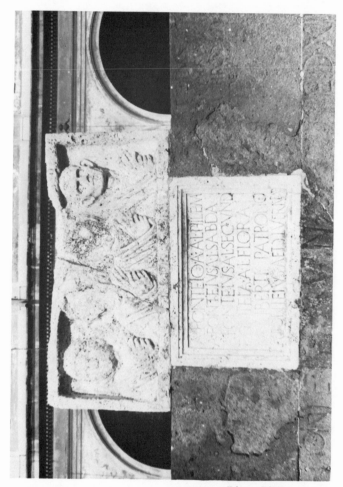

Fig. 73b

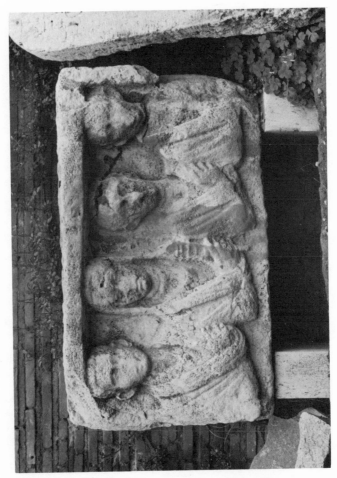

Fig. 74

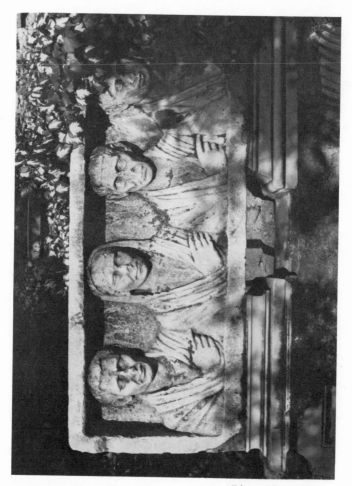

Fig. 75a

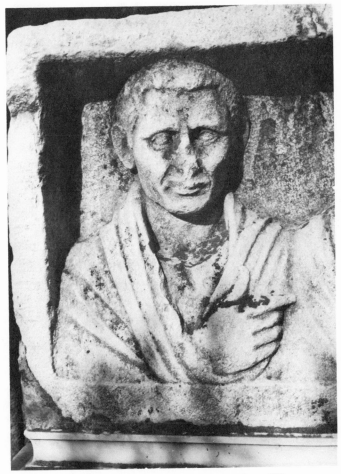

Fig. 75b

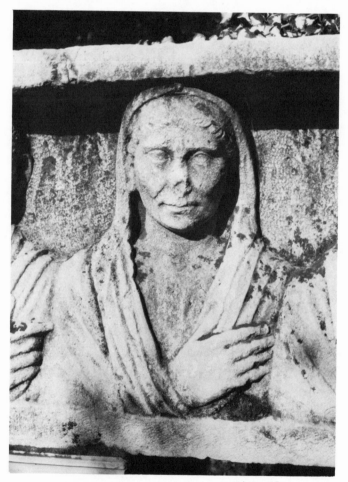

Fig. 75c

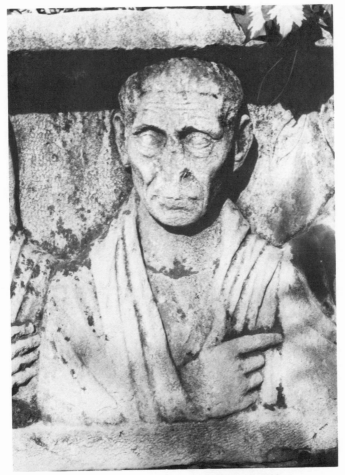

Fig. 75d

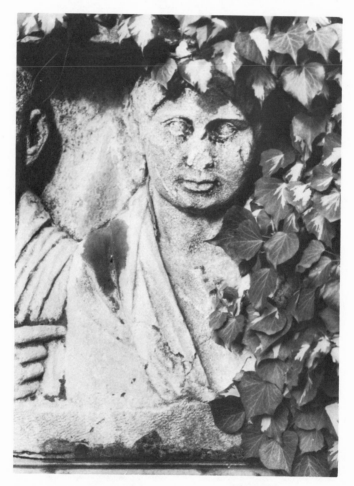

Fig. 75e

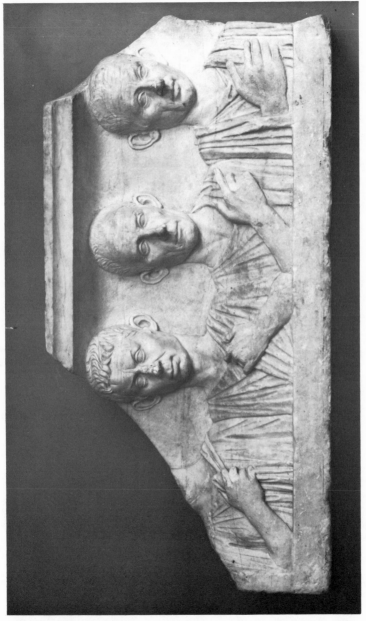

Fig. 76

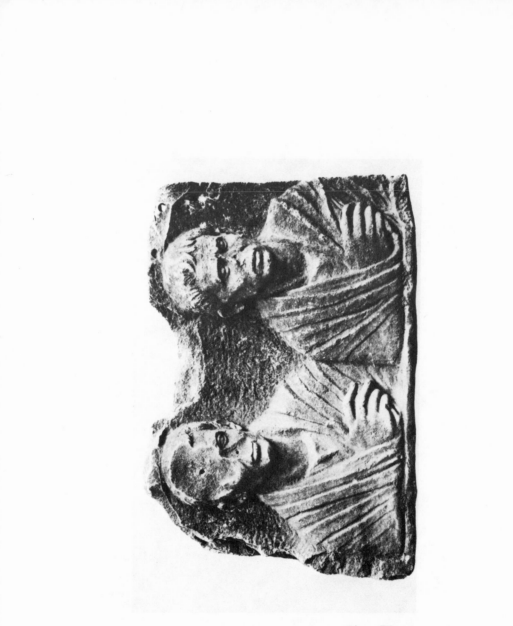

Fig. 77a

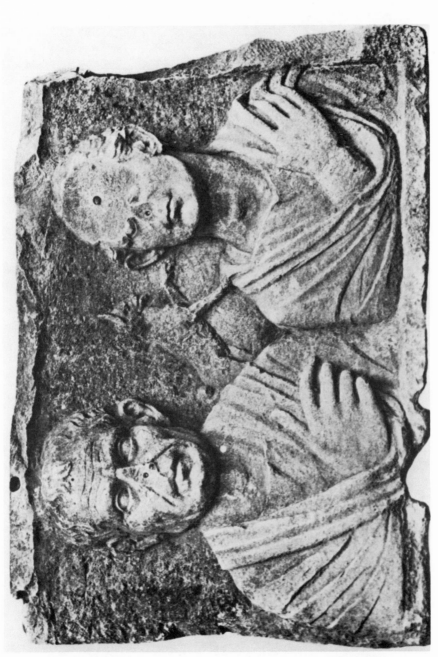

Fig. 77b

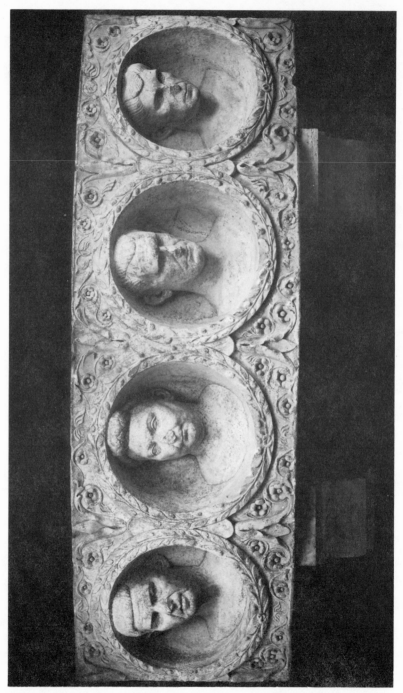

Fig. 78

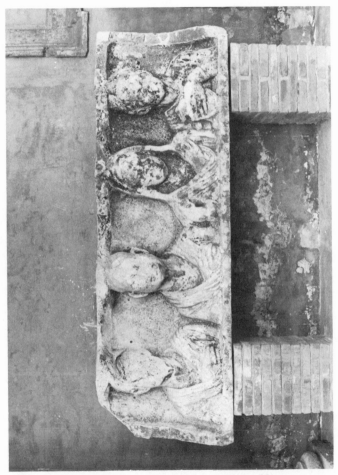

Fig. 79a

Fig. 79b

Fig. 79c

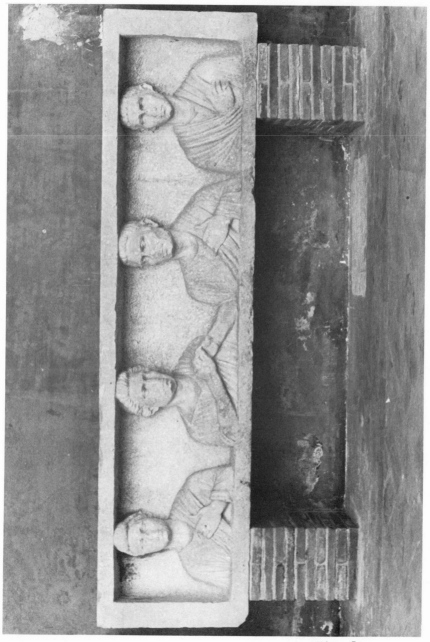

Fig. 80a

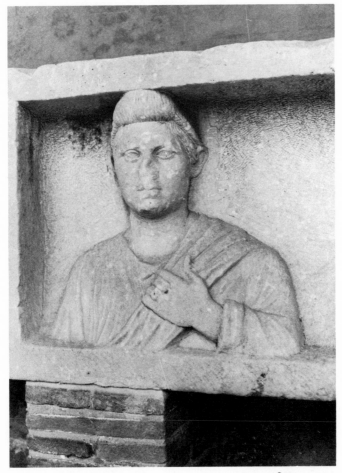

Fig. 80b

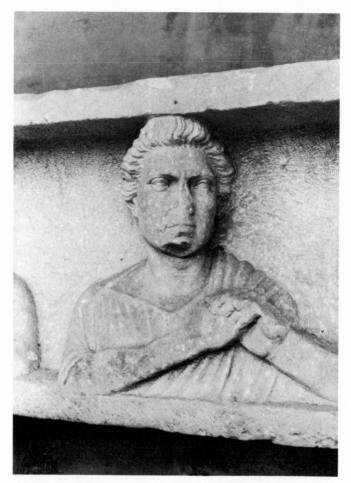

Fig. 80c

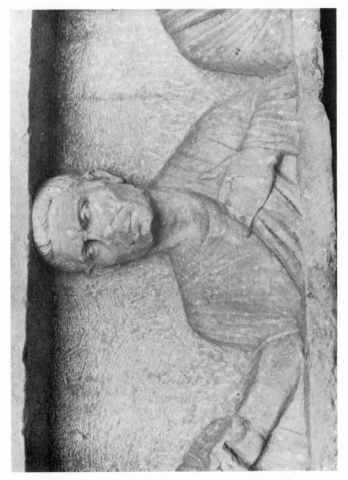

Fig. 80d

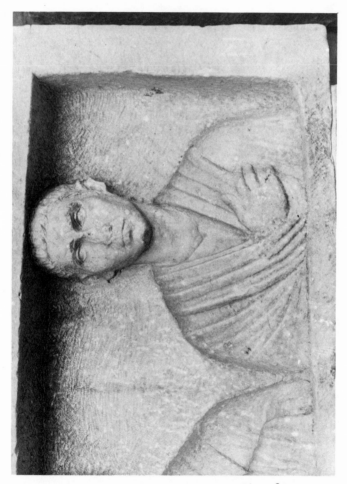

Fig. 80e

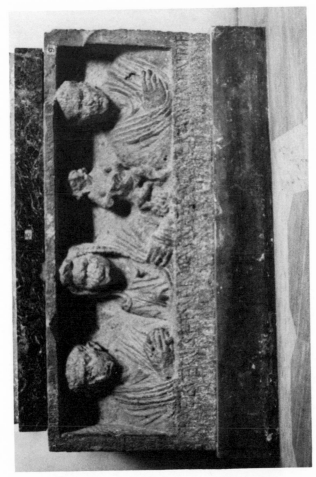

Fig. 81

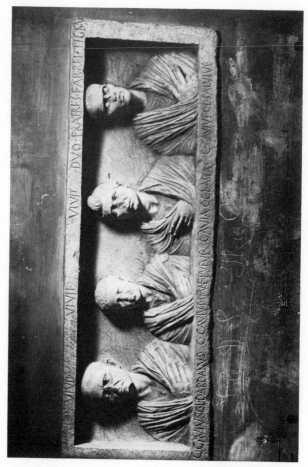

Fig. 82

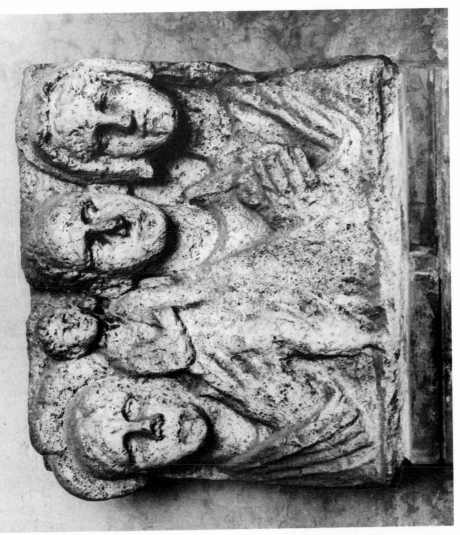

Fig. 83a

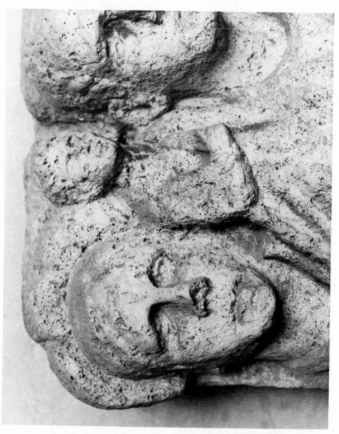

Fig. 83b

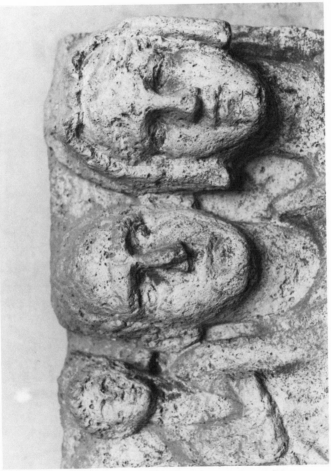

Fig. 83c

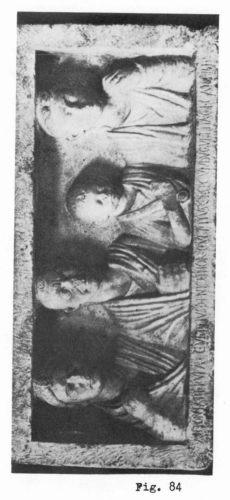

Fig. 84

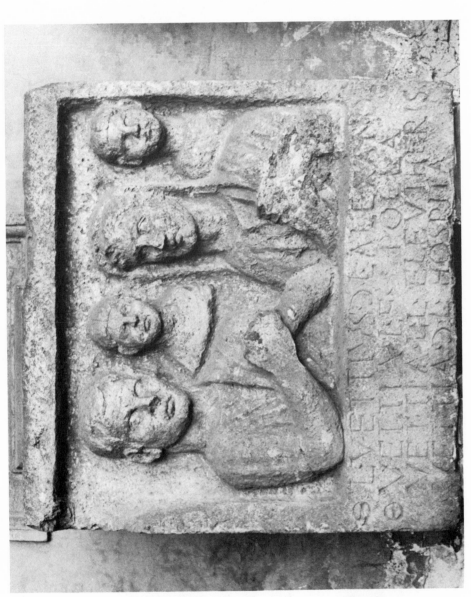

Fig. 85

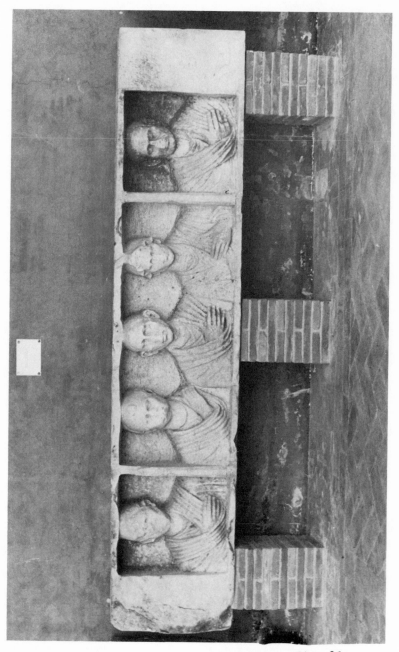

Fig. 86

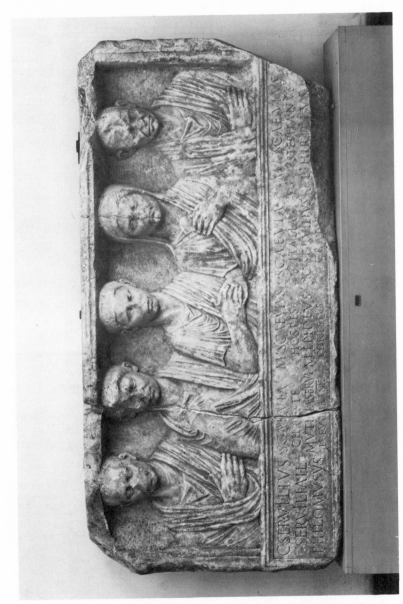

Fig. 87

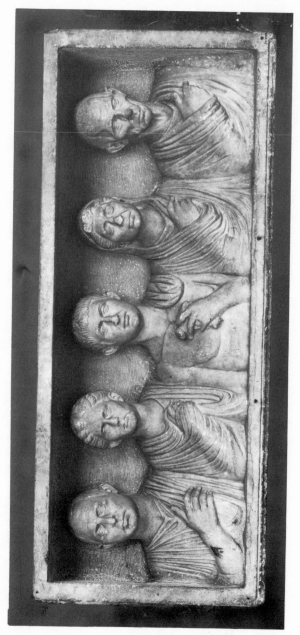

Fig. 88

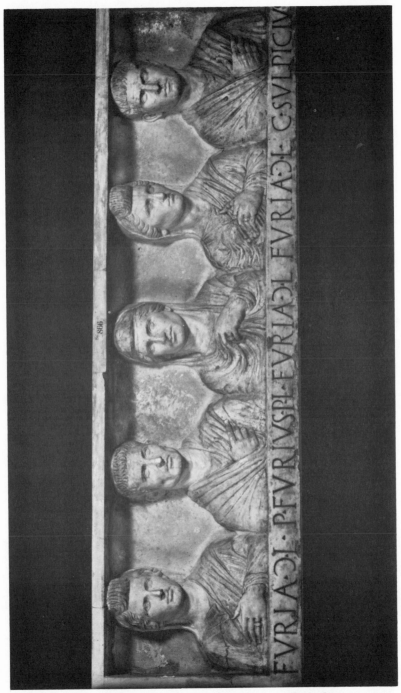

Fig. 89

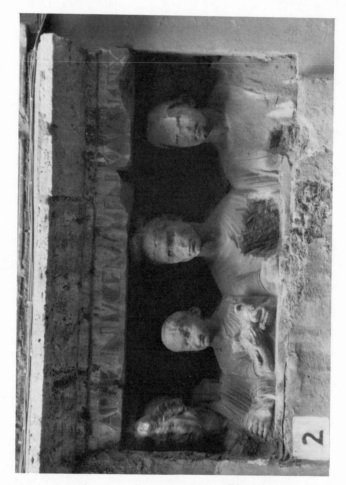

Fig. 90a

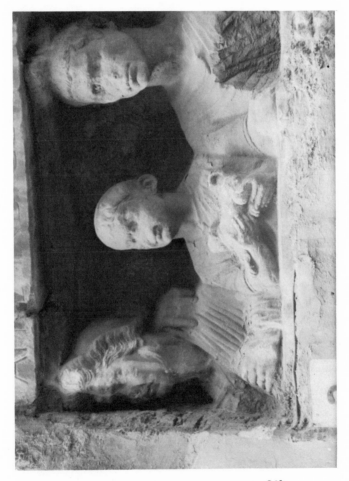

Fig. 90b

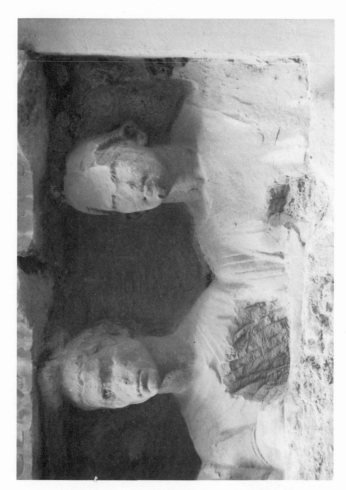

Fig. 90c

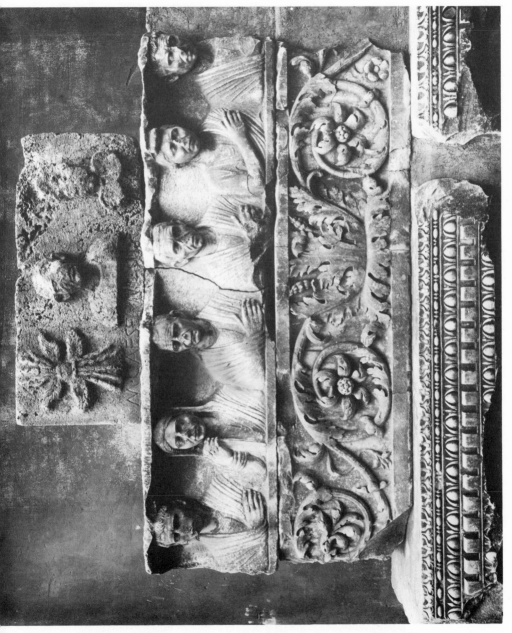

Fig. 91

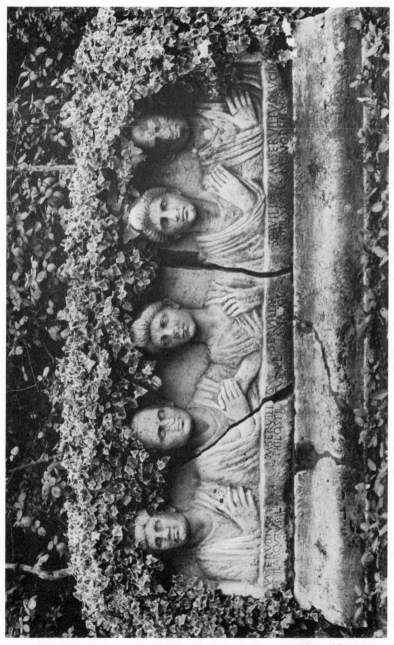

Fig. 92a

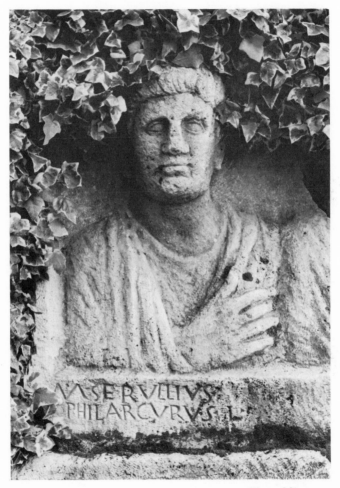

Fig. 92b

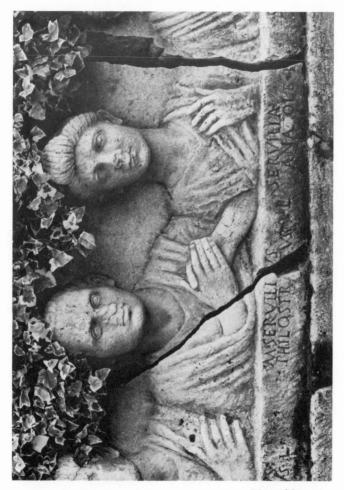

Fig. 92c

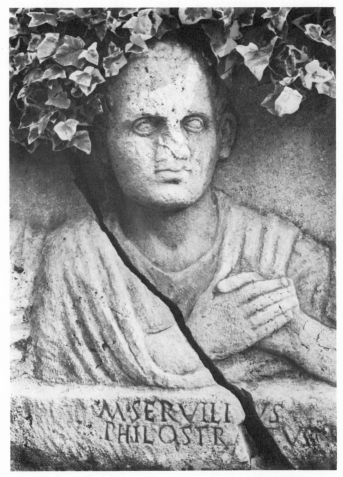

Fig. 92d

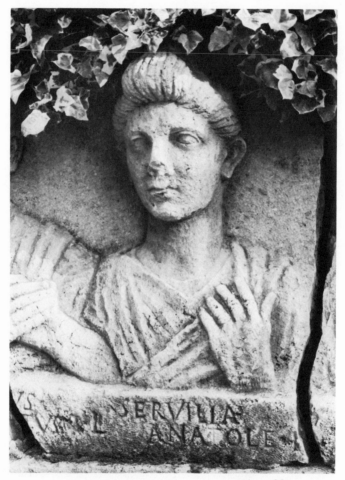

Fig. 92e

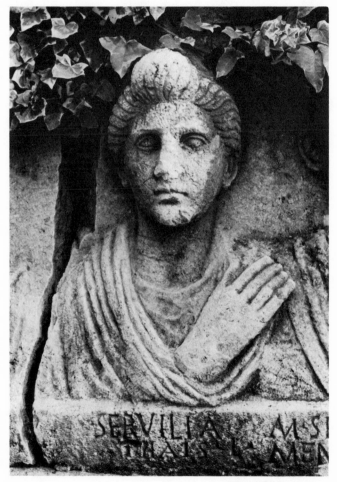

Fig. 92f

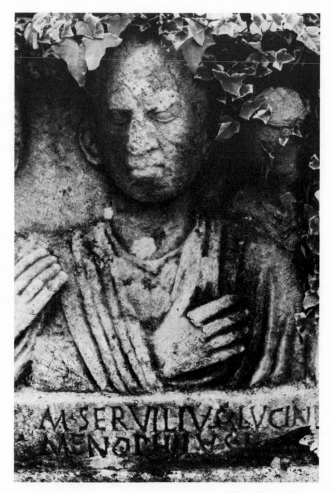

Fig. 92g

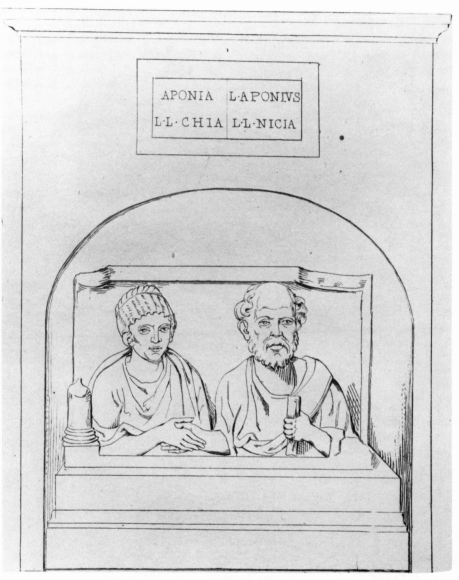

APONIA | L·APONIVS
L·L·CHIA | L·L·NICIA

Fig. 93

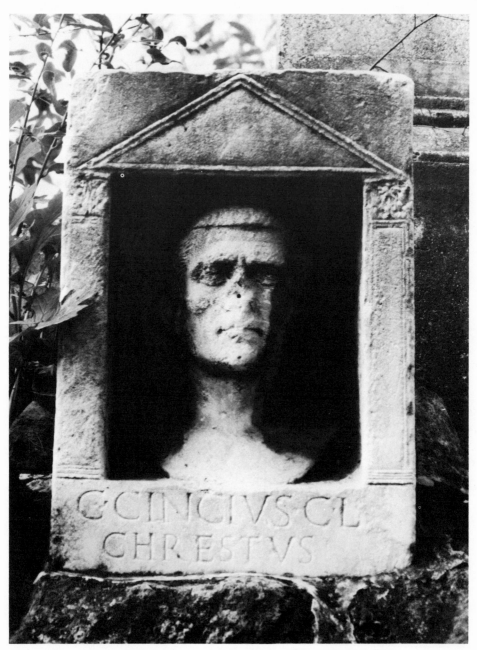

Fig. 94

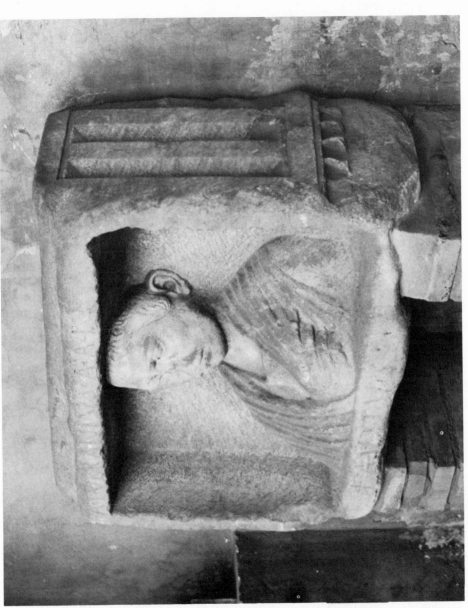

Fig. 95

Fig. 96